EDWARD S. CURTIS
COMING TO LIGHT

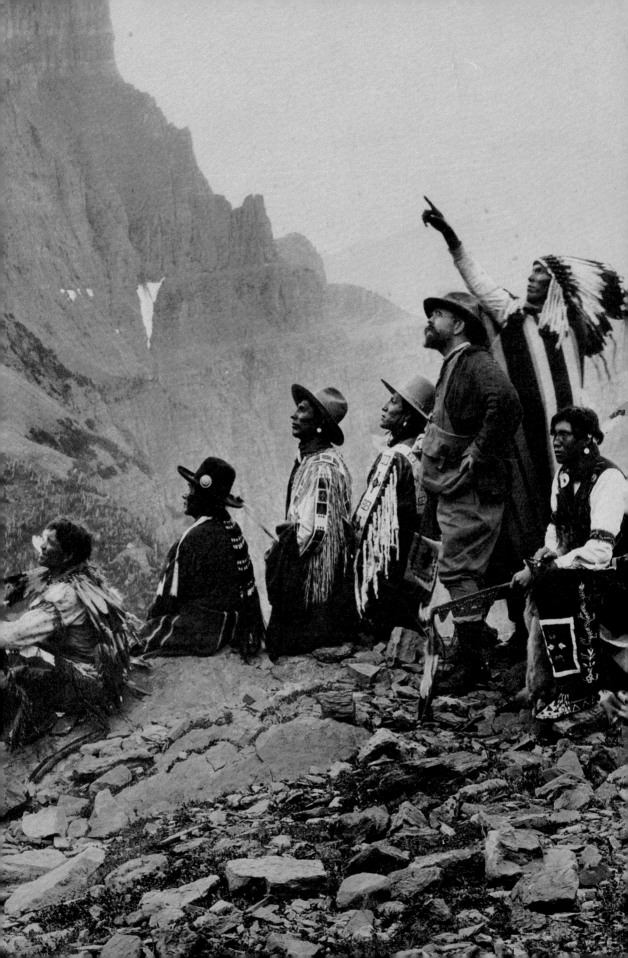

EDWARD S. CURTIS
COMING TO LIGHT

ANNE MAKEPEACE

NATIONAL GEOGRAPHIC

WASHINGTON, D.C.

Page 2: A rare, one-of-a-kind print of Edward Curtis, probably doing fieldwork in the Southwest. The print bore no date or information on the Native Americans pictured in it.

DEDICATION

To the matriarch of the Hopi Flute Clan, Ethel Mahle, or Pahunmana, meaning the "Splash of Rain on Water."
She invited me into her world and gave me my Hopi name, Akausimana, "Sunflower Girl."

ETHEL MAHLE

1909-2001

CONTENTS

CURTIS'S CANYON DE CHELLY—NAVAHO

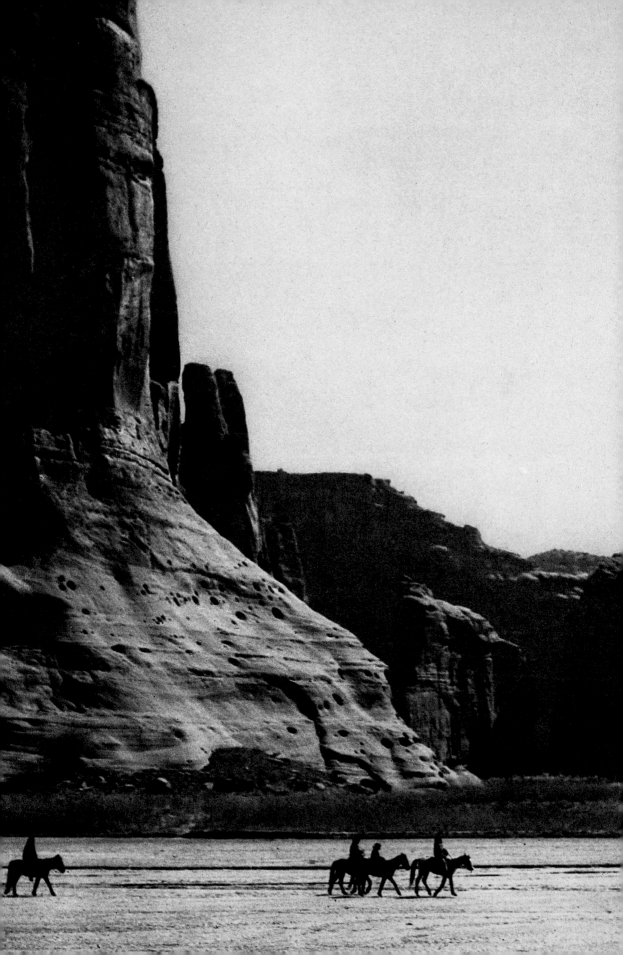

INTRODUCTION

Discovering Curtis

CURTIS FIRST SPOKE TO ME, NAMELESS, FROM HIS PHOTOGRAPHS. In the 1980s I came upon his sepia-toned pictures of American Indians in friends' homes, on postcards, book jackets, and posters, and occasionally in a gallery or museum. The first image that captured my imagination was "Canyon de Chelly," Curtis's large, painterly photograph of Navajo riders silhouetted against a towering cliff wall. I had had my own adventures in Canyon de Chelly, had set my first film script there, and remembered the pink and gold light that glowed from the sandstone walls. Curtis's photograph caught the beauty and grandeur I remembered, the feeling of being part of something so much larger and more lasting than my own small, short life. The riders seemed at peace, sure of where they were going and in no hurry—a part of the luminous landscape they were passing through.

I began to notice Curtis's portraits—of Geronimo, Red Cloud, Joseph—famous chiefs who had resisted the onslaught of the United States Army for decades but who were prisoners of war when Curtis met them. Their faces told so many stories of love and war, of grief at what they had lost but also of tremendous strength and dignity and of an unshakable sense of themselves.

As a filmmaker, I was curious about the man who had taken these pictures. I began to read about Curtis's life and was immediately struck by the amazing drama of his story. Here was a man who had been born in poverty and obscu-

rity, who had created himself from nothing. He was a pioneer in every sense of the word: As a homesteader on Puget Sound, he had taught himself photography and had become for a time the most famous photographer in America. By the end of the 19th century, he was winning international prizes for his work and publishing photographs and articles in *Century Magazine, Camera Craft,* and Alfred Stieglitz's *Camera Notes.* He became friends with President Theodore Roosevelt, succeeded in convincing J. P. Morgan to fund his giant project, and completed an enormous body of work recording traditional Indian ways.

Like most of his contemporaries, Curtis believed that Indian cultures were vanishing. War and disease had decimated the native population. A census taken in 1906 showed that American Indians had decreased by 95 percent from their precontact numbers. At the turn of the century, Curtis discovered the richness and diversity of the western tribes and became determined to make a record of their traditional ways of life before they disappeared. Between 1900 and 1930 he traveled from Mexico to the Arctic, from the Rockies to the Pacific, photographing and recording more than 80 tribes. He created an astonishing body of work: 40,000 photographs, the first full-length ethnographic motion picture, 10,000 wax-cylinder recordings, 20 volumes of ethnographic text with accompanying portfolios, and several books of Indian stories.

Curtis's rise from poor subsistence farmer and hired hand to an artist of international fame, as well as his adventures throughout the West, make a quintessentially American story—with elements of classic tragedy. In the early years he was full of confidence and ambition, declaring to J. Pierpont Morgan, one of the most powerful men in the world, that he, Curtis, was the one man with the strength and determination to make a comprehensive record of all Indian tribes in the West and that he could finish this work in five years. But at the end of that first five years, he had really only begun. Despite huge financial difficulties, he kept going for another 25 years, his debts rising, his marriage crumbling, his health failing. His story is one of tremendous fortitude, both of his own spirit and the spirit of the American Indians he set out to photograph.

The stories I read about Curtis inspired me to begin research for a dramatic feature film about his life. I planned to structure the film around his experiences

on the Hopi Reservation, where he had returned year after year and where for a time at least he had left the camera behind to participate in the religious life of the tribe. In 1991 I set out for Arizona in search of Hopi who might have met Curtis during his many visits there. I wanted to identify some of the people in the pictures, to find their descendants, and to hear stories that would reveal the world Curtis had entered a century ago.

As I drove through the Painted Desert toward the Hopi Reservation, I was thinking about Curtis's first journey there in 1900: his endless train trip from Seattle to Arizona, the 60-mile trek by wagon and mule across rough sand cut by deep arroyos. It would have taken him at least a week to get there. It took me six hours, including my flight.

I had planned to start my film with an old woman remembering Curtis's arrival when she was a child—the strangeness of this man with a wooden box for a head, lenses for eyes, a black cloth around his neck. My main goal on this trip was to meet elderly Hopi women, to hear their voices, to learn about their first experiences of white people coming to the reservation.

The desert was surprisingly green, the sunflowers blazing, the red walls rising up to the mesa, mottled light and dark by the shifting clouds. I was headed to tribal headquarters to meet with the director of the Office of Hopi Cultural Preservation and discuss my project with him. He was the key to finding people and getting permission to work on the reservation. I had arranged an appointment weeks before, but when I arrived, he had left for the weekend.

Reeling with hunger and disappointment, unsure what to do next, I headed to Second Mesa and the Hopi Cultural Center. As I was about to enter the restaurant there, I noticed a sign next to the museum: "Elders Lunch, All Welcome, $3.50." Right there in front of me was a whole table of women elders, laughing and talking, beckoning to me and calling, "Come in! Come eat!" Here they were, the Hopi women I had been looking for, whose voices would enter me like music and become part of my own story.

This was the first of many serendipitous events that have happened to me on the Hopi Reservation. They all have had the same structure: The disappointment in plans falling through, the turning away to the unknown, and the sudden appearance of something much more wonderful than I could have envisioned.

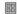

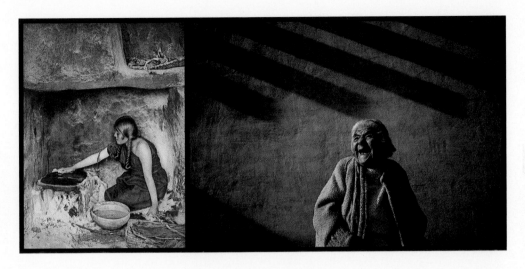

One of the last residents of the ancient Hopi village of Walpi, Ethel Mahle (right) was five years old when Edward Curtis photographed her mother, Dayumana (left), as "The Piki Maker."

I joined these women for a bowl of Hopi stew, a thick soup filled with mutton and hominy and served with thin blue-corn pancakes called *piki,* all washed down with Kool-Aid. The conversation flowed happily between Hopi and English, and that night I was a guest in one of their houses. I thought about Curtis and his descriptions of the welcoming kindness he had found among the Hopi. I began to understand the spirit that had brought him back here year after year.

I showed my new friends some of Curtis's Hopi photographs, and they were fascinated by them. They weren't sure of the identities of people in the pictures, but they knew every place Curtis had photographed. These places spoke to them as strongly as the portraits, and the women pointed excitedly to the houses and sheep corrals that were no longer there, the springs where they used to get water and where ceremonies are still held. They were silent and reverent over pictures of the Flute Ceremony but turned the pages quickly past the Snake Dance, shaking their heads and saying that ceremony should never have been photographed. They laughed over Curtis's image of Hopi girls grinding meal, pointing out that the girls would not have worn their wedding dresses for this messy task, and they certainly wouldn't have been getting married and grinding meal all on the same

day. Clearly, Curtis had asked them to dress up for the occasion, and the women thought that was very funny.

The next day I joined the tour to Walpi, the ancient village at the tip of First Mesa, which non-Hopi can visit only with a guide. The tour guides were friendly but seemed a little weary of tourists with their cameras and their questions. Photography has been banned on the reservation since 1917 and is still forbidden, but tourists have a difficult time understanding why and sometimes sneak pictures anyway. To the Hopi, this reservation is sacred land, and they do not want pieces of it taken away in photographs unless they know how the pictures will be used and have a say in how and where the images are made.

We trudged out over a long, narrow ridge with 500-foot sheer drops to the desert floor on either side and into the stone village of Walpi. A tiny old woman, Ethel Mahle, came out of her house, waving hello. I showed her my book of pictures and asked her if she remembered a photographer coming out there, a man named Edward Curtis. She seemed to have no idea what I was talking about and kept asking, "Who? Curtis who?" as she flipped through the pages. The other tourists were staring, and the guide was waiting. Finally, Ethel came to "The Piki Maker," Curtis's photograph of a woman turned sideways to the camera, a pottery bowl beside her, her hand stretched out to smooth the corn batter onto a flat heated stone. The photograph is carefully composed, painterly, iconic. Ethel stared at the picture. She held it close and scanned it up and down, while the tourists watched and shifted on their feet. Then she looked up, beaming, and told me that she used to have that picture, that the piki maker was her mother, Dayumana.

Ethel later told me many stories about her mother and explained that Dayumana spent hours in the piki hut, her hand callused by the hot stone, making piki. She sold them to support Ethel and her three siblings; they were poor and had no father, Ethel said. She told me about a time when her mother killed a porcupine with a shovel and served it for dinner and about how Dayumana had become a Baptist because the Christians had food.

These stories and those of others I met made me see Curtis's photographs in an entirely new way. The iconic image of "The Piki Maker" was transformed into a photograph of a single mother struggling to make sense of her world at a time of terrible transition, to feed her family, to make a little extra money posing

for a picture. The stories infused the photographs with emotional weight, adding a new tension between the beautiful images that Curtis had created and the realities of people's lives.

I decided to set up an exhibit on First Mesa of all the photographs Curtis took there, to find more descendants of the people in the pictures and elicit more stories. I went everywhere with my large Curtis book, knocking on doors, following up on leads, trying to identify the pictures for the exhibit and of course for my film. I am sure many people answering the door thought I was a Mormon missionary or a Jehovah's Witness, but instead I opened up a book and showed them Curtis's photographs of their ancestors. Most hadn't seen the pictures, but many elders recognized them and told me the stories behind the images.

We opened the exhibit at Ponsi Hall on First Mesa in November 1993. The framed sepia photographs glowed from the walls, arranged and hung by staff from the Museum of Northern Arizona in Flagstaff. At first the place was empty, and I was alone with the photographs. Then there was laughter and noise outside, and people started arriving with bowls of stew and platters of corn, mutton, piki, corn bread. It was a feast, a true celebration of the photographs coming home. People talked excitedly about the pictures, and some raced back to their houses with copies I had made, showed them to their ancient parents and grandparents, then came back with more names and stories and sometimes even with Curtis's cyanotype field prints.

These events gave me a window into the lives of the people Curtis had photographed. I decided to make the Curtis film a documentary, so that I could show the responses of Indian peoples to the pictures and let them bring Curtis's images to life. I followed Curtis's paths to Nunivak Island in the Bering Sea, to Vancouver Island, to Montana and Alberta, to Washington and Arizona, finding descendants of the people he had photographed and in some cases, the aging subjects themselves, hearing their stories, learning what life had been like for these people when Curtis had come among them.

What struck me most powerfully on my journey was the incredible resilience and determination shown by North American Indians to keep their cultures alive—and Curtis's own resilience. He had set himself the enormous task of documenting their cultures before it was too late. And he did it. ✖

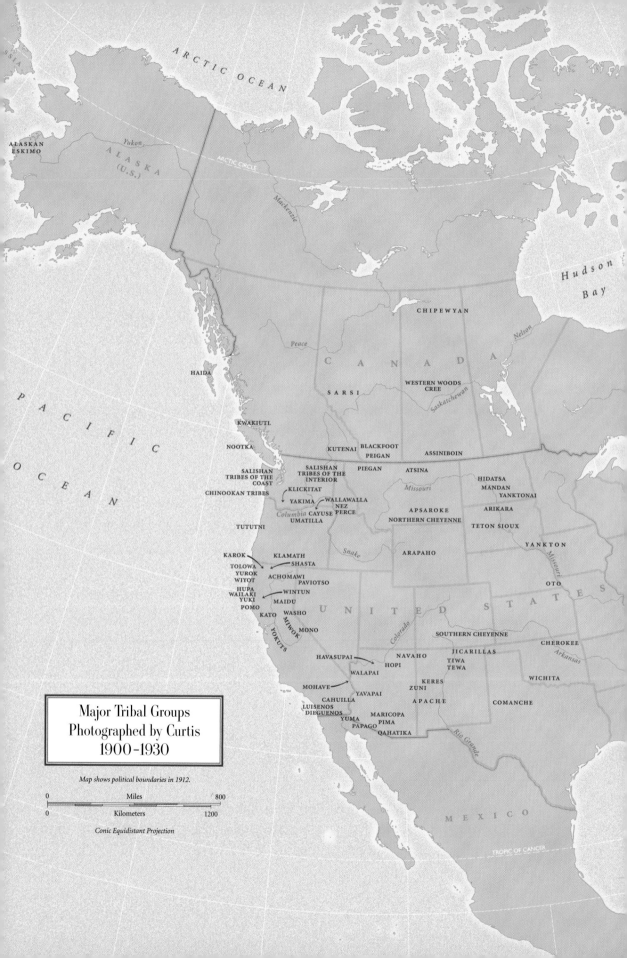

ARCTIC OCEAN

ALASKAN
ESKIMO

ALASKA
(U.S.)

Yukon

ARCTIC CIRCLE

Mackenzie

Peace

CHIPEWYAN

Hudson
Bay

C A N A D A

Nelson

HAIDA

SARSI

WESTERN WOODS
CREE

Saskatchewan

P A C I F I C

O C E A N

KWAKIUTL

NOOTKA

KUTENAI
BLACKFOOT
PEIGAN

ASSINIBOIN

SALISHAN
TRIBES OF THE
COAST

SALISHAN
TRIBES OF THE
INTERIOR
KLICKITAT

PIEGAN

ATSINA

HIDATSA
MANDAN
YANKTONAI

CHINOOKAN TRIBES

YAKIMA
WALLAWALLA
NEZ
PERCE
CAYUSE
UMATILLA

Missouri

APSAROKE
NORTHERN CHEYENNE

ARIKARA

Columbia

TETON SIOUX

TUTUTNI

Snake

ARAPAHO

YANKTON

Missouri

KAROK
TOLOWA
YUROK
WIYOT
HUPA
WAILAKI
YUKI
POMO

KLAMATH
SHASTA

ACHOMAWI
PAVIOTSO

WINTUN

MAIDU

KATO
WASHO
MIWOK
MONO

OTO

U N I T E D S T A T E S

YOKUTS

Colorado

SOUTHERN CHEYENNE

CHEROKEE

Arkansas

HAVASUPAI

NAVAHO
HOPI

JICARILLAS

WALAPAI

TIWA
TEWA

MOHAVE

YAVAPAI

KERES
ZUNI

WICHITA

CAHUILLA
LUISENOS
DIEGUENOS

APACHE

COMANCHE

YUMA
PAPAGO
QAHATIKA

MARICOPA
PIMA

Rio Grande

Major Tribal Groups
Photographed by Curtis
1900–1930

Map shows political boundaries in 1912.

| 0 | Miles | 800 |

| 0 | Kilometers | 1200 |

Conic Equidistant Projection

M E X I C O

TROPIC OF CANCER

The North American Indian

BY EDWARD S. CURTIS

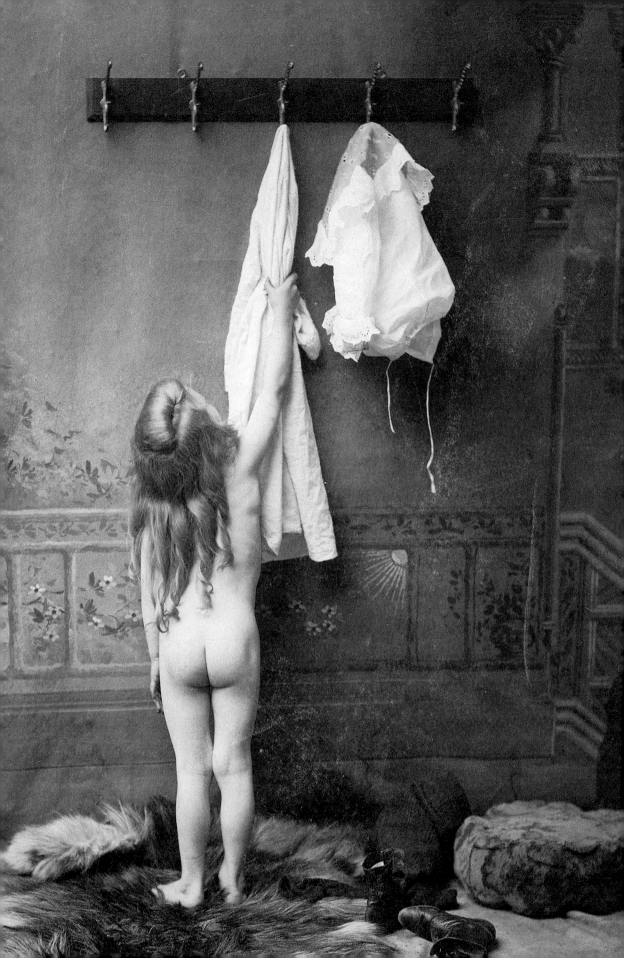

Plains Song

"A circus kind of business, and unfit for a gentleman to engage in."

—WILSON'S PHOTOGRAPHICS

IN SUMMER, THE PLAINS OF NORTHERN MONTANA ARE LUSH AND GREEN, THE GRASS blown flat by winds fragrant with sage and sweetgrass. Gentle hills roll east and north under a giant sky, and to the west are the sudden crags of the Rockies. The home of the southern Piegan Indians lies in these plains and foothills just east of Glacier National Park. Their reservation extends north along the Rockies from the ragged town of Browning, past the long lake at St. Mary's and up to the Canadian border.

In July 1900, Edward Curtis rode over these hills to see the Sun Dance ceremony of the Piegan. He had come by train on the Great Northern Railway from Seattle to Browning, where he joined his friend, the naturalist George Bird Grinnell. They rode on horseback through the blowing grass, the plains empty of the buffalo that had ranged over the area in the millions just a few decades before.

As Curtis and Grinnell reached the top of a high cliff, an awesome sight appeared. "Neither house nor fence marred the landscape. The broad, undulating prairie stretching away toward the little Rockies, miles to the West, was carpeted with tipis," Curtis later wrote.

On the plain below, hundreds of Blood, Piegan, and Blackfoot were arriving in wagons, on horseback and travois, greeting each other, setting up their tepees. As Curtis and Grinnell rode into camp, they passed teenagers racing their ponies, children and puppies

Curtis's studio portrait of his four-year-old son Harold has all the pictorial elements that made Curtis Seattle's premier society photographer.

romping in the grass, old men and women gathered around fires to share their news. Grinnell had visited the Piegan many times and had been adopted into the tribe, but Curtis had never seen anything like this. He wrote that it took two days to form the Sun Dance circle, which radiated out nearly a mile in diameter. "The placing of tribes and dignitaries, the herding of the common people, all this was arranged by masters of ceremony and criers carrying tufted, beaded wands." Within a few days, thousands of Indians, many in traditional dress, had come together to make offerings to the life-giving sun.

Curtis unpacked his heavy glass-plate negative holders, his tripod, and his cumbersome 14-by-17-inch camera, and captured scenes in the encampment: grandparents playing with babies, women in bonnets and children in calicoes, men drumming and singing and practicing the Sun Dance songs.

Grinnell brought Curtis inside a tepee to introduce him to the head chief, White Calf, and other important people. Curtis was impressed by the decorum observed inside the lodge: "To have compared the exact and demanding courtesies of every day life in a Piegan tipi with that of the most exalted brown-stone fronted home would have put the dwellers in them to shame.... It was difficult if not impossible for the white guest to conform to rules of usage and etiquette."

Curtis must have made a good impression, because White Calf invited him to stay and watch the ceremony. The next day, Curtis photographed members of the Brave Dog Society galloping their horses over the fields, bringing back willow branches to build the sacred sweat lodge. The riders held the long branches upright like banners as they thundered over the plain, whooping and ululating. Curtis also photographed the men as they found, then attacked, the tree for the Sun Dance lodge pole. "Warriors rein in their horses ready for the charge.... As the thousands of tribespeople crowd close, the hand is dropped and the horses leap out, churning up clouds of dust as their heels are flung high. Releasing pent up shouts of savagery and shrill war whoops, the attackers charge the mystery tree and lash it with all the frenzy and fury of primitive passions. If the tree stands the withering assault, it is accepted as the sun pole and felled."

During the ceremony, the participants tied offerings to the center pole and to the rafters of the lodge. Bandannas, tobacco, shirts, and pieces of cloth attached to crossed sticks fluttered from the pole and the roof beams. These offerings were believed to contain sickness, bad thoughts, and other evils that supplicants were putting away from them-

selves. They prayed for health, for the love of someone longed for, for a change in fortune. Young men who wanted to make a sacred vow and prove their courage pierced their chests with sharp thongs, tied the thongs to the center pole, and hung until their flesh was torn away, while singers chanted high-pitched, wailing songs. They were offering their lives to the sun.

Curtis saw the whole ceremony, but he was not allowed to photograph the piercing, the self-torture, the physical sacrifices. Perhaps these parts were considered too sacred, or perhaps the Indian people knew that pictures would only bring outside attention and more restrictions to their practices. Christian missionaries and government agents were working hard to stop the Sun Dance. To them the ceremony was an affront to Christianity and an obstacle to converting and civilizing the Indians. Missionaries had recently convinced the federal government to enact a Religious Crimes Code, banning rituals they saw as pagan or obscene. When Curtis and Grinnell arrived in Montana in 1900, the Sun Dance had been outlawed. This was to be the last one, forever.

Curtis was deeply moved by the spirit of community he saw, by the religious feelings of the participants, their wrenching sacrifices, and their faith. He knew that the way of life of all the Plains tribes had been destroyed by the decimation of the buffalo, that these people were under tremendous pressure to leave the old ways behind, and that they had come together this last time to sacrifice and pray for their own survival.

When the Sun Dance was over, the camps packed up, the travois and wagons loaded and hauled away, Curtis returned to Seattle, leaving behind the plains and the tepees and the sounds of the wind in the grass for the clanging trolleys and bustling streets of the city.

He resumed his life as a successful portrait and landscape photographer. His prosperous downtown studio, considered the place to go for society portraits, was staffed by family members who also lived with Curtis and his wife, Clara, in their large house at 413 Eighth Avenue.

EDWARD SHERIFF CURTIS HAD COME A LONG WAY FROM HIS IMPOVER-ished midwestern childhood. He had been born in 1868 on a small hard-scrabble farm near Whitewater, Wisconsin, the second child of Johnson Asahel Curtis and Ellen Sheriff Curtis. Johnson had served as a Union private and army chaplain during the Civil War, and the harsh conditions of war had ruined his health. He never recovered the strength to take on the hard labor of subsistence farming. When Edward was five,

the family moved north to a farm in Le Sueur County, Minnesota, which Johnson's parents had bought as an investment. They stayed there for seven years, scratching a living from the sandy soil.

In 1880 the family moved again, to the tiny town of Cordova, Minnesota. Johnson Curtis opened a grocery store, but there were two others already in town, and his business did not do well. Edward attended Cordova's one-room schoolhouse, the only formal education he would have.

Curtis family members, including Edward's maternal grandmother (seated), pose in front of the Le Sueur County, Minnesota, farmhouse that was, for a time, Edward's boyhood home. His father, Johnson, in overalls, struggled to support his family but had little success.

Throughout Edward's childhood, his father was haunted by the fear that the family would end up in the Le Sueur County Poorfarm, a grim home for the impoverished, the insane, the disabled, and the incompetent. While the grocery store limped along, Johnson took on a new job as a preacher for the United Brethren Church, an evangelical Christian sect that sent its ministers out into the countryside to preach. Edward often went along on Johnson's visits to his parishioners, paddling through the inland waterways of southeastern Minnesota, camping along the shores of rivers and lakes. Edward loaded and carried the heavy supply packs, portaged the canoe between waterways and around rapids, and did most of the paddling. He learned to navigate rivers, pitch a tent, and cook over open fires, and he loved the outdoor life. Johnson preached to isolated farm families, performed weddings and baptisms, and was usually paid in food or other goods for his services. He was sometimes rewarded with a "flour sackful of delicious smoked leg of muskrat," which he took home to his family.

Edward worked hard to make his father's life easier, but Johnson's failures and his poor health made him moody and depressed. Daily life in the Curtis home was a constant struggle. The family sometimes had to survive for weeks on boiled potatoes. Curtis remembered an evening when the presiding church elder came to call unexpectedly at dinnertime and there was nothing to serve him. While his mother distracted the old man, Edward went down to the creek and caught an old snapping turtle that lived there. Ellen boiled the turtle up for dinner, and the minister enjoyed the dish tremendously—until he learned what the delicious meat was.

The first book Curtis remembered reading as a child was a lurid account of the Minnesota massacre, a raid by Sioux Indians in 1862 that had occurred only a few miles from the Curtis home. Sioux raiders had killed hundreds of settlers, and 40,000 whites fled their homes. In an unpublished memoir, Curtis described the massacre in his own words: "With the suddenness of an earthquake the storm broke: villages and

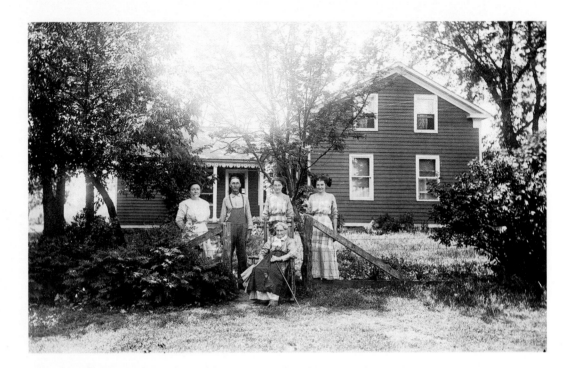

Fort Ridgely were set upon and besieged by parties of several hundred blood-drunk savages; small parties of a half dozen to a half hundred raiders swept upon the scattered settlers…. The night sky was red with flame of homes, stores, hotels, and ripening fields…. Every conceivable brutality was perpetrated. Within the brief space of three days an area of fifty miles wide and two hundred in length was but a picture of desolation…." Curtis also wrote that the Indians had been provoked by encroaching settlers, who were harassing them and driving game from the land; by missionaries who were enraging the traditional Sioux by converting tribal members to Christianity; and by the government's continued disregard of treaty stipulations and its failure to supply the promised, desperately needed rations of food and clothing.

Three hundred Sioux were arrested and sentenced to death for the attack. President Lincoln commuted most of these sentences, but 39 Indians were hanged. Curtis studied the pictures in the book long before he could read the text, "and all through life I have carried a vivid picture of that great scaffold with thirty-nine Indians hanging at the end of a rope. I paddled my canoe over the lakes of that region of slaughter, hunted and trapped, and drew mental pictures of the horrors which had occurred there. Around the fireside and camp-fire during my first conscious years, I listened to survivors' stories of days of horror which

had occurred but a few years before. Such early association with grounds and survivors gave me a near inherent interest in the subject." Curtis also wrote: "The immediate outcome of this deplorable affair was a nation-wide cry for the total elimination of all American Indians. Radicals even suggested that small pox germs be implanted among all tribes, giving no thought to how this scourge would be contained."

THE 1860S AND 1870S WERE BITTER YEARS FOR AMERICAN INDIANS, AS the United States spread its claim across the continent from the Atlantic to the Pacific. Wave after wave of emigrant pioneers set out to claim lands in the West. Conflicts between Indians and the settlers who invaded their lands resulted in a series of bloody battles known as the Indian Wars. In 1863-64, Kit Carson defeated the Navajo in Canyon de Chelly and forced them on the Long Walk to Bosque Redondo, New Mexico, where they were held prisoner until they signed a treaty four years later. Col. John M. Chivington, who told his troops to "kill and scalp all, big and little; nits make lice," massacred 150 innocent Cheyenne and Arapaho at Sand Creek, Colorado, in 1864. Four years later, George Armstrong Custer defeated Black Kettle and the other Cheyenne, who had escaped the Sand Creek massacre. Between 1866 and 1875, more than 200 battles were fought between U. S. troops and tribes from the Dakota Territory to Mexico.

During the 1860s, Chief Red Cloud and his band of 4,000 Oglala Sioux had succeeded in driving 25,000 troops from their territory. In 1868, the year Edward Curtis was born, Red Cloud had finally agreed to peace in exchange for a giant reservation in the Dakotas, including the sacred Black Hills. He signed the Treaty of Fort Laramie, but later that year the government declared that it would not recognize any Indian tribe or nation within the borders of the U.S. When Curtis met Red Cloud nearly 40 years later, the reservation had been parceled out and much of it sold to settlers, the Indians confined to undesirable lands that Red Cloud called "very small islands." Red Cloud had kept his pledge never to fight again in battle, but the government had broken every promise in the treaty.

Battles raged over the plains throughout Curtis's early childhood. When he was eight years old, the Sioux and Cheyenne defeated Custer at the Battle of the Little Bighorn, killing him and all his men. The following year, Gen. Oliver O. Howard and 2,000 soldiers chased Chief Joseph and his Nez Perce band for 1,700 miles, crossing the Rocky

Mountains three times. Joseph and 300 warriors won 13 battles against the soldiers. They were 40 miles from the Canadian border and freedom when Joseph finally surrendered north of the Bear Paw Mountains, his people freezing and starving. In his eloquent surrender speech, he said, "I am tired of fighting. The little children are freezing to death. My people, some of them, have run away to the hills and have no blankets, no food. No one knows where they are—perhaps freezing to death. Hear me, my chiefs! I am tired. My heart is sick and sad. From where the sun now stands, I will fight no more forever." Joseph and his band were arrested and imprisoned at Fort Leavenworth, Kansas, then exiled to reservations far from their homeland in the Wallowa Valley.

Within a few years of Joseph's surrender, the U.S. Army had put an end to armed Indian resistance. Almost every surviving tribe now lived on reservations, where their people were to be "educated," Christianized, and assimilated into the general population. Indians were virtually prisoners on their own lands, forbidden to travel freely, dependent on corrupt government agents for their food, struggling for their very survival.

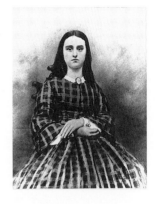

A portrait of Edward's mother, Ellen Sheriff Curtis, taken about 1862, may have been the one Edward's father carried with him in the Civil War.

BY THE EARLY 1880S, JOHNSON CURTIS'S HEALTH HAD DETERIORATED badly. His oldest son, Raphael, had left home, and at 14 Edward had become the main support of the family, bringing in a little cash by doing odd jobs for local farmers. As a boy, Edward had developed an intense curiosity about the new science of photography. He made his first camera when he was 12 years old by fitting one wooden box inside another and mounting a stereopticon lens on the front. The lens, which his father had brought back from the Civil War, had originally been part of a camera that created pictures with a three-dimensional effect when looked at through a viewer; it was a popular form of entertainment in the 1860s and 1870s. Curtis built his own camera according to instructions in a book called *Wilson's Photographics: A Series of Lessons Accompanied by Notes on All Processes Which Are Needful in Photography.* In his introduction, Wilson warned that photography was a "circus kind of business, and unfit for a gentleman to engage in." Edward studied the lessons carefully and taught himself how to take photographs and make crude prints. It must have been exciting to freeze his family in pictures, to frame his life according to his own vision of the world.

When he was 17, he took a job in a photography shop in St. Paul, where he learned professional methods for developing and printing.

Apparently, Edward even briefly opened his own photography shop but was unable to make a profit in the struggling new town. That summer, he was hired to supervise 250 French Canadians on the Sault Sainte Marie railroad line. The crew members were rough men who had worked on railroad gangs before, and Curtis was younger than all of them. "Because I was tall and strong, over six feet, they did not ask my age. I was not yet eighteen." The men didn't speak English and Edward didn't speak French, but he got them to finish the job.

THE SEVERE WINTERS OF 1886 AND 1887 DESTROYED WHAT WAS LEFT OF Johnson Curtis's health, and the drought that followed killed the crops, ruining Minnesota farmers and businessmen alike. The grocery store failed, and the family was in desperate circumstances. Johnson decided that the family should move west to Puget Sound, where the climate was milder and homesteads open for the taking. In the fall of 1887, he and Edward took a train to Portland, Oregon, and made their way north. They claimed a homestead near the settlement of Sidney, now Port Orchard, across the sound from Seattle. Edward cut down spruce trees and built a log cabin with a stone fireplace. Johnson made plans to open a brickyard.

"This is fine, invigorating country, but raw and frontier-like. Lots of Indians around, and water, water, water. It's rainy and foggy but not cold like there," Johnson wrote to Ellen. He went on to describe the town of Seattle itself: "They call it the Queen City and talk about its great future although it wasn't very long ago there were Indian attacks on the town. It's over 10,000 and there's a university in the middle of town and hills all around it. Edward says they have telephones, 120 of them!"

Within a year, Johnson had convinced Ellen to bring the two younger children, 17-year-old Eva and 13-year-old Asahel, and settle in Washington Territory. They boarded a train and rolled west across the great northern plains. In the railroad car, Eva wrote, "there was a coal stove which provided warmth as well as a means of cooking our food. We brought provisions from our farm as well as our bedding, so we were very cozy....We were so eager to see our new home, which we endeavored to picture...."

Edward had planted fruit trees and a garden at the homestead, and the cabin looked out over the water at passing ships. It was a lovely spot. The family of five were happy to be together again, but their

reunion was short-lived. Just three days after his wife's arrival, Johnson died of pneumonia. His obituary read, "He was too ambitious…and took a severe cold which settled on his badly diseased lungs, and the end came quickly." The family was devastated. Edward later said, "I felt so sorry for my mother. She had worried and suffered through the war years and had been so courageous. She was such a beautiful woman and held the reins of the family in her gentle hands. My heart ached for her."

According to Eva, after their father's death, "Edward had the full responsibility of the family, and he felt the load. There was never any frivolity about him." He and his younger brother, Asahel, cleared the dense forest, tended an orchard, fished and dug clams for food, and worked in lumberyards or hired themselves out to other homesteaders to earn cash.

Perhaps it was as a hired hand that Edward met Clara Phillips, whose family had recently emigrated from eastern Canada to Puget Sound. Clara was six years younger than Edward, a lively girl who also loved the wild wooded country, the gently lapping waters of the sound, and the snow-covered Olympic Mountains.

In 1890, while Edward was working in a lumberyard, he fell and injured his back. Clara's nephew William Phillips described Curtis's long convalescence: "He lay on an invalid's bed, limp, thin and bleached, under the constant care of a tireless mother and a girl destined later to become his wife." Clara was 16 years old when she helped nurse Edward back to health.

The injury made it impossible for Edward to continue the hard manual labor of logging and farming. He tried to make the brickyard business profitable, but the location was isolated, and with wood plentiful there was little demand for bricks.

Soon after his recovery, Edward bought a 14-by-17-inch large-view camera from a hopeful traveler on the way to the goldfields of California. He began to roam the tide flats and the harbors, taking pictures of steamboats and sunsets, loggers and sailing ships. Like many of his contemporaries, he had been bitten with camera fever, but he spurned the cheap, popular Kodak cameras and their hundred-shot roll of paper film, in favor of large-format, glass-plate negatives with their amazing clarity and resolution.

Ellen Curtis saw the "camera bug" as a waste of time and money. She wanted her son to be more practical, to keep his attention on work that would bring in food and other necessities. But by this time Edward had become serious about photography. In 1891, he sold the brickyard,

mortgaged the family homestead, moved across the sound to Seattle, and bought a partnership for $150 in a photography shop. He and his partner, Rasmus Rothi, established themselves in an alleyway in the heart of downtown and renamed the business Rothi and Curtis, Photographers.

Clara Phillips had also left her family's homestead on the Kitsap Peninsula to live with her sister Susie in a Seattle boardinghouse, possibly the same one where Curtis was living. Clara was just 17, a dark-haired beauty whom her daughter Florence later described as "bright, well-read, a good conversationalist. She shared Edward's love for this great, scenic land of the Northwest, but not his interest in photography."

In the spring of 1892 Edward and Clara were married at the Presbyterian church in Seattle. Shortly afterward, Curtis left Rothi and formed a new partnership with Thomas Guptil at 614 Second Avenue. Edward and Clara moved into an apartment above the studio. Their first child, Harold, was born there in November 1893.

Depression struck the rest of the country that year, but Seattle was booming. The decade before, the population had grown exponentially, from 3,500 to nearly 43,000. J. P. Morgan's Great Northern Railway had reached the city, and the transcontinental connection had put Seattle on the map. Within a few years, Curtis's business was thriving. He and Clara moved into a larger apartment in a boardinghouse, and his mother, sister, and younger brother left the homestead to join them.

Curtis and Guptil became the place to go for printing, engraving, and fine photography. The *Seattle Times* reported: "While still in their twenties, they have by steady application and straightforward, honorable business dealing, achieved a place in the art and business world often striven for in vain by men of maturer years." In 1896 a series of their portraits won a bronze medal at the National Photographers' Convention in Chautauqua, New York. *Argus* magazine declared that they were the leading photographers on Puget Sound and mentioned their invention of a "photograph on a gold or silver plaque, a method original with Curtis and Guptil, brilliant and beautiful beyond description." This was probably the forerunner of the process Curtis later developed called Curt-tone, in which a positive image was printed directly onto glass backed with a mixture of gold and banana oil, creating luminous, sepia-gold images.

Edward and Clara's first daughter, Beth, was born in May 1896, and the family moved to a large house on Eighth Avenue. Edward's

Curtis courts his future wife, Clara Phillips, while her sister glares at the camera in this early 1890s photograph. When she was 16, Clara helped nurse Curtis back to health after a lumberyard injury and married him two years later. Her family did not approve of the match.

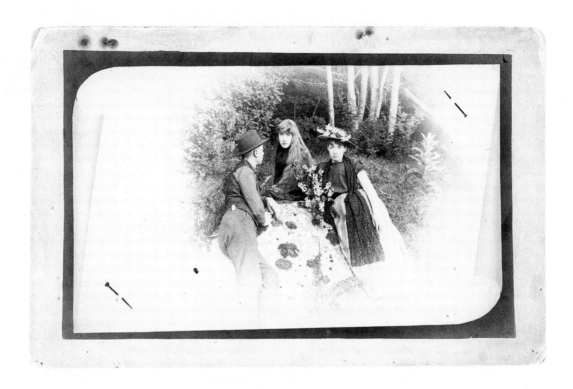

mother, Ellen; his sister Eva; his brother Asahel; Clara's sister Susie; her cousin Nellie Phillips; and Nellie's son, William—all lived with Edward, Clara, and their two young children. At one time or another they all worked in the studio, including the children. Asahel was an engraver, Susie and William were photo printers, and Nellie held various studio jobs.

According to William Phillips, his uncle Edward had no time for anything but photography. "Work was his duty, pass-time and recreation; all else was incidental." At night, when his work at the studio was done, Curtis sat up late studying photographs and planning his compositions. "I can see him now, sitting on the floor, his knees drawn up and held between clasped hands, his head tilted back against the wall, with clippings and pictures of all sorts scattered about in front of him, a book of poems by his side, lighted only by the flames from a fireplace.... When he broke the silence, his usual remark was, 'Wait till you see the next picture I make; it's going to be a cracker jack.'"

CURTIS HAD SPENT HIS BOYHOOD CAMPING ALONG THE INLAND waterways of Minnesota and his early manhood carving out a living along Puget Sound. In Seattle, he missed the rugged outdoor life and was drawn to the mountains and the shores of Puget Sound. Curtis often

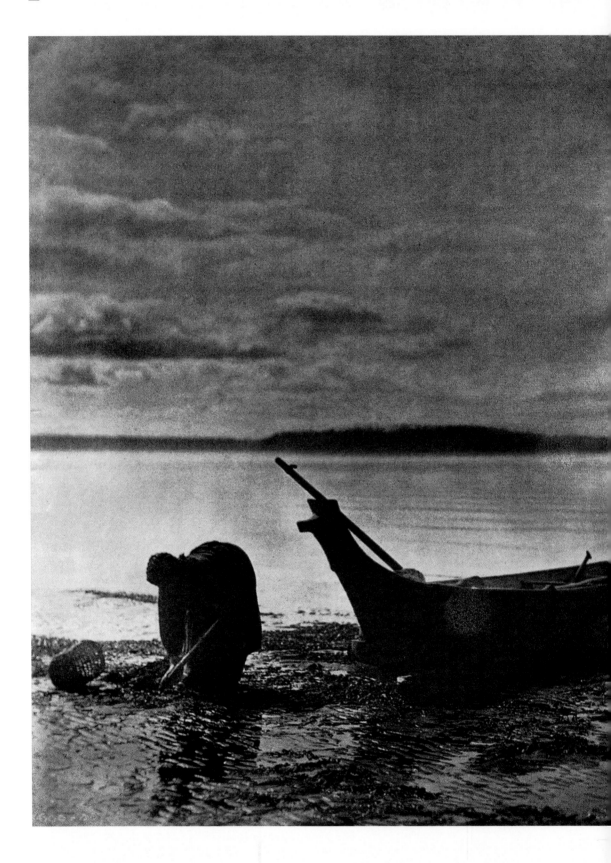

EDWARD S. CURTIS

escaped from the busy studio and the noisy Seattle streets to roam the tide flats. He always took his camera with him and photographed local Indians bringing in their catch or setting out in dugout canoes. It was here that he met Princess Angeline, as white people liked to call her. A famous character around town, Angeline was the aged daughter of Chief Seattle, for whom the city was named. She had been born in the first decade of the 19th century, when her people had unlimited access to the rich resources of the sound. In 1855 Isaac Stevens, Governor of Washington Territory, had coerced Seattle and other local chiefs into giving up enormous amounts of land. Many Puget Sound Indians were disenfranchised entirely, and others lived on small reservations or on the fringes of city life. Angeline eked out a living by digging clams and mussels near her shack at the water's edge. She carried a cane and wore a bandanna tied around her hair, a wool cape fastened with a safety pin, and flowing calico skirts. The city repeatedly threatened to tear down her shack, and she had been known to protest loudly outside the sheriff's house.

Known to Seattleites as Princess Angeline, the elderly daughter of the great Chief Seattle once remarked that posing for Curtis's camera was a lot easier than digging clams. This picture and two other photographs by Curtis won prizes in 1898 from the National Photographic Society.

Local photographers often brought Angeline into their studios to photograph her against painted backdrops of waterfalls or mountains. In 1895 Curtis went out to the sound and found her on the tide flats gathering shellfish to sell. Angeline was known for her temper and had a reputation for throwing clams at people when she was angry. Whether by his charm or his silver dollars, Curtis won her over and photographed her many times along the shore and in his studio.

"The first photograph I ever made of Indians was of Princess Angeline, the digger and dealer in clams. I paid the Princess a dollar for each picture I made. This seemed to please her greatly and with hands and jargon she indicated that she preferred to spend her time having her picture made than in digging clams."

Angeline died a year later on the edge of Seattle's skid row.

In 1898 two of Curtis's photographs of Angeline, "The Mussel Gatherer" and "The Clam Digger," were chosen for an exhibition sponsored by the National Photographic Society, along with "Homeward," his luminous sunset image of Indians paddling to shore in a dugout canoe. "As a loan exhibition it traveled over a good part of the civilized world. Naturally I was quite proud of myself and the pictures." "Homeward" won the exhibit's grand prize and a gold medal.

Curtis's painterly style in these images reflected the new emphasis on photography as art. On the East Coast, cutting-edge photographers were rebelling against the general perception of photography as

a mechanical process incapable of showing subjective feeling. In New York, Alfred Stieglitz, Gertrude Kasebier, and other photographers formed the Photo-Secession Club, dedicated to creating and promoting photography as art. They used diffused lighting, soft-focus lenses, and abstract backgrounds to make their images look more like paintings than photographs.

Curtis had used pictorial techniques to create romantic images of society women and children in his Seattle studio, and he took the same techniques into the field. His award-winning photographs of 1898 were carefully composed, the Indian people dark silhouettes against the luminous water and sky. He used light and composition to create the illusion of a timeless presence untouched by change. Angeline's calico skirts, her safety-pinned cape, and the mackinaws, dungarees, and rubber boots worn by the fishermen are obscured through retouching and backlighting. In a sense he was taking his subjects out of time.

Curtis began to publish his own ideas about photography in local magazines. He urged photographers to study landscape paintings and to infuse their photographs with their own individual style. In a series of articles published at the turn of the century in *Western Trail* magazine, he wrote: "Let everyone's work show individuality. Try to make it pronounced enough that a friend could pick up one of your pictures anywhere and know it was yours." He also wrote: "Many artists claim that a photograph cannot be a work of art. However, I do not think that even the most radical of them can deny that a photograph can show artistic handling and feeling. After all, it is the finished product which hangs on our wall and not the implements with which it is made."

Clara was a great help to Curtis in his early work. She had more formal education than he did, and, according to her daughter Florence, Clara "read every magazine, paper or book she could lay her hands on and in an era when women's lib was unheard of, she enjoyed discussing world and national affairs." In addition to running the Curtis household, she helped manage the business and edited all of Curtis's early writings.

Thomas Guptil had left the partnership in 1897, and the studio became known as "Edward S. Curtis, Photographer and Photoengraver." In addition to society portraits, Curtis specialized in landscapes and "scenic views." He was an avid mountain climber, and often rode out to Paradise Valley to climb Mount Rainier, which he called "my beloved mountain of mountains."

Curtis became an honorary member of the Mazamas, a presti-

gious mountaineering club based in Portland, Oregon. (John Muir was also an honorary member.) In July 1897, Curtis was appointed as "commander" of a large expedition, overseeing the other "captains" and "companies" during a climb up Mount Rainier. It was a challenging ascent for the climbers, who were aided only by crampons, ice axes, and ropes. The nine women on the expedition, including Clara, were required to wear bloomers.

The climbing party spent the night at Camp Muir and began their ascent early the next morning. Curtis rigged all the ropes and supervised the climb. By 3:30 in the afternoon, 59 members of the expedition had made it to the summit, an impressive achievement for the group of mostly amateur climbers. Curtis described the view from the top: "Far to the west in the hazy distance could be seen the Pacific Ocean, and nearer at hand, Puget Sound, pearly in the emerald setting of firs. We could trace the bed of the Cowlitz, Nisqually, Carbon, Paradise and Seven Glaciers melting in to rivers that radiated to the sea."

A small party of men decided not to spend that night at Camp Muir with the rest of the group. As they made their way down the mountain in darkness, one of them slipped on a rock and fell to his death. The next day, another member of the party fell into a deep crevasse and nearly froze before he was pulled to safety in a dramatic rescue. The events made headline news in Seattle, and articles mentioning Curtis's name were published in newspapers throughout the Northwest, and in *Harper's Weekly*.

Curtis returned to Seattle to find the city in a fever. On July 19, the *Portland* had pulled up to Schwabacher's Dock, and unshaven, gaunt, but gleeful prospectors from the Klondike struggled to carry off heavy suitcases and blanket rolls filled with gold. Edward's son, Harold, then four years old, remembered seeing men disembarking from a ship just back from the north with their pockets bulging with gold dust. Prospectors clogged the streets and rushed the docks, desperate to get on board any ship headed for Alaska. Thousands left their jobs. The mayor of Seattle, on business in San Francisco, immediately resigned and headed for the Klondike.

In October, Curtis wrote to *Century Magazine*, saying that he had just "secured the most complete as well as the latest series of photos of the various trails yet taken. These views, one hundred and fifty in number, picture the Argonauts in their mad rush to the gold fields, showing camp scenes, storms in the mountain passes, river crossings, etc." He wrote that he himself had "passed over the trails, climbed the mountains,

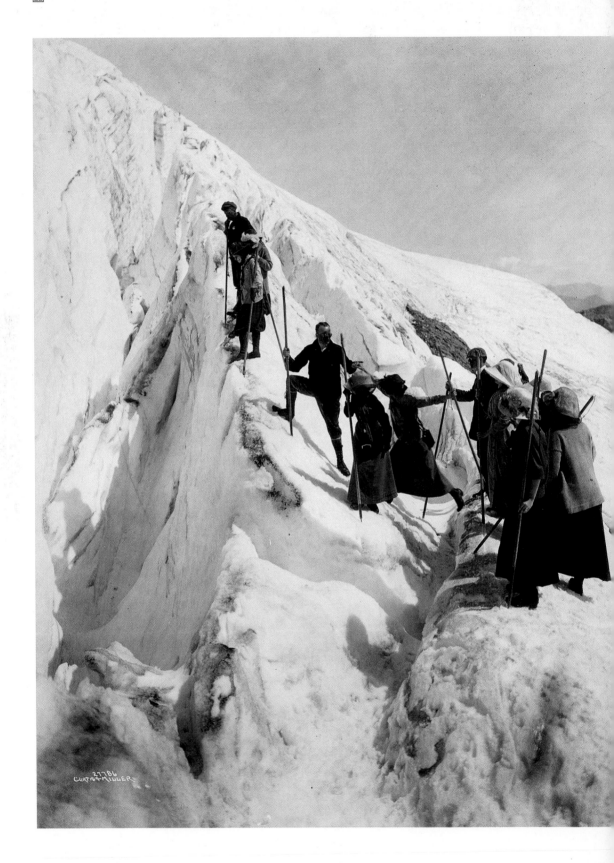

EDWARD S. CURTIS

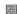

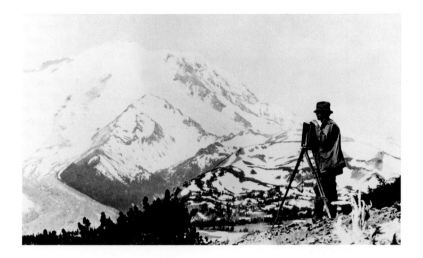

crossed the rivers, waded through the mud and snow, and endured the cold and hunger." He also announced that he would be sending at least four photographers into Alaska the following year. A local newspaper reported, "E. S. Curtis…will go into the Alaska view business on the most gigantic scale ever attempted with the coming of Spring…. As soon as is practicable, Mr. Curtis will start a party for the gold field in charge of Mr. A. Curtis. The party will take 3000 photographic plates and will spend the entire season in the interior…. Arrangements have been made to forward the plates that have been exposed to Seattle, in order that the views may be put on the market as soon as possible."

Century Magazine bought a vivid article he wrote about the journey: "The crush of men and animals on both these trails was terrific…. Horses fell in their tracks…many animals died from exhaustion…. The men overworked themselves, ate poorly prepared food, slept in wet clothing; and many there are who, in consequence of these privations, will never regain their full strength." Seven photographs ran along with the article in March 1898. All were credited to Edward Curtis, but some were actually the work of his brother Asahel.

In December, Asahel set out again for the Klondike. The entire Curtis household helped him prepare for the journey, drying and canning a year's worth of food, making a special tent for his camp, and building watertight containers for the negatives.

Asahel stayed in the Yukon for two years and took hundreds of photographs, sending the glass plates back to the studio for printing and publication. His camera captured the haunted looks of men who had awakened from dreams of glory to a nightmare of dead horses, impassable peaks, violent rapids, hunger, and disappointment.

Like his older brother, Asahel Curtis (above) was a skilled mountaineer and became a successful landscape and commercial photographer. Carrying a huge camera, glass-plate negatives, and a heavy tripod up the face of steep glaciers, he took shots of fellow climbers tackling the icy extremes of Mount Rainier (opposite).

When Asahel returned, he discovered that Edward had claimed copyright to all of the negatives he had sent home. It was common practice then as now for an employer to claim copyright in works created by employees, but Asahel had suffered all the hardships and struggles of the gold seekers to get his images, and he wanted credit. It may have been their disagreement over ownership of these plates that caused the rift between the two brothers. Whatever the cause, Asahel quit his job at the studio and moved away from the family home. He became a successful Seattle photographer and created his own body of beautiful works—stark black-and-white photographs of ships, buildings, and other aspects of city life; Makah whalers in Neah Bay and other Indians along the sound. Asahel's photographs were documentary rather than pictorial in style: crisp, vivid images of Northwest coast life.

The two brothers were alienated from each other for the rest of their lives. Their children grew up within a few miles of each other, their fathers both well-known photographers, but the cousins did not know each other. In 1988 Harold accepted an invitation to attend a memorial dedication to Asahel at Snoqualmie Falls, where he met his cousins for the first time. He was 94 years old.

While Asahel had been photographing the rush to the Klondike, Edward had stayed close to home, running the studio. In good weather, he often set out for Mount Rainier and spent long days painstakingly arranging his compositions and waiting for the light. "Good pictures are the result of long study rather than chance, and a number of the pictures I worked up in my mind the first season are not made yet. I have not been able to be at the right spot at the right time of day and the proper condition of atmospheric effect."

In 1898, Curtis published "Scenic Washington," a sales catalog of his photographs, some as large as 18 by 60 inches. He was rapidly becoming the foremost landscape photographer of the Northwest. That same year, a chance meeting on Mount Rainier changed Curtis's life. He was pitching his tent at Camp Muir, planning to climb to the summit the following day, when he saw a party of men approaching the Nisqually Glacier and its dangerous, snow-covered crevasses. He knew the men were heading for disaster in the falling darkness, and he offered to guide them to his camp, where he "thawed them out and bedded them down." They were "a party of scientificos," famous scientists from Washington, D.C. Among them were Clinton Hart Merriam, head of the U.S. Biological Survey and a founder of the National Geographic Society; Gifford Pinchot, Chief of the U.S. Forest Service; and George Bird Grinnell, natu-

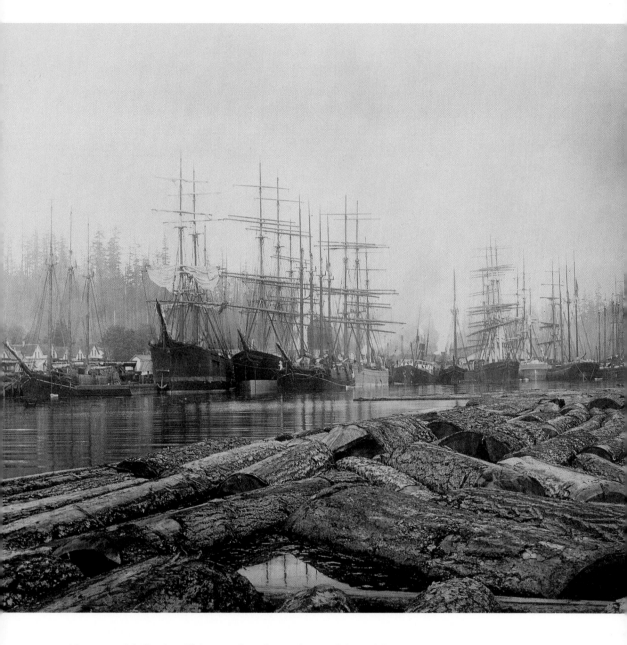

High masts and drifting logs fill the Port of Seattle in a photograph by Asahel Curtis,
possibly taken just before he set off for the Klondike goldfields in 1898.

ralist, editor of the influential *Forest and Stream* magazine, founder of the Audubon Society, and an expert on Plains Indians.

Curtis became their guide on the mountain, then invited them to a studio in Seattle, and he showed them his landscapes and award-winning photographs of local Indians. "It was the same men who sold Harriman on the thought of spending a lot of money on an Expedition to Alaska. Also they suggested that I accompany the Expedition as official photographer."

The railroad tycoon Edward Henry Harriman had recently succeeded in taking over the Union Pacific Railroad, to the great annoyance of his rival, J. P. Morgan. Harriman's doctor had prescribed a rest cure, and Harriman had planned a pleasure cruise to Alaska with his family. Like Curtis, Harriman was a self-educated man, and, perhaps also like Curtis, he could never do anything on a small scale or just for pleasure. Harriman wanted to assess the possibility of building a trans-Alaska railroad line with a bridge across the Bering Strait to Siberia. He also wanted to impress the East Coast blue bloods with a philanthropic gesture. At C. Hart Merriam's suggestion, the pleasure cruise expanded into a hugely ambitious scientific expedition—a Noah's ark of scientists, writers, and artists who would document the Alaska wilderness.

Harriman appointed Merriam to choose the members of the party. In addition to Grinnell and Merriam, the expedition included the mountaineer, conservationist, and founder of the Sierra Club, John Muir; the nature writer John Burroughs; poets and artists; and nationally recognized experts in the fields of botany, geology, paleontology, zoology, ornithology, entomology, and mineralogy.

Edward Curtis was invited as official photographer. It was a great honor and Curtis's first introduction to a larger world. He invested a substantial sum to outfit the expedition, purchased additional cameras, thousands of glass-plate negatives, and darkroom equipment, and hired his friend Duncan Inverarity as his assistant. As would happen often later in his life, he took no salary and hoped to recover his costs from orders for the photographs.

Boarding the *George W. Elder* on May 30, 1899, the expedition set sail for Alaska. Harriman's seven-year-old son, Averell, who would later become the Governor of New York as well as Secretary of Commerce and Ambassador to Great Britain and the Soviet Union, would remember the journey all his life. "I recall steaming into the fiords with the great glaciers all around and hearing at intervals the boom from the icebergs breaking off. The trip up the newly built railroad to White Pass,

Harriman Expedition members pose with local Indians at Plover Bay, Siberia, in 1898. A floating university of writers, artists, and scientists, the expedition introduced Curtis to the rigors of scientific methodology—and to the idea that native North American cultures were on the point of vanishing.

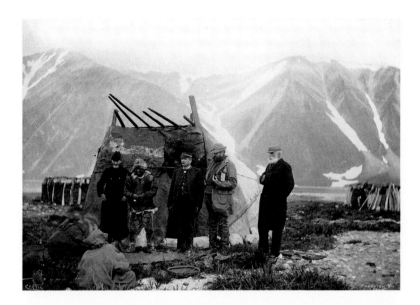

and the many tragic stories of the Gold Rush miners attempting to climb their way to the upper reaches of the Yukon, is still indelible in my mind…."

By day the scientists collected animal, mineral, and plant specimens; the artists drew; the poets and writers recorded their impressions. Curtis watched Harriman record the songs of Alaska natives on an Edison wax-cylinder recorder, the same machine Curtis would take into the field five years later. Curtis was the youngest man on the expedition, and he worked hard to prove himself. "The summer days in Alaska are long on both ends and Mr. Harriman urged that I make use of all the daylight."

At night, members gave talks in the great salon below decks. George Bird Grinnell made a presentation about the culture and ceremonial life of the Blackfoot Indians, which must have stirred Curtis's curiosity deeply. It was here that Curtis became acquainted with current scientific methods for documenting and classifying the natural world.

Curtis made his own presentations in the salon, showing lantern slides he had developed in a darkroom belowdecks. He apparently brought with him an early motion picture camera; in an unpublished memoir, he wrote that he climbed up the rigging and shot moving-picture footage from the mast. According to Curtis, when he showed the footage in the salon, everyone became seasick.

John Burroughs and John Muir were often seen together talking excitedly as they paced the deck or climbed up glaciers. Averell Harriman remembered, "They would walk the deck together and stop and

talk to us in a kindly manner. This kindness tended to offset their rather terrifying appearance with their long gray beards." Curtis wrote that "for some inexplicable reason those two naturalists were forever in an argument and it was a very heated one at that." He photographed the two men standing on a glacier lost in conversation, hats pulled low over their foreheads, feet apart, right hands raised as if in a duel."

The ship's passengers were often kept awake by the booming sounds of ice breaking from glaciers and plunging into the sea, and by the huge waves that followed. One of these nearly drowned Curtis and his assistant in Glacier Bay. They had paddled close to the glacier to photograph its front, their small canvas canoe loaded down with heavy camera equipment in the freezing sea. Muir wrote that "Curtis and his assistant were fighting for their lives in a canvas canoe almost to the level of the water. A great berg broke from the face of the glacier and we feared they would capsize." Merriam turned away as a giant wave rolled toward the canoe, but Curtis and Inverarity headed their boat directly into the wave. They paddled furiously and to everyone's amazement, they rode up over the crest and remained afloat. Sharp chunks of ice rained down on them from the glacier until they finally reached the shore. They lost some of their negatives and the rest of their equipment was soaked, but they had survived with their cameras intact.

Curtis shot plate after plate of mountains, glaciers, icebergs, and the expeditioneers themselves. As always, he brought an artist's eye to the work, and the techniques he had developed on Mount Rainier served him well. His images of huge undulating glaciers, of towering icebergs, billowing clouds, and luminous seas are painted with streaks of light and dark. The rich textures of rippled ice, the dark waters, and billowing clouds create painterly masterpieces reminiscent of the American luminist artists of the 19th century. He also photographed fields of Arctic flowers, the flattened paths of glaciers, and the villages of the natives.

The Alaska natives had been devastated by the arrival of white men. Canneries polluted their shores; the sea otters that had played up and down the coast had been hunted to near extinction for their valuable pelts. Burroughs described the destruction: "In places, the country looks as if all the railroad forces in the world might have been turned loose to delve and rend and pile in some mad, insane folly and debauch."

Curtis's photographs of native seal hunters and fishermen are a world apart from the romantic images he would later make of American Indians. They are straightforward, documentary pictures of natives

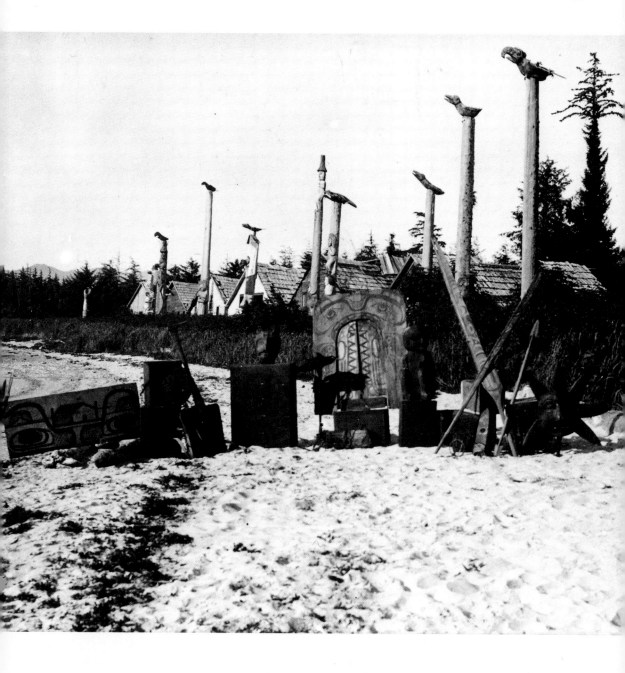

At Cape Fox, Alaska, some members of the Harriman Expedition pulled down totem poles and looted native houses for artifacts—all in the name of science. The plunder was later shipped to the Field Museum in Chicago.

looking unhappily at the camera. Many of these photographs were taken during the annual seal hunt in Yakutat Bay. While Muir and other sensitive souls hung back from the stench of seal carcasses, Curtis moved in with his camera. The women were busy with their work and did not want to be photographed. It may be that what appeared to the expedition members as squalor was actually a happy time for the natives, when successful hunters had brought in the seal meat that would feed them throughout the winter. They did not want their pictures taken and turned their backs on Burroughs's camera until he gave up trying to photograph them. Curtis was more successful, but his subjects are unsmiling, grim-faced, annoyed by the intrusion.

On the return journey, the expedition members discovered an Indian village at Cape Fox that seemed to be abandoned. Children's clothing hung from the rafters, baskets sat on the tables, Chilkoot blankets lay on the beds. It was as if the people had mysteriously vanished. The scientists gleefully looted the village, pulling down totem poles and even a whole house to ship to the Field Museum in Chicago; stealing blankets and carvings from graves; and taking baskets, children's clothing, and masks from the cabins. It took a whole day to load this loot onto the ship. Muir called it a robbery, but his protests did not stop the men, who felt they were preserving important specimens for science. In all likelihood, the village was not abandoned. The inhabitants had probably gone off to work in canneries for the season, or perhaps they were camping nearer to the seal population.

Curtis's photographs of the "abandoned" village, with totem poles standing like sentinels over the deserted houses, show the beginnings of the aesthetic of nostalgia that would pervade his later Indian work. His thinking was influenced by his friend George Bird Grinnell, who believed that indigenous cultures were doomed to disappear. Of the Alaska natives, Grinnell wrote, "Perhaps for a while a few may save themselves by retreating to the Arctic to escape the contaminating touch of the civilized, and thus the extinction of the Alaska Eskimo may be postponed. But there is an inevitable conflict between civilization and savagery, and wherever the two touch each other, the weaker people must be destroyed."

The *George W. Elder* sailed to Seattle laden with enough material to fill the collections of many museums, as well as the 13 official volumes of *The Harriman Alaska Expedition,* which would take 15 years to organize and publish. Curtis himself arrived home with thousands of glass-plate negatives, and Harriman ordered a selection of them for a souvenir

These Alaska natives clearly were not happy to have Curtis's lens leveled at them. His mentor and fellow expedition member, George Bird Grinnell, wrote, "White men, uncontrolled and uncontrollable, already swarm over the Alaska coast and are over-whelming the Eskimos."

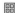

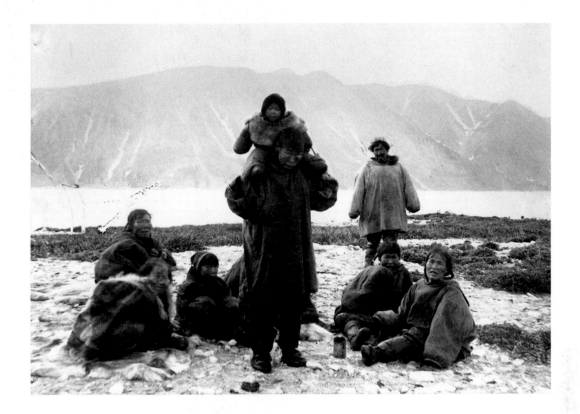

album of the expedition. Curtis spent months printing and reprinting the photographs, which Merriam carefully critiqued before they went to the publisher.

Many of the expedition members had taken pictures with their own Kodak cameras, and orders for Curtis's photographs did not come close to meeting his expenses. But he had made valuable contacts, had been given a crash course in every field of scientific study, and had made a particular friend in George Bird Grinnell, who would open doors not only to the eastern establishment but also to Curtis's imagination.

The following year Grinnell invited Curtis to join him in Montana for the Sun Dance. Curtis believed that he was witnessing the last one forever. Curtis wrote that it was "wild, terrifying, elaborately mystifying…. It was at the start of my concerted effort to learn about the Plains Indians and to photograph their lives, and I was intensely affected."

If some Indians believed that the camera could capture one's soul, at this Sun Dance in 1900 it was Curtis's soul that was captured. This vision of a passing world would change Curtis's life, uproot him from his home, and send him on an Odyssean journey that would consume him for the next 30 years. ✖

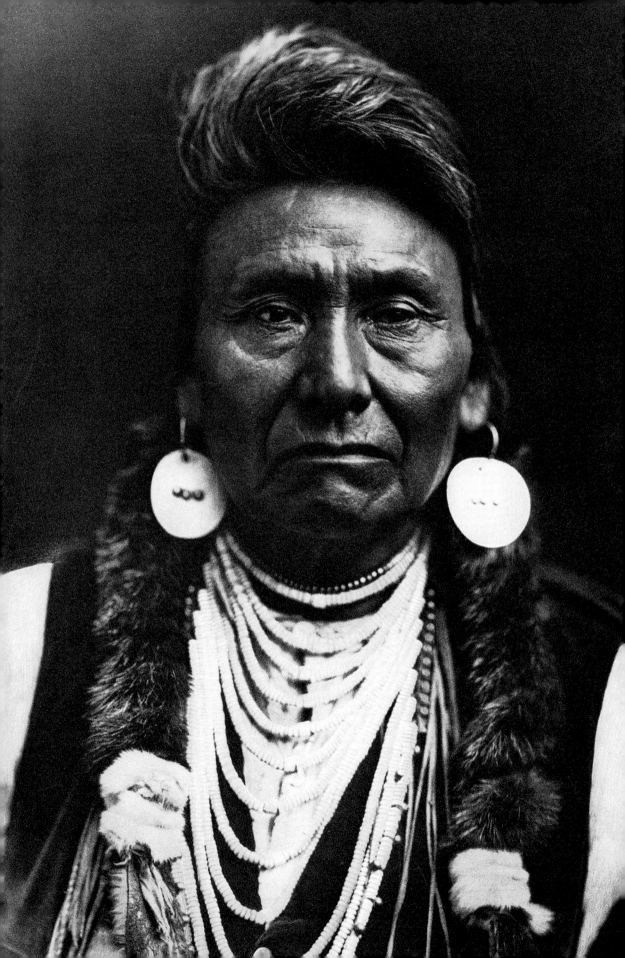

Light on Glass

"It's such a big dream, I can't see it all."

—EDWARD S. CURTIS

THE PRAIRIE LIGHT HAD BURNED THROUGH CURTIS'S LENS, ETCHING IMAGES OF THE SUN Dance onto his glass-plate negatives and into his imagination. As his train rolled west across the plains, he was fired with a new sense of mission, wanting to stop time with his camera, to capture the old ways in pictures before it was too late. He began to envision a huge project, a series of beautiful books that would show the traditional lives of every tribe in the West. He stayed home just long enough to print his photographs, say hello to his wife and three children—Harold, now six; Beth, three; and eight-month-old Florence—repack his gear, and arrange for transportation to the Southwest on the Atchison, Topeka, & Santa Fe.

Curtis was off to see the Snake Dance on the Hopi Reservation in northeastern Arizona. He went by train to Winslow, Arizona, then hired a team and wagon to haul his field equipment 60 miles over sandy track to the reservation. Hopi children were astonished to see him blow up an air mattress, then lie down on top of it. From then on, the children called him "the man who sleeps on his breath." In the morning, Curtis loaded his camera gear on mules to get up the steep trail. A procession of curious children followed him, some carrying equipment and others just tagging along for fun.

Curtis had never seen anything like the ancient Hopi villages. Whitewashed stone

Chief Joseph, legendary leader of the Nez Perce, photographed in Curtis's studio, 1903

apartments were stacked four stories high around a central plaza at the cliff's edge, with a sheer drop of hundreds of feet to the desert floor. Children jumped between rooftops or sat dangling their feet over the eaves. "All day the village is stirring with preparation for the ceremony and the feast that follows.... To one endeavoring to catch pictures of Indian life the day offers many favorable opportunities, as the Indians are likely to be dressed in their primitive costumes and are continually forming picturesque groups."

The Snake Dance, held in odd years on First Mesa and on even years on Second and Third Mesas, was a huge annual tourist attraction. The Fred Harvey Company and the Santa Fe Railway advertised trips to the Southwest wonderland with its "Indians galore...all living as did their ancestors hundreds of years ago." Advertisements described the Pueblo Indian as "a true pagan—superstitious, rich in fanciful legend, and profoundly ceremonious in religion." The Hopi Snake Dance was the most popular destination. Tourists, photographers, anthropologists, and other sightseers flocked to the mesas to see the ceremony. Just the year before Curtis's visit, the Harvard Glee Club had swarmed into the plaza and given the dancers a rousing cheer.

Among the people Curtis may have met on this first visit were Charles Lummis, director of the Los Angeles Public Library and later founder of the Southwest Museum in Pasadena; ethnomusicologist Natalie Curtis; Smithsonian anthropologists Matilda Cox Stevenson and Frank Hamilton Cushing; and a number of other photographers, one of whom, Ben Wittick, was so enthusiastic that three years later he brought a sack full of rattlesnakes to give to the dancers. One of the snakes bit him and he died.

Missionaries had denounced the Snake Dance as pagan and obscene, but it was such a popular attraction that government agents were unable to stop it. To the Hopi, the dance was—and still is—a deeply religious ceremony. The priests fast and pray for 16 days before the event, conducting secret rituals in their underground kiva. On the final day the priests emerge, carrying rattlesnakes, bull snakes, and whip snakes around their necks and sometimes in their mouths, and they dance solemnly around the plaza. The Hopi revere the priests, who are willing to risk their lives to ensure the survival of their people.

The Hopi religious system centers around a cycle of rituals in which kachinas, embodiments of the gods, bring abundance to the villages, throwing melons, peaches, apples, oranges, and other gifts to villagers in the plaza and on the rooftops. Kwikwilaqa, the mimetic

kachina, has a boxlike head with three cylindrical eyes sticking out of his face. He stalks around the plaza during kachina dances, singles out individuals, and mimics their songs and their actions, capturing their every move, reflecting their actions back to themselves. Often the other kachinas become annoyed with Kwikwilaqa and discipline him, setting his hair on fire and throwing him out of the plaza.

With his black cloth thrown over his head and his lenses staring out at them, Curtis must have looked a lot like the mischievous kachina to the Hopi, as he stalked them and captured their actions in his camera. The Hopi usually tolerated him, but sometimes they treated him like Kwikwilaqa. He later wrote of his experiences on a Hopi rooftop, "I have grown so used to having people yell at me to keep out, and then punctuate their remarks with mud, rocks and clubs that I pay but little attention to them if I can only succeed in getting my picture before something hits me."

After the ceremony, Curtis talked to some of the snake priests, who explained that the songs are messages for the snakes to take to the rain gods. "The Hopi's greatest religious ceremony is the Snake Dance," Curtis wrote. "In reality it is not a dance, but a beautiful dramatized prayer for rain. Rain and food are synonymous terms to the Hopi in that dry desert country of Arizona. Corn is the staff of life, and crop failure means hunger. If the gods are angry and withhold the rain, famine and subsequent death stalk the land…. To them the snakes are messengers to the divine ones."

Curtis felt a strong desire to understand the snake ritual from the inside. "I realized if I was to fully understand its significance, I must participate, if permission could be obtained. To this end I returned over a period of many years, twelve in fact, renewing my acquaintance with the Snake Priest, as well as my sincere request to be made a priest in the ceremony." He introduced himself to the Snake Chief, Sikyaletstiwa, who must have wondered why this *pahana* (white man) from near the ocean would want to participate in the ceremony, since his village already had plenty of rain!

Rain often falls at the end of the Snake Dance, and when it does, general pandemonium breaks out in the plaza. Hopi men, women, and children race after each other, splashing through the mud, teasing and laughing. The celebration lasts for four days. Curtis would have experienced the joyous, wildly playful fun that often erupts in Hopi life.

The fun was short-lived. A few days after the Snake Dance, government agents and Navajo policemen forced their way into Hopi houses

and dragged the children out, transporting them to the boarding school at Keams Canyon, 20 miles away. After one Snake Dance, a snake priest named Hongvi from First Mesa walled his daughters up with stone and mortar to prevent their being taken away. All over the West Native American children were being forced into boarding schools, where they were forbidden to speak their own languages and were told that their religious practices were the work of the devil and that they had to learn English, become Christian, and farm the way white people did. Administrators from Indian schools across the country concentrated on bleaching out all sense of Indianness from the children in hopes that the next generation would become assimilated into the general population.

Curtis wrote to his friend George Bird Grinnell, "You and I know, and of course everybody does who thinks of it, the Indians of North America are vanishing…. There won't be anything left of them in a few generations and it's a tragedy—a national tragedy…. Bird—I believe I can do something about it. I have some ability. I can live with these people, get their confidence, understand them and photograph them in all their natural attitudes. I can start—and sell prints of my pictures as I go along. I'm a poor man but I've got my health, plenty of steam and something to work for."

For the next two years, Curtis traveled throughout the Southwest, Oregon, and Washington, photographing people from many tribes. In 1903 he brought a newspaper reporter with him into the field. Later that year, a series of articles about his adventures was published in the *Seattle Times:* "The year of 1901 found him away down the Navajo and Moki [Hopi] country in the wilds of Arizona, where he found 'Anonai' [a Navajo portrait subject] and brought her back on a bit of cardboard and put the artistic portion of the world on fire…. For the time being Curtis became an 'Indian.' He lived 'Indian;' he talked it; he was 'heap white brother.'... He dug up tribal customs. He unearthed the fantastic costumes of a bygone time. He won confidences, dispelling distrust. He took the present lowness of today and enshrined it in the romance of the past."

Curtis wanted to be seen not only as an adventurer and as the photographer of Indians but also as an artist. George Bird Grinnell wrote of Curtis, "The work that he has done and is doing is, from the ethnological point of view, of the very highest value…. But while he does this, he considers also—and, I fancy, considers chiefly—the art side; and the result is that his pictures are full of art…. The results which Curtis gets with his camera stir one as one is stirred by a great

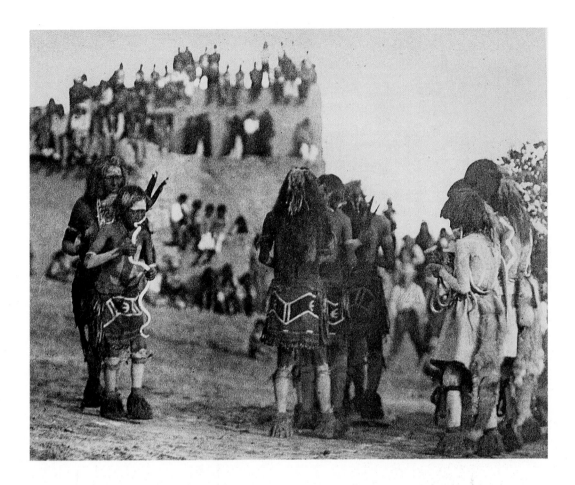

painting; and when we are thus moved by a picture, and share the thought and feeling that the artist had when he made the picture, we may recognize it as a work of art."

A Seattle newspaper reporter who had interviewed Curtis compared him rather humorously to the stereotypical artist of his day: "His light yellow beard is cut a bit on the Du Maurier order, but he might change that…. He is sort of tall and angular. He wears a flimsy black tie, tied carelessly, while he always has a hat on his head that looks as though it had been run over by a train of cars…. He has a dreamy sort of a drawly voice, and it steals over one like the distant murmur of a waterfall. His blue eyes are sleepy ones, with a half-subdued air of humor lurking in their depths…."

IN 1903, CHIEF JOSEPH CAME TO SEATTLE. TWENTY-SIX YEARS EARLIER, after a brilliant campaign and near escape to Canada, Joseph and his band of Nez Perce had finally surrendered. Gen. Oliver Howard had promised Joseph that he and his people could return home to the Wallowa Valley in Oregon,

Light on Glass

47

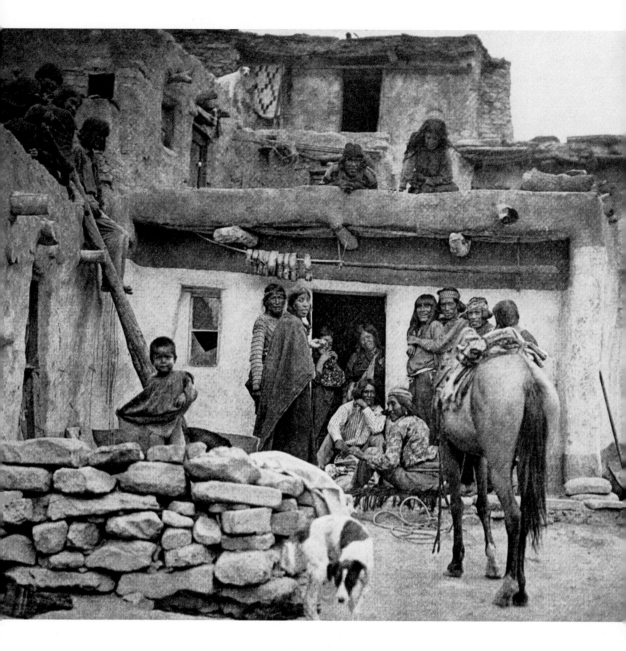

In this casual, unposed photograph, taken later in Curtis's career, the Hopi wear everyday clothes and welcoming smiles for the returning Curtis, back among them after an eight-year absence.

where they had fished for salmon in the wild rivers and hunted for deer, elk, and mountain sheep. Instead, they were held as prisoners of war for eight years in Kansas's Fort Leavenworth and in Indian Territory, then were moved to the barren lands of the Colville Reservation in eastern Washington. At Colville they were expected to support themselves by raising crops in the dry sandy soil. The Nez Perce had never been farmers and considered digging in the earth a sacrilege.

Ever since his surrender, Joseph had been on a quest to return to his homeland. "My father and mother are buried there. If the government would only give me a small piece of land for my people in the Wallowa Valley, with a teacher, that is all I would ask." Joseph had traveled as far as Washington, D.C., giving speeches and trying to sway public opinion, and had even met while in the capital with President Theodore Roosevelt. But settlers had moved into the Wallowa Valley, and the government would not let Joseph go home.

Joseph's visit to Seattle was sponsored by two friends of Curtis: Sam Hill, president of the Northern Pacific Railroad, and Edmond Meany, a history professor at the University of Washington. Professor Meany brought Joseph and his nephew Red Thunder to Curtis's studio to have their portraits made. Harold Curtis, then ten years old, was amazed to see the two towering Indian men arrive in full regalia, wearing the beaded buckskins and headdresses they used for formal occasions. Curtis was moved by the old chief's dignity, his gentleness, and his determination to bring his people home. He later wrote to Meany, "Perhaps he was not quite what we in our minds had pictured him, but still I think he was one of the greatest men that had ever lived." Curtis's portraits of Joseph are among the most powerful of all his Indian photographs.

Joseph was an eloquent and moving speaker, but he never succeeded in convincing the government to let his people go home. He died the following year; the reservation doctor recorded the cause of death as a broken heart. Curtis wrote to Meany: "Well, our old friend Chief Joseph has passed on. At last his long, endless fight for his return to the old home is at an end. For some strange reason, the thought of the old fellow's life and death gives me rather a feeling of sadness.... I only wish that I could have had the opportunity to have spent more time with him and tried to learn more of his real nature."

In the summer of 1903, Curtis opened at his studio his first exhibit of Indian photographs. Publicity described the work as "Negatives Made During the Artist's Recent Trip Through the Southwestern States," with

the latest in photographic methods. Included in the exhibit were images taken among the Apache, Zuni, Mohave, Supia, Hopi, and Navajo in Arizona and New Mexico. Curtis had been traveling for most of the previous three years to make those photographs.

Despite his growing reputation, Curtis was becoming desperate for funds. Field trips to reservations were enormously expensive affairs, and the Indian work was draining income from the studio's more lucrative landscape and society-portrait business. The more Curtis traveled, the more ambitious his project became. In addition to taking photographs, he began to gather ethnographic information about Indian songs, myths, legends, and ceremonial customs.

In the late summer of 1903 Curtis made his first trip across the country to Washington, D.C., hoping to convince the Smithsonian Institution's Bureau of American Ethnology (the B.A.E.) to sponsor his project. His timing could not have been worse. In the last decades of the 19th century, the Smithsonian had sent many amateur ethnologists—painters, biologists, librarians, photographers, and collectors—into the field to gather information about Indian cultures. But when Curtis arrived, the bureau was just recovering from a congressional investigation into the qualifications of their field researchers and was being very careful about the people and projects it chose to support.

The towering Castle of the Smithsonian, with its thick red sandstone walls, its huge mahogany doors, high ceilings, and echoing halls, was not a welcoming place for Curtis. The men he came to see did not know what to make of him. Here was a rugged six-foot Westerner with a gigantic idea and astounding self-confidence. A man without even a high school education, he proposed to document all of the Native American tribes in the West, both in photographs and text. They told Curtis that the project was impossible. He wrote indignantly, "They say I am trying to do the work of fifty men and don't believe I can do it!"

There was one man in the Castle who saw the potential of Curtis's idea. Frederick Webb Hodge, secretary of the B.A.E., was a highly respected ethnologist who had done his own extensive fieldwork in the Southwest. He was the editor of *American Anthropologist* and was also writing and editing *The Handbook of North American Indians* when Curtis arrived. Curtis impressed Hodge with his energy and ambition, his vision, his determination, and especially his photographs of southwestern Indian life. He wished Curtis well, not knowing that within a few years he would become the editor of the largest anthropological book project ever published, with the young upstart Westerner as his employer.

Undeterred, Curtis went to New York in search of a publisher, but his luck there was no better than in Washington. Walter Page at Doubleday, Page & Company told Curtis that Indian prints had flooded the market, that you couldn't give them away. He was not willing to invest the capital required to publish Curtis's work in a series of books.

Despite these disappointments, Curtis planned an ambitious field season for the following year. In October he wrote to Hodge: "I will be at work in the field by the middle of January [1904] and hope to give practically all of the time from then until the coming Autumn to the Indian work, and on my next trip to Washington I hope to have another selection of good things...." He asked Hodge to write if any funding sources occurred to him.

Curtis realized that he needed someone to run the Seattle studio full time. He was fortunate to find Adolph Muhr, a talented photographer in his own right. As an assistant to Frank A. Rinehart, Muhr had taken more than a thousand pictures of the Indian delegation that had attended the 1898 Trans-Mississippi and International Exposition. Thirty-six Indian tribes had been represented. The compelling platinum prints of Indian chiefs Muhr published under Rinehart's name show his artistry and his genuine interest in Indian people. He was a master printer whom Curtis described as "the genius in the darkroom." Their admiration was mutual; a few years later, Muhr wrote: "Curtis himself is the most tireless worker I have ever known... and his example is so contagious that everyone connected with him seems fired by the same enthusiasm and imbued with the same energy and ambition...."

A young woman named Ella McBride also worked in the studio and lived with the Curtis family. Ella was lively, energetic, and competent, and a fellow member of the Mazamas Climbing Club. Curtis described her as his "star helper" in the studio and a second mother to his children. With Muhr in charge of printing and the day-to-day running of the business, Ella taking most of the portraits, and Clara's sister and other relatives handling the bookkeeping and advertising, the studio ran fairly smoothly when Curtis was in the field, if not as profitably as when he was there.

Early in the spring of 1904, Curtis added a motion picture camera to his outfit and set out for the Navajo Reservation. He was hoping to film a Yeibechei Dance, which was part of the Night Chant ceremony. According to a *Seattle Times* article, the previous summer in Washington, D.C., "Smithsonian Institution men told Mr. Curtis that

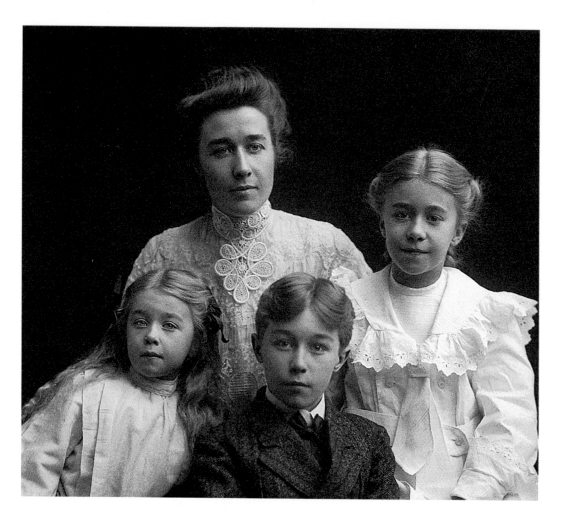

A studio portrait of Curtis's wife, Clara, and their three children—Florence, Harold, and Beth. Taken about 1905, the photograph was probably the work of Adolph Muhr, as Curtis was rarely home after 1904.

pictures of the dance together with a set of the masks would make a priceless contribution from the standpoint of the Indian historian. But they also told him the Government had been working to get the views for twenty years without result, and that it had reached the conclusion that the work was beyond the pale of the possible."

At Gallup, New Mexico, Curtis hired a wagon team and drove a hundred miles north to the town of Chinle at the edge of Canyon de Chelly. Just 40 years earlier, Kit Carson and his men had burned the orchards and cornfields in the canyon, chasing the resisting Navajo for months until they trapped them in Canyon del Muerto. In a newspaper interview, Curtis said, "The real war was in destroying the flocks and crops, and in this way starving them into submission. At last the government had them sufficiently starved so that a large number of the people surrendered, and then they were moved to the Bosco.... There the climate was much more successful in the extermination policy than

the armies had been. Disease and hunger reduced numbers rapidly. It cost our government millions to feed the Indians as poorly as it did."

Curtis arrived in Chinle in April 1904 with a letter of introduction from his friend, the photographer Frederick Monsen, to Charley Day, a son of the local trader in Chinle. Charley and his brother Sam had grown up with the Navajo, and they spoke the language fluently. Curtis later wrote that for Charley, participating in Navajo ceremonial life was as natural as it is for a duck to swim and meant more to him than the Fourth of July.

Curtis arrived too late in the season to witness the actual Yeibechei Dance; the ceremonial masks were buried until the following winter. With Charley Day interpreting, Curtis convinced a few Navajo to help him make new masks and to dance for his camera. Curtis paid the Day brothers and the Navajo with silver dollars and calico. "Of course, money might have helped some, but money was not in the running with those long bolts of bright red and blue calico that Curtis had securely tucked away in his saddle bags," the *Seattle Times* reported.

Word leaked out among the Navajo that the ceremony was being re-created, and heated arguments ensued. Several medicine men were furious. Two Navajo rode off to inform the government agent, who was trying hard to suppress the ceremony. "It was a day's ride to the Indian agent and that meant the passing of two days before the messenger could return. As everything was in readiness for the dance Curtis did not delay another moment."

Curtis set up his motion picture camera in a secluded grove a few miles from the store. Charley, Sam, and 12 Navajo painted themselves with white clay, dressed in the masks and skirts of the Yei gods, and performed the dance for Curtis's camera. It was an eerie scene, the painted dancers rushing toward the camera in their vivid masks, shaking their rattles as they shouted high-pitched calls, then moving solemnly back to the end of the line.

When the group returned to the Days' store, a Navajo policeman arrested Charley and one of the Navajo participants. "For the offending Indians there was a long trip to the Indian agent's ranch, and in the tangle and the parley that preceded the trip, Curtis quietly shook hands

Adolph Muhr with Curtis's last child, Katherine (Billy), taken about 1911. Born in 1909 after her parents had separated permanently, Katherine saw her father only once as a child, then not again until she was 18.

with the storekeeper, stepped out the back way, and, accompanied by his interpreter and his guide, put spurs to his ponies and headed due west for safety and San Francisco."

Curtis's insistence on getting the Yeibechei Dance on film had wreaked havoc on the reservation. The hand of the government came down harder on Navajo religious practices. Charley Day was forbidden to take part in or even to witness ceremonies and was later banned from the reservation. The Seattle papers, however, hailed Curtis's exploits as a triumph. "Edward S. Curtis, the local photographer, who but recently returned from a sojourn among the Navajo Indians of Arizona, has the distinction of accomplishing what the Smithsonian Institution has tried for years to do and failed. Mr. Curtis overcame the superstitions of the red man…and suffered many hardships to secure a full set of pictures of the famous Yabachi [sic] dance."

Curtis returned from Arizona in May with his rare photographs

and motion pictures. "The victory over the superstitions of the fast disappearing Navajos has greatly enhanced the Seattle man's reputation among the government's ethnologists," the *Seattle Times* reported. "His mysterious ability to go among the Indians and get that which they are determined not to reveal has brought him a letter from the highest Indian authority in the United States [Commissioner of Indian Affairs Francis Leupp], commanding every Indian agent to do everything in his power to carry out the wishes of Mr. Curtis."

Curtis had gotten his footage, but Charley and the Navajo did not show him the whole ceremony, nor did they allow him to see the exact designs of the masks.

Back in Seattle, Curtis and Muhr worked long nights in the darkroom printing the season's photographs. Harold remembered seeing his father and Muhr despair over one negative that was so underexposed they could not get an image. They were about to break the negative when they decided to use the goldtone method of printing that Curtis had developed earlier with his partner, Thomas Guptil. Curtis and Muhr refined the process, using smelly banana oil and gold pigment to back the glass on which they printed the positive image. The effect was luminous, mysterious, haunting. The underexposed negative became perhaps Curtis's most famous image, "The Vanishing Race."

In June 1904 Curtis was preparing to set off for fieldwork in Montana when an astonishing invitation arrived. President Theodore Roosevelt wanted him to come to Oyster Bay, New York, to photograph his sons during their summer vacation. Earlier that year, Curtis had been one of the winners of a contest sponsored by *Ladies' Home Journal* for pictures of "the prettiest children in America." The magazine published the winning photographs, and the well-known portrait artist, Walter Russell, planned to paint them in oil. Russell had been impressed by Curtis's image of a young girl and recommended that the Roosevelts hire Curtis to make photographs of the boys to use as a basis for paintings of them. Perhaps the President knew that his sons would not sit still long enough for oil portraits but hoped they could be coaxed into posing long enough for photographs.

Curtis immediately unpacked his camp gear and repacked his bags for the East.

The Roosevelts welcomed Curtis to Sagamore Hill, their rambling Victorian mansion surrounded by manicured gardens and a spacious piazza overlooking Long Island Sound. The Roosevelt children, known as "the White House Gang," were a wild bunch who liked to roller-skate

The reception room of the Edward S. Curtis Studio in downtown Seattle was decorated in the then fashionable arts and crafts style.

through the rooms, climb up and down the steps on stilts, and even ride ponies through the halls. They took to Curtis immediately. With his rugged six-foot frame dressed up in natty camp clothes from Abercrombie and Fitch, his self-assured good looks, and his air of being ready for anything, Curtis must have appealed to Roosevelt's own love of the outdoors and of all things Western. "They made me feel like one of the family, and I had my initiation into the President's Obstacle Walk. He led the procession, over, under and through, followed by the children, their friends, and any guests that wished to be included. It was a strenuous game of 'follow the leader,' but believe me no place for sissies, and a mortification for anyone who dropped out. We returned exhausted and out of breath to sit in one of the great rockers on the porch from where we looked across the sloping lawn and grounds toward Long Island Sound." Curtis photographed the boys, then the entire family. The pictures were published in *McClure's* magazine the following year. It is not known whether Russell ever painted the portraits; perhaps the Roosevelts realized Curtis's photographs were, after all, works of art.

Curtis was especially pleased with his portrait of the President. With characteristic bravado, he wrote to his friend Gifford Pinchot: "My picture of the President is great. It is quite different from anything before taken and, I believe, will be considered by all who know him, a splendid likeness. I made no effort to retouch up the face and make him a smooth-visaged individual without a line or anything to show his character. Background, clothing and everything is carried in one great mass of shadow, bringing the face, with its great strength of character, the only thing that we see, and I believe it is good."

Curtis was not alone in his enthusiasm for the photograph. When he sent a copy of the picture to Jacob Riis, the famous documentary photographer of New York City street life—and a man Curtis admired greatly—Riis replied, "The picture of the President, I will always maintain, is more than a picture, it is the man himself. I did not know that it was possible for photographs to do just that."

ROOSEVELT'S IDEAS ABOUT INDIANS HAD CHANGED DRAMATICALLY OVER time. Just two decades before, he had described the typical Indian as a "lazy, dirty, drunken beggar, whom…the frontiersmen despised and yet whom they feared; for the squalid contemptible creature might at any moment be transformed into a foe whose like was not to be found in all the wide world for ferocity, cunning, and bloodthirsty cruelty." He

had also said, "I don't go so far as to think that the only good Indians are the dead Indians, but I believe nine out of every ten are, and I shouldn't inquire too closely into the case of the tenth."

By the turn of the century, many of Roosevelt's friends were discovering the richness of the Indian cultures that his administration was trying so hard to change. The President's old Harvard friend Charles Lummis had been lobbying him for years to stop abuses by government agents at the Hopi and Rio Grande Pueblos and had often written to Roosevelt about the intricate ceremonies of the southwestern Indians. The ethnomusicologist Natalie Curtis, a friend of the Roosevelts, had played Hopi songs for TR on her Edison recorder, and the President had been moved by their poetry. Although Roosevelt had reportedly said that he had no intention of keeping the Indian as "bric-a-brac," he had begun to see the value of preserving a record of Native American cultures before they vanished.

Curtis had brought a portfolio of his Indian pictures to show the President. "I poured forth my consuming desire to photograph and obtain the history of the primitive tribes while it was possible to contact the ancient ones who carried that vital information in their heads. Roosevelt's deep intellectual grasp of the significance to the history of our country and to students and scientists of the world was greater than even I had envisioned."

Roosevelt thought the pictures were wonderful, especially the image of a young Mohave girl named Mosa and the portrait of Chief Joseph, who had visited him earlier that year. According to Curtis, the President exclaimed: "'Bully for you, Curtis! It must be done, I believe you are the man who can do it and I will give you every assistance within my power for the accomplishment of such a great undertaking.' Stimulated by Roosevelt's magnetic personality and enthusiastic encouragement, I was determined to fulfill his confidence in me and produce a photo-history of The North American Indian."

Curtis was elated. In New York, he bought a teddy bear—toys named for President "Teddy" Roosevelt and then the rage—for his younger daughter, Florence, and headed home to Seattle.

Within a few weeks, Curtis left for the Southwest. He had gone to the Hopi Snake Dance every August since 1900, and this time he brought his motion picture camera with him. He set it up on a rooftop and aimed it at the plaza. "One old fellow, on whose roof there was room for two dozen spectators, had sold it to three times that many. This occasioned a little hard feeling. However, as I was first purchaser, and perhaps the

"…I found the Roosevelts the most vital, energetic family, and enjoyed being included in their activities. They made me feel like one of the family," Curtis wrote in 1904 of the summer he spent with President Roosevelt's family at Sagamore Hill, overlooking Long Island Sound.

EDWARD S. CURTIS

biggest bluffer, I kept possession of a small part of it. It was from this roof I proposed to work the motion picture machine or kinetoscope."

Curtis filmed the Snake Dance at Oraibi on Third Mesa, then went over to Second Mesa to watch the dance at Shipaulovi and to ask his friend Sikyaletstiwa again to initiate him into the ritual. The priest declined, but he did invite Curtis into the snake kiva, an unusual honor.

In those early years, when Curtis was just beginning the work that would become his grand opus, the contradictory themes of his life emerged. Curtis wanted to infuse his work with emotional content, with the finer feelings of an artist, but at the same time he wanted to document Indian cultures in a way that would be of value to science and history. He was deeply interested in the religious beliefs of the Indian people he met. The two events that inspired him to begin his monumental work were both sacred ceremonies, the Sun Dance and the Snake Dance. Perhaps his own religious upbringing, combined with the loss of his father, drew him to the sacred ceremonies of cultures he believed to be on the edge of extinction. He studied comparative religion intensively, reading books on Buddhism, Confucianism, Hinduism, Christianity, and Taoism, as well as anything he could find about American Indian beliefs. His quest to be initiated into the Snake Society was informed by his own need to rediscover a faith so deep that its believers would risk death as they performed a ceremony dedicated to the continuing life and livelihood of their people.

Curtis climbed down the ladder into the circular underground room, lit only by a dusty shaft of sunlight and the flickering mesquite fire. He watched as the priests tamed the snakes with eagle feathers, chanting their low soothing songs. Curtis felt at peace there, momentarily freed from the rigors of travel, the strain of fund-raising, the demands of the studio and his family, and even from the difficulties of taking pictures. He took one image, then set his camera down and watched as the priests lulled the snakes, and him, with their songs. After the ceremony he wrote to Hodge, "Hopi has become a spiritual crossroads in my work, a still place in the middle of the continent. These events are beyond words, but the urgency of continuing my work carries me forward."

Curtis said good-bye to his Hopi friends and drove his wagon to reservations throughout the Southwest, taking hundreds of photographs. He wrote again to Hodge from the field, "The longer I work at this collection of pictures, the more certain I feel of their great value.... The only question in my mind is, will I be able to keep at the thing long

enough, as doing it in a thorough way is enormously expensive."

Back home in Seattle, Curtis wrote to Gifford Pinchot, "Well, my trip to the South-west has been a very successful one. One of the hardest trips that I have ever made, met with more trouble from rains, accidents and that sort of thing than I have in my work heretofore, but withal, succeeded in getting a very large amount of splendid new material. Saw the Snake Dance of the Mokis [Hopis]; also the Buffalo Dance and the Antelope ceremony of the Acomas, the annual ceremonies of the Jiciralla [sic] Apaches and a nine day ceremony of the Navajos. Eight hard, happy weeks! but you know how it is—results is what a fellow wants, and if you get them, what matters a few camp hardships, and the occasional loss of more or less of one's outfit to cloud bursts, freshets etc...."

In December, Curtis rented Seattle's Christensen's Hall for his first public lecture on Indian life. As he spoke, he projected hand-colored lantern slides, then stunned his audience with his films. A reporter from the *Portland Oregonian* described Curtis's "New and Remarkable 'Motion Pictures' of Snake Dance and Other Mystic Ceremonies" as having moved the audience to a "fever heat of enthusiasm." Curtis wrote to Charley Day, "The people who have seen my motion picture...say that it gives them the creeps—they feel that the whole howling mob of Indians is coming right at them!" Just one year earlier, *The Great Train Robbery* had terrified audiences into stampeding out of theaters when a train rushed toward them from the screen.

CURTIS BEGAN 1905 WITH A WHIRLWIND OF LECTURES AND SCREENINGS. In January he presented his program to leading Seattle citizens at the Rainier Club, then took the train across the country to Washington, D.C. His old friends E. H. Harriman and C. Hart Merriam had arranged for him to speak at the Cosmos Club, a meeting place for the scientific elite that had been founded by John Wesley Powell and others in 1878. Curtis also spoke at the prestigious Washington Club, at the National Academy of Science, and at the National Geographic Society. Society director Gilbert H. Grosvenor described the event as "the most wonderful exhibition last night I have seen. We had about a thousand people and they just sat and clapped and clapped. He showed a hundred and thirty pictures and they applauded nearly every one, though our audiences are usually very staid."

In February Curtis received an invitation from Francis Leupp, Roosevelt's commissioner of Indian affairs, to photograph the Apache

chief Geronimo at the Carlisle Indian School in Pennsylvania. Leupp had been awed by Curtis's uncanny abilities in the field. "There is a great art in collecting such material as Mr. Curtis has acquired.... Mr. Curtis's personality seems to have impressed his Indian friends most favorably, and his tactful methods have been such that he is the one historical prospector to whom I have felt justified in giving absolute freedom to move about in the Indian country wherever he would."

Leupp believed that Curtis would be able to win Geronimo's trust, if anyone could. In the 1850s, the Apache chief had gone on a series of rampages after his wife and children were murdered by Mexican soldiers. He had eluded both Mexican and U.S. troops for two decades, raiding and plundering and escaping into the mountains. Gen. George Crook had finally defeated him in 1875, and 11 years later, the chief had agreed to peace. When Curtis met him, Geronimo had long ago given up fighting, but he did not often choose to cooperate with his captors. Curtis later wrote, "The spirit of the Apache is not broken; he has lost none of his cunning, craftiness or endurance, but he sees that the day of the war-path is no more."

Commissioner Leupp had brought Geronimo to Carlisle to impress him with the progress of the children there. Like other Indian boarding schools, Carlisle was run with military-style efficiency. The students marched from class to class in uniforms, their hair shorn, their traditional clothes burned. Curtis must have felt empathy for these children, who were thousands of miles from their homes and millions of miles from the cultures in which they had been raised, and this shared feeling may have connected Curtis and Geronimo at Carlisle. In one of the portraits, Geronimo looks off to his right, his head wrapped in a cloth, his face lost in thought. Perhaps he is thinking of his past, or of the thorny path his descendants would have to follow. In Curtis's more formal portrait, Geronimo is wearing traditional headgear, holding a spear, and glaring straight at the camera.

A few days later, on March 4, 1905, Curtis photographed the old Apache again, this time on the White House lawn. President Roosevelt had asked him and several other chiefs to ride in the inaugural parade. Geronimo appreciated the honor but refused to wear an eagle feather headdress, as the other chiefs did, as this was not his traditional regalia.

The inauguration took place on a cold, wet, and miserable day. "As I approached in a drizzle of rain, I saw a tall figure wrapped from head to foot in a bright red blanket who waited for me," Curtis wrote. "It was my old friend Geronimo. He opened his right arm wide and

pulled me under his protecting blanket and we proceeded together." Curtis photographed the chiefs lined up on horseback in front of the White House—men who had fought the U.S. government long and hard, had lost their battles, but had, in spite of everything, survived.

Later that spring, Curtis held his first New York exhibit, at the Waldorf-Astoria Hotel. His old patron E. H. Harriman helped to arrange the show. Roosevelt wrote to the railroad baron, "I am pleased that Mr. Curtis is to exhibit his really marvelous collection of Indian photographs in New York. Not only are Mr. Curtis's photographs genuine works of art, but they deal with some of the most picturesque phases of the old-time American life that is now passing away. I esteem it a matter of real moment that for our good fortune Mr. Curtis should have had the will and power to preserve, as he has preserved in his pictures, this strange and beautiful, and now vanishing, life."

The bill for the exhibition room shocked Curtis. "The $1300 figure nearly gave me a heart attack!" But New York's wealthiest families came out in force. Among them were Mrs. Jay Gould; Mrs. Frederick Vanderbilt; Mrs. Stuyvesant Fish; President Roosevelt's sister, Mrs. Douglas Robinson; and J. P. Morgan's favorite daughter, Mrs. Herbert Satterlee; as well as his daughter-in-law, Mrs. Jack Morgan. Curtis lectured and projected his slides and films in the Waldorf's Astor Gallery and in the Myrtle Room. Glowing reviews appeared in the New York press: "Just one man, an American, an explorer, an artist with the camera, has conceived and is carrying into execution the gigantic idea of making complete photographic and text records of the North American Indians so far as they exist in primitive conditions to-day."

To his great relief, Curtis sold enough prints to make a small profit and also to pay for the shipping of the unsold pictures to the Lewis and Clark Exposition in Portland, Oregon. In the Fine Arts Building, his pictures hung beside the work of 24 other leading photographers, including Edward Steichen and Alfred Stieglitz, avant-garde pictorialist photographers who had also been on the exposition's selection committee.

In June, Prof. Edmond Meany of the Washington State Historical Society asked Curtis to participate in a ceremony for Chief Joseph. Curtis had attended Joseph's burial on the Nez Perce's Colville Reservation the year before, but the chief was to be reburied under a tall marble monument. A picture of Joseph was carved on one side of the stone, and on the other side was an inscription of his Nez Perce name and its translation, "Thunder Rolling in the Mountains."

Curtis later wrote, "In the days of long ago I helped bury the chief twice. In order to bury him the second time we had to dig him up. I did most of digging. It was a very hot day and the Noble Red Men said 'let the white man do the digging, they know how.'" This wry comment probably refers to the government's obsession with turning the Nez Perce into farmers, an occupation they despised. At the funeral, Meany remarked to Curtis, "When I watch you dig in that barren soil I wonder how the powers that be in Washington could possibly think that anyone could raise a crop for sustenance." Curtis replied that he feared that all the lands set aside for Indians were equally useless.

Meany and other dignitaries from the historical society gave speeches, while the new chief, Yellow Bull, and his people looked on. After the burial, Joseph's wife gave away "every earthly possession" in a potlatch ceremony, called a *Hi-u*, or "big giving." "Through it all the wife sat by the side of the great stack of goods being distributed, handing out each article and trinket. At times when some article obviously dear to her heart was handed out, great tears would roll down her cheeks. Two days were taken in this giving, and then the visiting Indians tore down the grand council lodge, and so closed the last chapter in the life and death of the most decent Indian the Northwest has ever known."

According to a Seattle journalist, several of the more traditional Nez Perce objected to pictures being taken of the potlatch. When Curtis began photographing anyway, Chief Albert Waters tried to stop him with physical force, shoving his camera aside. The journalist reported that Curtis threatened Waters, telling him, "If you lay your hands on that camera again I will feel compelled to punch your face, and if that is not sufficient I will blow the top of your head off." Curtis did not normally carry a gun, so that part of the story is probably exaggerated.

After the ceremony, Curtis and William Phillips tried to talk to the elders. "Yellow Bull, the old warrior, though carefully approached, effactually evaded all attempts to get him to reveal anything relative to ritualism, legends, gods, or the world hereafter. The very seriousness of the deference to the gods and spirits gone to the great beyond proved a barrier to the securing of details of its underlying causes. Persuade, reward as we would, veterans of the tribe refused point blank to divulge information.... After the dispersal of the gathering... I scanned the pages of my notebook and wondered if succeeding efforts were to be as barren of results."

From Colville, Curtis and Phillips set out for a season in the north-

Curtis's own typed thoughts on "The Vanishing Race" predicts a grim, if "unknown future," for the traditional Native American way of life.

ern plains. They began their work on the Pine Ridge Reservation, on the windswept prairies of southeastern South Dakota. Just 15 years earlier in 1890, U.S. troops had ridden there to stop the Ghost Dance, which was sweeping across the plains. The dancers believed that their "ghost shirts," emblazoned with eagles and buffalo, would protect them from the white man's bullets, and that, if they kept on dancing, the dead would rejoin the living, the buffalo would return, and white people would vanish from the Earth. The nervous Indian agent at Pine Ridge had called in the Army to put an end to the ritual.

On the bitter cold morning of December 29, 1890, at Wounded Knee Creek in South Dakota, a shot rang out during talks between Col. James Forsyth and the Sioux chief Big Foot. The soldiers raised their rifles and fired into a group of Indians. Several Sioux grabbed their confiscated arms and returned fire. Guns and cannon blasted the Indian camp, ripping open tepees and sending women and children running through the smoke, only to be cut down by gunfire. More than 150 Sioux men, women, and children died that morning at Wounded Knee. This

"battle" marked the end of armed resistance by American Indians.

After 1890, Indian people across the country were confined to reservations controlled by government agents. The buffalo were gone, and Indian people were dependent for food and clothing on rations promised to them in treaty negotiations. Corrupt Indian agents and an indifferent government meant that these rations were rarely distributed according to treaty agreements, and many Indians froze or starved. Curtis found the Sioux at Pine Ridge in desperate shape. "A span of years between the extermination of the buffalo herd and the present has seen such management of many groups of Indians, however, as to demoralize and make beggars of them.... A visit to the average Indian reservation means to go away discouraged. You find a lack of sympathy for the Indians by those who are responsible for their management.... Talk with the Indian, and he will tell you a story that is most startling. At the best, it is an accusation that the management of the reservation affairs is dishonest and corrupt...and that the Government at Washington is not keeping the promises of the past, nor those of to-day."

At Wounded Knee, Curtis and Phillips met Chief Red Hawk and rode with him 50 miles north to the Badlands. Red Hawk and his men had fought many battles against the invading U.S. Cavalry and had defeated Gen. George Armstrong Custer at the Battle of the Little Bighorn three decades before. Now they were living in poverty on a small fraction of the land they had once roamed. In the Badlands, Curtis took his classic photographs of Red Hawk on horseback in full regalia, watering his horse at an oasis, and of three chiefs framed by jagged peaks riding toward the camera—a photograph he would call "In the Bad Lands." Curtis promised that he would return the following year and hold a feast if Red Hawk and his men would re-enact scenes from the Battle of the Little Bighorn for his camera.

Back at Pine Ridge, Curtis approached Chief Red Cloud, who had signed the Treaty of Fort Laramie in 1868, the year Curtis was born. Under the terms of that treaty, the Sioux were granted a huge reservation that included the sacred Black Hills. In 1874 gold was discovered there. By the time Curtis arrived, the Black Hills were overrun with miners, and much of the reservation had been sold to settlers. The old chief allowed Curtis to take his picture but did not respond to his questions. "Red Cloud is, without doubt, the record holder of the living North American chiefs today.... Ninety-one years old, blind, almost deaf, he sits dreaming of the past. No wonder he is

Curtis photographed Geronimo on March 3, 1905, at the Carlisle Indian School in Pennsylvania and again the next day at Theodore Roosevelt's inaugural festivities.

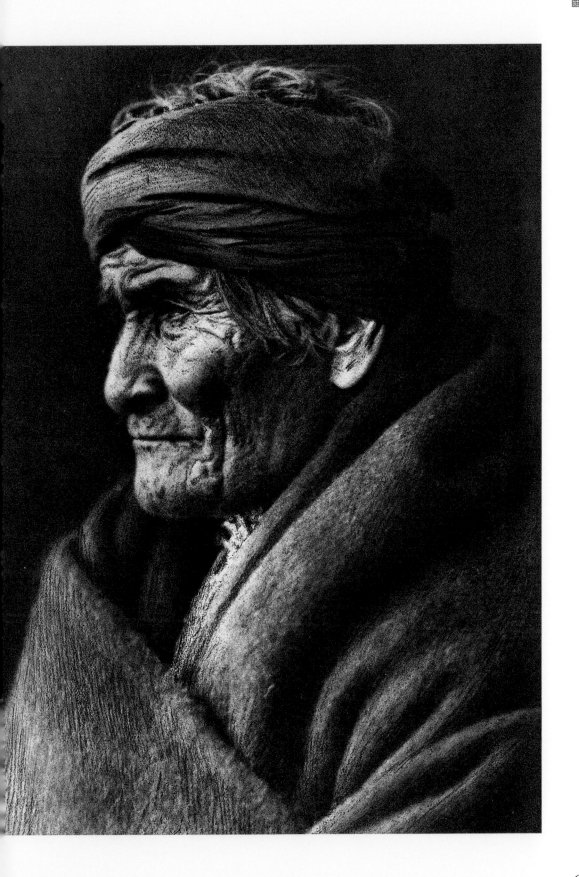

irritated by the idle information seeker! Who would be called back from the dreams of his youth? Sightless and infirm, he is living over the days when in youth he sat his horse as a king, the pride of the great Sioux nation."

On the Cheyenne Reservation in Wyoming, he found the people there in even more desperate condition than the Sioux had been. According to William Phillips, the Cheyenne were "pictures of poverty." The photographs Curtis took there show the grief and loss the Cheyenne were feeling about their recent past but not the hunger and desperation of their present circumstances.

CURTIS'S OWN FINANCIAL SITUATION WAS GROWING DESPERATE. HE was spending huge amounts of money on travel and fieldwork, and his debts were mounting. In November, he traveled again to the East Coast hoping to sell enough pictures to pay for his summer's fieldwork. He presented programs at the National Arts Club in Washington, D.C., and at the Cosmos Club, showing hand-colored lantern slides as he described traditional Indian life, but these shows did not bring in even enough money to cover the expenses of the trip. Finally, at the very end of the year, Edmond Meany helped Curtis to secure bank loans totaling $20,000, guaranteed by Seattle friends. Curtis used the money to pay his debts and keep the studio going, but he could not continue the Indian work at such a huge loss. He wrote to Roosevelt asking whether he might help him find a patron. In December the President replied: "My dear Mr. Curtis, There is no man of great wealth with whom I am on sufficient close terms to warrant my giving a special letter to him, but you are most welcome to use this letter in talking with any man who has any interest in the subject."

Roosevelt went on to praise Curtis in glowing terms: "I regard the work that you have done as one of the most valuable works which any American could now do. Your photographs stand by themselves, both in their wonderful artistic merit and in their value as historical documents.... You are now making a record of the lives of the Indians of our country which in another decade can not be made at all, and which it would be the greatest misfortune, from the standpoint alike of the ethnologist and the historian, to leave unmade. You have begun just in time, for these people are at this very moment rapidly losing the distinctive traits and customs which they have slowly developed through the ages. The Indian, as

an Indian, is on the point of perishing, and when he has become a United States citizen, though it will be a much better thing for him and the rest of the country, he will lose completely his value as a living historical document. You are doing a service which is much as if you were able suddenly to reproduce in their minute details the lives of men who lived in Europe in the unpolished stone period. The publication of the proposed volumes and folios, dealing with every phase of Indian life among all tribes yet in primitive condition, would be a monument to American constructive scholarship and research of a value quite unparalleled."

In January 1906, Curtis brought his wife, Clara, with him on a whirlwind tour of the East Coast. He lectured again at the National Geographic Society in Washington and also gave his "stereopticon picture talk" at the Century Club. According to Curtis, during this trip Roosevelt suggested that he approach railroad magnate J. Pierpont Morgan for financial support. Morgan's daughter, Louisa Satterlee, may have shown her father the photographs she had bought at the Waldorf the previous year, or perhaps Roosevelt's letter opened the door. In any event, Curtis was granted an appointment at Morgan's offices at 20 Wall Street on January 24, 1906. The day before, he sent Morgan a letter: "My dear Mr. Morgan, As you have been so good as to give me an opportunity to bring my matter before you, I take the liberty of writing you and sending you an outline of the work, previous to my coming.... As to the scientific accuracy of the work I can give ample endorsement. As to its artistic merit, it must speak for itself, and no one can better judge of that than yourself.... I feel that the work is worth while, and as a monumental thing nothing can exceed it. I have the ability, strength and determination to finish the undertaking, but have gone to the end of my means and must ask some one to join me in the undertaking and make it possible for all ages of Americans to see what the American Indian was like."

The writing in this letter is an interesting combination of humility, deference, and extraordinary boldness, qualities that undoubtedly led to the outcome of the meeting. "The hour arrived and I sat nervously waiting my turn. My name was called, and then I stood in that beautiful teak-lined room before Mr. Morgan.... His greeting was terse and businesslike. I told my story. He listened carefully, and his answer came quickly. 'Mr. Curtis, there are many demands on me for financial assistance, and I will be unable to help you at this time.'"

Morgan was famously intimidating. His huge purple nose was

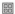

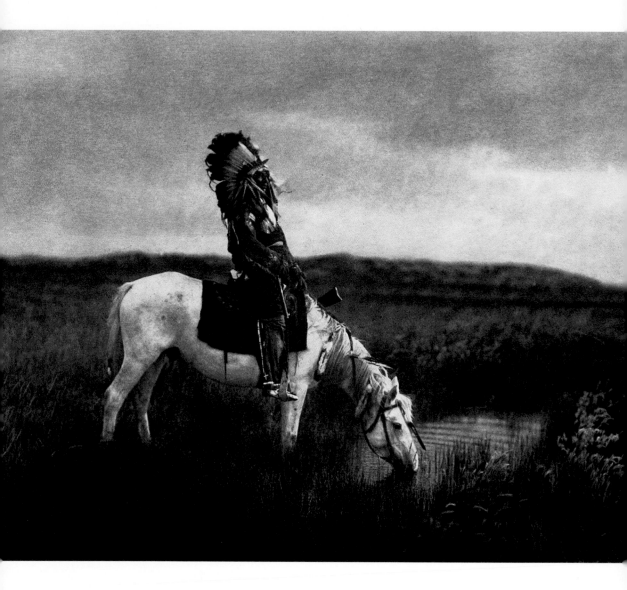

"An Oasis in the Bad Lands" is Curtis's haunting image of Chief Red Hawk, who fought against Custer in the Battle of the Little Bighorn. Red Hawk returned with Curtis 30 years later to the South Dakota Badlands, and he and his Sioux band staged mock battle scenes for Curtis's camera.

permanently swollen, his eyes glared. The photographer Edward Steichen said that looking at Morgan was like "confronting the headlights of an express train bearing down on you."

Curtis was not easily deterred. He opened his folder of Indian photographs and placed them on Morgan's desk. Morgan slowly turned them over, one by one. Finally, he looked up at Curtis with a different expression. "Mr. Curtis, I will lend financial assistance for the publication of a set of books illustrated with photographs such as these. My staff will take care of the financial arrangements."

Curtis walked from his presence in a daze. An incredulous secretary met him in the hallway. "Weren't you aware that Mr. Morgan had dismissed you, yet you opened your folder of photographs? It is a rare occasion when Mr. Morgan changes his mind. In fact, during the years I've been with him, it is the first time."

Curtis's proposal was hugely ambitious. In his letter to Morgan he had outlined a 20-volume set of leatherbound books "showing pictures and including text of every phase of Indian life of all tribes yet in a primitive condition, taking up the type, male and female, child and adult their home structure, their environment, their handicraft, games, ceremonies, etc.... going fully into their history, life and manners, ceremony, legends and mythology."

Each set of books would be accompanied by a portfolio of large, loose photogravures suitable for framing, and the sets would be sold for $3,000 each. Curtis promised Morgan 25 sets of the volumes in exchange for an investment of $75,000, to be paid at $15,000 a year for five years.

Curtis had not intended to write the books himself. He had planned to give his field notes to "recognized authorities" to write and edit, "thus affording unquestionable authenticity." Morgan had another idea. "You are the one to write the text. You know the Indians and how they live and what they are thinking."

Morgan dashed off a note confirming his participation. Curtis had found his patron just in time. For five years, he would be able to follow his dream and continue the Indian work.

"There were so many tribes to contact and so much work to do, but at last it looked as though the books would be published." He rushed from the office full of enthusiasm, ready to make plans for the next field season, which he planned to spend in the Southwest. Later, he was to say, "Little did I realize the full magnitude of the task I contemplated, or the vicissitudes ahead." ✹

Art of a Shadow Catcher

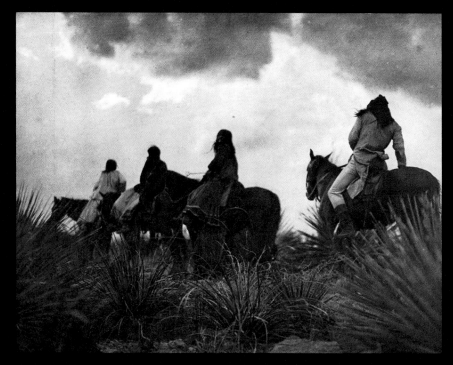

THE STORM—APACHE
CRYING TO THE SPIRITS—HIDATSA *(opposite)*

When Curtis started his work, photography was just beginning to gain validity as an art form. In 1902 Alfred Stieglitz and other photographers had formed the Photo-Secession Club, dedicated to promoting photography as art. They used diffused lighting, soft focus, and abstract backgrounds to create images that looked more like Impressionist paintings than photographs. Curtis had used this "pictorial" style in his Seattle society photographs of women and children, and he brought these same techniques into the field. He infused his Indian photographs with a feeling of nostalgia by using soft-focus effects to blur backgrounds and create a sense of nobility and timelessness. He wanted to memorialize his subjects as the last survivors of a lost Eden.

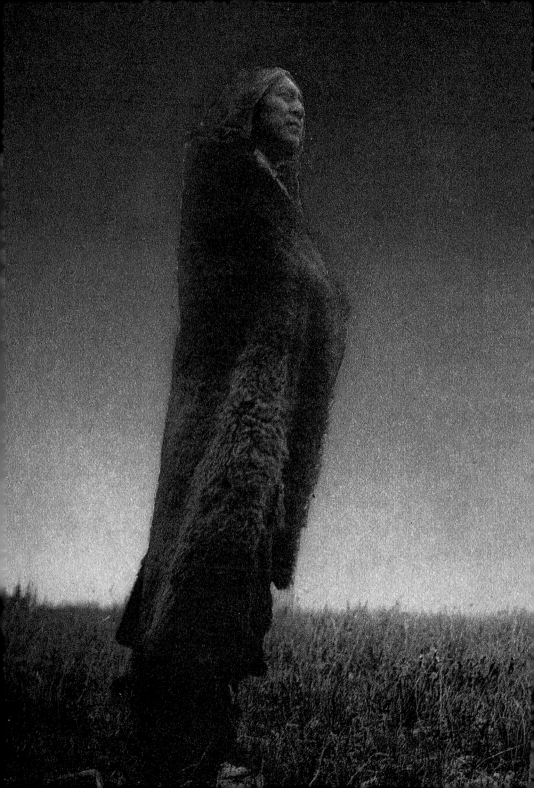

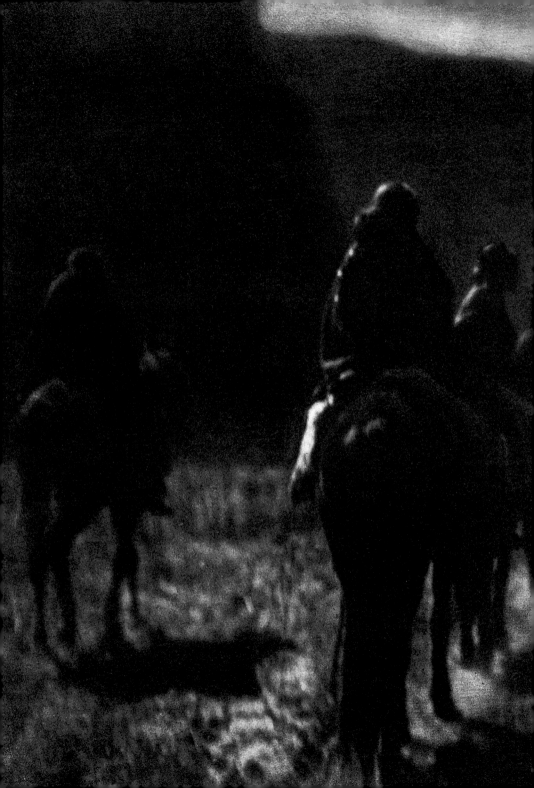

Harold remembered his father staying up all night with Adolph Muhr, trying to print this image from an underexposed negative. "This picture is meant to convey…the Indians as a race, already shorn of their tribal strength and stripped of their primitive dress… passing into the darkness of an unknown future," Curtis said of it.

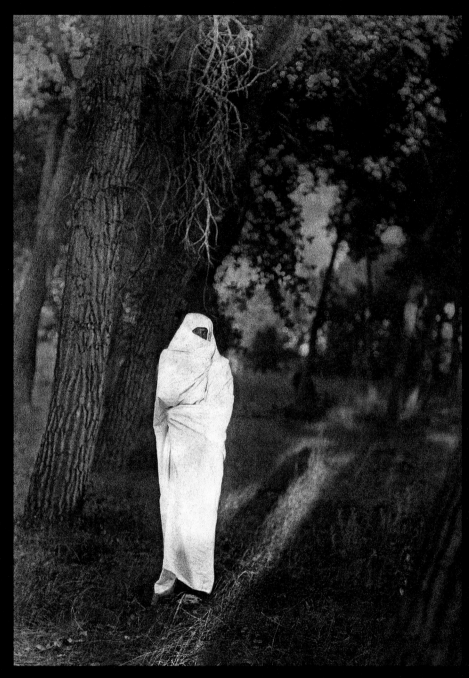

WAITING IN THE FOREST—CHEYENNE

WATCHING THE DANCERS—HOPI *(opposite)*

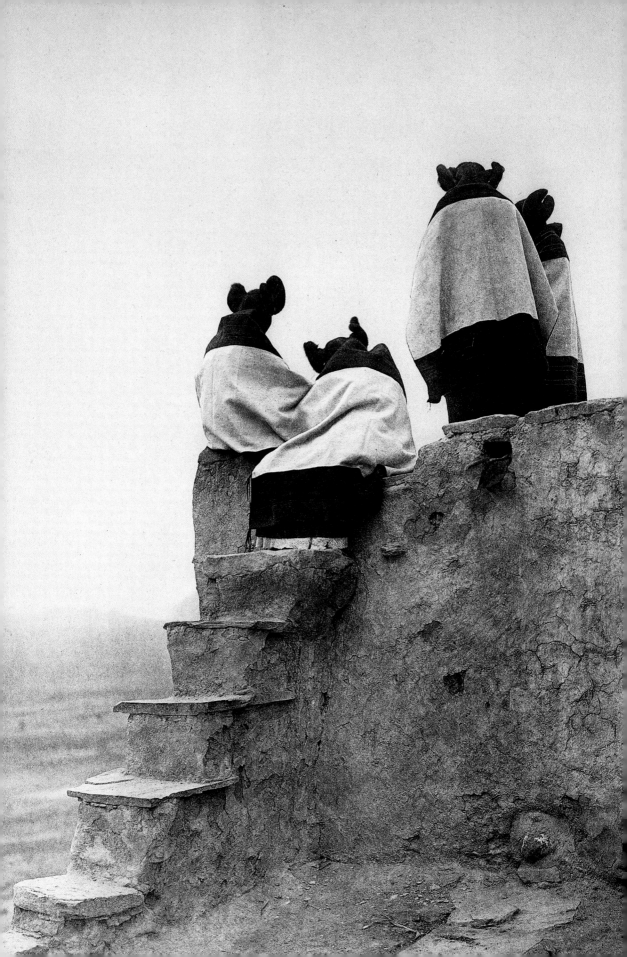

A Kutenai Indian
gathers reeds to be
woven into mats,
cushions, lodge-
covers, and mattresses.
Using backlighting,
Curtis obscured the
man's modern cloth-
ing and achieved a
sense of peace and
timelessness.

KWAKIUTL HOUSE-FRAME

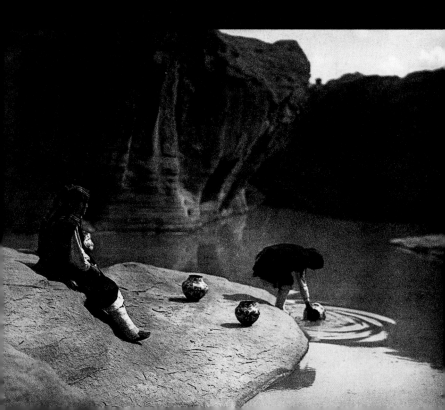

THE BLANKET WEAVER—NAVAHO

MAID OF DREAMS—TRIBE UNKNOWN

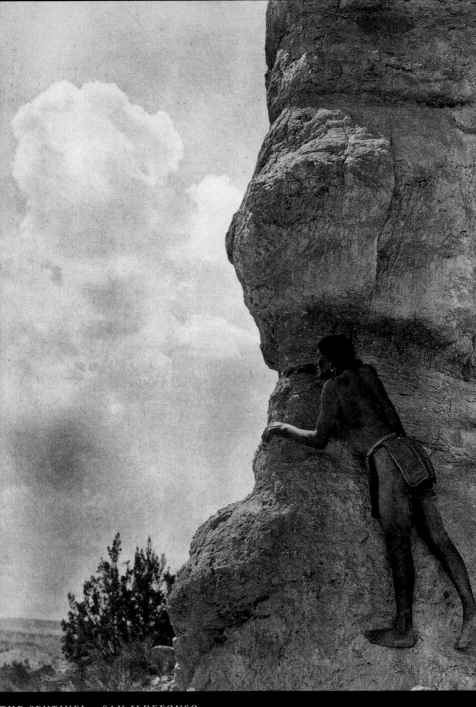

THE SENTINEL—SAN ILDEFONSO

<div style="border:2px solid #000; padding:20px;">

CHAPTER THREE

1906 TO 1910

Adventures in the Field

</div>

*"The most gigantic undertaking in the making of books
since the King James edition of the Bible."*

—*NEW YORK HERALD*
ON CURTIS'S *NORTH AMERICAN INDIAN*

"MORGAN MONEY TO KEEP INDIANS FROM OBLIVION!" BLAZED ACROSS THE HEADLINES OF the *New York Press* on March 26, 1906. There was much irony in this arrangement. Morgan's Great Northern Railroad had carried thousands of settlers West, forcing Indian peoples from their lands, bringing a variety of diseases, creating conflicts that led to the decimation of the native population, and destroying the buffalo. During the 1870s more than 15 million buffalo were killed by white hunters, who often shot at herds from Morgan's moving trains. Buffalo bones and carcasses lay in piles along the railroad tracks.

Curtis considered the plight of the Indian tragic but inevitable, and, if he was aware of the ironies of his patronage, he did not let it stop him. The next day, he set out into the New York winter to find a publisher for his books. With Morgan supporting the project, Curtis assumed this would be a simple matter. He went to see Walter Page at Doubleday, but Page was not willing to commit the capital required for such an elaborate publication. Curtis then approached Harper Brothers and several other publishing houses in New York, but all gave him the same answer: They could not invest the enormous sums required unless Morgan would guarantee them against loss.

Morgan had another solution. He suggested that Curtis publish the books himself

The Curtis family camp in Canyon de Chelly, summer of 1906

and sell subscriptions to pay for the printing costs. Just a few weeks before, Curtis had told Morgan that selling the books before they were finished would be impossible. But in his eagerness to finalize arrangements and begin the real work, Curtis agreed to take on the added burden of publishing the lavish volumes.

From the very beginning, Morgan's investment fell far short of the funds Curtis needed to carry on the project. His commitment of $15,000 per year covered only half the field expenses. Curtis would have to sell subscriptions to pay for the expensive engraving, printing, and binding of the leather volumes, as well as costs for additional fieldwork. Overnight, Curtis had become not only the photographer for *The North American Indian,* but the project's ethnologist, writer, publisher, fundraiser, and salesman. Morgan had said he liked a man who attempts the impossible. He had found that man in Edward Curtis.

Curtis stayed in the East, mounting shows at the Waldorf Astoria and at the Astor Gallery, then traveling with Clara to Pittsburgh, where he lectured at the Carnegie Gallery. He next went to Boston to arrange for John Andrew and Son to engrave the expensive copper plates from his glass negatives, so that high-quality photogravures could be printed: 700 large images and 1,500 small ones at an estimated cost of $53,000. He also arranged for the Cambridge University Press

American titan, J. Pierpont Morgan, was Curtis's major benefactor—though hardly an easy man to please. His private librarian and confidante, the glamorous Belle da Costa Greene (above) became Curtis's principal contact with the Morgan empire.

to typeset and print the text. In Washington, he hired Frederick Webb Hodge at the Smithsonian as editor of the series. Hodge was busy writing *The Handbook of the American Indians of Northern Mexico,* but he agreed to edit Curtis's text at a salary of seven dollars per thousand words.

In February President Roosevelt invited Curtis to photograph the wedding of his daughter Alice to Nicholas Longworth. No other photographers were allowed. Immediately afterward, urgent telegrams arrived from newspapers across the country demanding that Curtis send them his best pictures. According to Curtis, editors of these newspapers were annoyed that they had to pay an unknown Seattle photographer for his images of this national event.

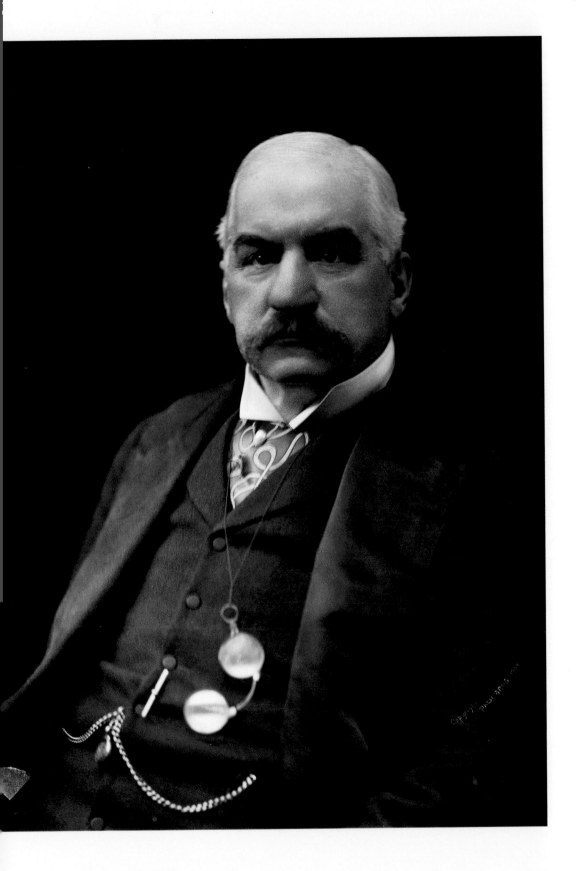

EDWARD S. CURTIS

Curtis returned to Seattle in the early spring to prepare for an ambitious season in the Southwest. Before leaving, he wrote to Hodge that he was "a little upset" by the loss of some of his equipment. He had stored most of his field gear in a San Francisco warehouse for the winter. The great earthquake and fire of April 1906 destroyed thousands of dollars' worth of his cameras and other supplies. Curtis replaced the equipment, then assembled his camp gear and ordered a new, canvas-covered field wagon. He also hired a Seattle newspaper reporter and stenographer named William Myers to act as his field assistant. Myers was to join him and his crew later in the summer.

In May, Curtis set out for Arizona with his son, Harold; his nephew William Phillips; and a Mexican cook named Justo. They rode by rail to Holbrook, Arizona, then set off across the desert to the White Mountain Apache Reservation in their new wagon, a mountain stage pulled by a four-horse team that "rode with the swing of a Pullman coach." From this time onward, Curtis was called the Chief by everyone in the crew.

They camped at a place called Cooley's road station along the way. The busy crossroads camp bustled with characters who came in droves to the Southwest, drawn by their desire to photograph, study, convert, teach, or subdue Indians. "Cowboys with high boots and Mexican spurs were everywhere about, and there beneath that hospitable roof…were the coming and going throng of army officers and soldiers, missionaries and priests, teachers, carpenters, cowboys and Indians, Mexicans and Mormons, Jew and Gentile, bear hunter and ethnologist…." Harold remembered. "With our supper over, the men gathered about the small camp-fire to talk of Indians of many lands, and the possibility of securing such information from the Apaches as was needed. It was old ground to the Chief…but the important lore possessed by them had so far been carefully withheld."

Edward Curtis had worked with the White Mountain Apache the year before and had taken many beautiful photographs. When he had asked about Apache religious beliefs, the Indians declared that they had none. He had tried to buy a sacred buckskin chart depicting their creation myth, but the owner denied that such a thing existed. When Curtis offered a large sum of money to photograph the chart, the old Apache refused, because he would be killed by the other medicine men if he complied, and, if he were dead, what good would money be to him?

When Curtis returned to Apache country in 1906, he discovered that a rivalry had formed between two medicine men. He decided to

When Alice Roosevelt married Nicholas Longworth in 1906, Edward Curtis, by then a family friend, was the only photographer invited to cover the White House wedding. Newspapers from across the country sent him urgent telegrams requesting copies of his photographs.

play them off against each other in order to get the information he needed. The owner of the chart had died, and Curtis was able to convince his widow to sell it. He took the chart to Goshone, the head medicine man who had refused to talk the previous year. He asked Goshone to prove that he knew the creation story, and that he—not his rival Das Lan—was the true medicine man. After much hesitation and propitiation of the gods, Goshone gave Curtis a detailed account of the Apache creation myth illustrated by the chart.

When Das Lan discovered that Goshone had talked, the whole reservation was in an uproar. Goshone sent word to Curtis not to try to see him again. Curtis had a stormy meeting with Das Lan and later admitted that the "crafty old man" had gotten more information from him than vice versa. "Das Lan…insisted that I had helped him kill his enemy, as that Goshone in talking to me killed himself and even I, a white man, would be destroyed by the angry gods." Goshone's daughter and two of his brothers died that year, and Goshone died the following year. "Considering this, it is not surprising that no further information dealing with the Apache religion has been secured."

IN JULY, THE CHIEF DROVE THE WAGON NORTH TO MEET THE rest of the family at the Gallup, New Mexico, train station. The family planned to spend the summer together on the Navajo Reservation. From Gallup, they drove the wagon north to Chinle, where they met the trader and interpreter Charley Day, then all of them headed down the dry riverbed into Canyon de Chelly. "Gradually the red sandstone walls increased in height until they extended from hundreds to a thousand feet into the turquoise sky. Dripping water through the ages has developed a tapestry of pattern on the walls, changing color with the sun's illumination."

It was a magical journey for the children. They were dazzled by the Navajo, with their fast horses, their silver-and-turquoise jewelry, bright head scarves, velvet blouses, and rippling skirts—so different from the Puget Sound Indians. The sandstone walls towered above them. Cottonwood trees along the wash quaked in the breeze, leaves glittering. Petroglyphs of mythical figures—horses, riders, deer, and bears— painted on the walls spoke to them of ancient Anasazi days.

The weeks in Canyon de Chelly were a summer idyll for Clara and the children, and a season of hard and rewarding work for Curtis and his new assistant, William Myers. With Charley Day, they devised

a system of interviewing elders and recording Indian legends and songs. Charley translated Curtis's questions, and Myers wrote everything down in shorthand. Myers's astonishing skill at phonetics was invaluable. "An old informant would pronounce a seven syllable word and Myers would repeat it without a second's hesitation, which to the old Indian was magic—and so it was to me. We might spend the early part of the night listening to the Indian dance songs, and as we walked back to the camp Myers would sing them." After dinner Curtis and Charley Day sat up talking with Navajo visitors, and Myers typed up the day's field notes.

One evening, they noticed that a strange quiet had fallen. The Navajos had disappeared from the camp. Eerie sounds of chanting punctuated the silence. Charley discovered that a woman was having a difficult time giving birth in a nearby hogan, and that the medicine man blamed her complications on the presence of white men in the canyon. In the middle of the night, Charley rode into camp and told Curtis to leave immediately. Curtis woke the children and began heaving tents and equipment into the wagon. "I herded the family aboard in the greatest haste. The horses, quickened with the whip, struggled to hurry through the sands of the canyon. Charley had explained: 'Pray the baby will live for there is no power on earth that will save you and your family if it should die.'... I knew I was completely helpless to save my family. Their lives hung on the birth of a child and the whim of medicine men."

Contemporary Navajo do not believe that the Curtis family was in danger. A medicine man would never threaten the lives of anyone, especially during the birth of a child, when no negative thoughts are allowed. Charley Day knew that the presence of white people was upsetting the medicine man. Perhaps he made the situation sound life-threatening so that the family would leave quickly. In any case, Curtis was frightened. "Fortunately the baby lived or the story would never had been told." He vowed that he would never again take the whole family into Indian country.

Curtis sent Clara and the children home, and he and William Myers drove the wagon a hundred miles west to the Hopi Reservation. They found the villages at Third Mesa in an uproar. The demands of missionaries and government agents had created warring factions among the Hopi in the village of Oraibi. Antagonism between so-called progressive Hopi, who had agreed to allow their children to attend the missionary schools, and traditionalists, who refused to let their children

EDWARD S. CURTIS

go, had risen to a dangerous pitch. Violence had broken out, arrests had been made, and as the time of the Snake Dance approached, tensions came to a head.

Curtis apparently filmed the Oraibi Snake Dance in 1906. A few days after that, the opposing leaders of the village drew a line in the sand and held a shoving match to determine which families would have to leave. The so-called "hostiles" were pushed over the line, and half the families of Oraibi left their centuries-old homes to spend a desperate winter nine miles away at the site of the current village of Hotevilla.

Curtis had already moved his camp to Second Mesa, where the snake priests in Shipaulovi were preparing for their ceremony. He had visited the Shipaulovi Snake Chief Sikyaletstiwa every year since 1900, repeating his request to be initiated into the religious society. The old priest must have liked Curtis and believed in his sincerity. In August 1906, he adopted Curtis, giving him a Hopi name and a clan affiliation that would make initiation possible. Sitting across from him in the underground kiva, Sikyaletstiwa said, "If you will call me father, I will call you my son."

Sixteen days before the Snake Dance, Curtis began his initiation. "I entered the kiva with the Chief Priest and followed his orders and directions in every detail. I slept beside him. I fasted through the nine days [remaining]…." On the tenth day, the hunt began. Curtis and the snake priests stripped and smeared their bodies with red paint, then hiked down from the mesa to search for snakes in the desert. Curtis was the first to see a rattlesnake. "The one who discovers it must first tame it with his eagle feather whip till it straightens out and tries to escape…. I quickly seized it by the neck…they indicated I must wrap it about my neck before it was placed in my bag." Curtis wrote that the rituals in the kiva had enabled him to sublimate himself to the Hopi beliefs, so that the handling of the snakes and the feel of them on his neck "presented no difficulty."

For the next four days, the group hunted snakes from the four cardinal directions. At sunset each day they returned to the kiva to wash the snakes. They spread sand on the floor, so that they could trace the movement of any escaping reptiles. Spending the nights in the kiva, Curtis must have spent some sleepless hours, knowing that the rattlesnakes were writhing just a few feet away from him.

On the day of the Snake Dance, Curtis was painted and dressed in the regalia of a snake priest. He later wrote that he had taken part in every aspect of the ceremony except the public dance in the plaza and

Seven-year-old Florence Curtis reins in a burro Curtis bought for the children during their summer in Canyon de Chelly. "Like most burros he was an unpredictable creature, only moving when he desired and very often his desires did not coincide with the children….his raucous hee-haw…re-echoes through the canyon," Curtis wrote.

that the only reason that he did not dance was that he feared newspaper publicity and missionary criticism.

Curtis had accomplished his dream of experiencing this sacred and mysterious religious ceremony from the inside. He had learned secrets that only Hopi snake priests were allowed to know. In a footnote to his thorough, vivid description of the Snake Dance in Volume XII, published in 1922, he wrote that he would not have revealed some of this information while the priest who gave it to him was alive, for fear of putting him in danger of reprisals. Most of the unposed, documentary-style photographs Curtis took of the snake hunt remain unpublished.

IN LATE SEPTEMBER 1906 CURTIS WENT HOME FOR A BRIEF TIME TO work with Muhr on finalizing prints for the first volume. Within a month, he and Myers were back with the Hopi, camping below First Mesa. He set up his photographic tent, which had a flap that could be opened to let in light, and took many portraits there. He also made unposed photographs in the villages: little girls in calico dresses eating watermelon, women in doorways laughing and joking with their clan members. These show a new, welcoming ease among the villagers toward Curtis. They also indicate a change in him, a new way of seeing Native Americans not just as subjects of formal portraits or examples of traditional life but as people with families, home lives, humor, and kindness.

In October Curtis and his crew loaded their wagon, said goodbye to their Hopi friends, and headed west to the Grand Canyon to photograph Havasupai people on the canyon floor. They packed their equipment on mules and headed down the steep, rocky trail. Suddenly, the mule carrying Curtis's only camera slipped, and the camera tumbled down the canyon, exploding into fragments. "Twelve hours steady, patient work and it was patched up so it could be used. But such a sight…. On the outside it was a bunch of ropes bound and twisted in every direction to hold it together." When Curtis returned from the season, Muhr was astonished to see the camera covered with rope but still working.

In a lecture to a Seattle photography club the following year, Curtis elaborated on the difficult logistics of the fieldwork: "Our camp equipment weighing from a thousand pounds to a ton, depending upon distance from a source of supplies; in photographic and other equip-

ment there were 6½ x 8½ cameras, a motion-picture machine, phono-graph for recording songs, a typewriter, a trunk of reference books… correspondence in connection with the work, its publication and the lectures all from the field. Tents, bedding, our foods, saddles, cooking outfit, four to eight horses—such was the outfit…at times the handling of the material side of the work almost causes one to lose sight of art and literature.

"And then come the elements. The rain pours down. What was an arid desert when you made your camp is soon a lake…. And then comes the sand storm. No horse can travel against it…. It may be two hours or it may be ten, and when it is passed your equipment is in sorry shape…. Cameras, plate box, plate holders, motion machines, food— everything is sifted full of this fine, powdery sand. Hail storms and wind beat down on you and whip your tent into tatters. At another time it may be the heat, so intense that a furnace seems cool in comparison— And on the other hand, it may be snow storms and cold that will cause you to forget that you ever were warm."

When snow drove Curtis and his crew from the field, they settled down for three months in rented rooms to write the first two volumes of *The North American Indian*. They worked from eight in the morning to one o'clock at night, seven days a week, eating and sleeping in their rooms, and Curtis allowed no interruptions. He was determined to finish the text for Volumes I and II, as well as setting the style and categories that would be used in all the later volumes.

In January 1907 Curtis went home to Seattle to finalize the prints for the first two volumes. The next month, William Phillips took the manuscripts to Boston, and Curtis went to New York to establish head-quarters for the North American Indian Corporation at the Belmont Hotel. It must have been a triumphant moment when he presented the master prints to Morgan's librarian, the young and beautiful Belle da Costa Greene.

Curtis's triumphs were always short-lived. He was deeply in debt to the engravers, to the press, to his editor, and to most of his crew. In New York, he tried desperately to sell subscriptions. A financial panic had hit Wall Street, and Curtis's potential patrons, wealthy members of the eastern elite, were in no mood to commit the huge sum of $3,000 for a set of books that did not exist yet. In addition, Curtis's champion, President Roosevelt, had alienated tycoons like Harriman with his antitrust laws; other wealthy men felt that Morgan's contribution should cover the whole cost of the work. In May, Curtis wrote to his friend

Charles Lummis, "Confidentially, the fact that the stock market has gone to the bow-wows is making my work a bit difficult.... I have but three weeks more here in the East, and then I shall start for camp, and no word can tell you how I look forward to getting out in the open."

Curtis had probably met Lummis on one of his trips to the Hopi Reservation. The eccentric Harvard graduate, a former classmate and a friend of Teddy Roosevelt, had walked across the country in 1880, visiting the Hopi villages and the pueblos along the Rio Grande. He often lectured on Indian subjects at the National Geographic Society and other distinguished organizations, wearing moccasins and a loud green corduroy suit belted with a Pueblo Indian sash. As the head librarian in Los Angeles County, he had written to Curtis suggesting ways to market the books to libraries. Curtis replied, "You have the happy faculty of saying just the right thing at the right time. Your letter is bully.... Nothing could be better to hit the library people with than this."

Just as he was leaving for fieldwork in Montana, Curtis received an alarming letter from President Roosevelt. Franz Boas of Columbia University had raised questions about the accuracy of Curtis's work. Boas had recently established the field of anthropology as an academic discipline. He saw Curtis as an uneducated upstart Westerner with pretensions beyond his abilities, who did not deserve the support he had received from Roosevelt and Morgan. Boas's challenge was a potential embarrassment to the President and a threat to Curtis's entire project.

According to Curtis, Roosevelt appointed a committee to examine his methods. The committee members were impressive: Henry Fairfield Osborne, curator at the American Museum of Natural History in New York; William Henry Holmes, chief of the Smithsonian's Bureau of American Ethnology; and Charles Walcott, the secretary of the Smithsonian Institution. Curtis boldly presented his field notes and wax-cylinder recordings. He explained his methods of collecting and organizing data in the field and of reconstructing precontact cultures in text and photographs, using the same methods Boas had used in his work with the Kwakiutl. According to Curtis's later memoir, the committee

Curtis took this cyanotype of Piegan chief Red Plume as a test print, using the sunlight to develop it—a technique he often used in the field. He also scribbled field notes around glass-plate negative holders, like the one (opposite) showing a Piegan play tepee.

members were impressed by the presentation, and Osborne later wrote a letter approving Curtis's methods. The crisis had passed.

In July Curtis finally headed west to meet his crew at the Pine Ridge Reservation in South Dakota. Myers, Phillips, and Justo the cook had already set up camp, and Harold and Clara had arrived for the summer. Curtis's friend Edmond Meany, an expert on Plains Indian history, also came to help with the fieldwork. The last and most important person to join them was Alexander B. Upshaw, a Crow (also called Apsaroke) Indian who had graduated from the Carlisle School in Pennsylvania. Harold remembered him as "a pure blooded, educated Indian, a thinker, and leader…in addition to his education training at Carlisle, [he] had done post graduate work at a theological institution. His work was to keep in touch with the Indians, to assist in bringing out their thoughts, as well as to give aid in collecting material. The characteristic pride of race oozed from every pore, and each argument proved his great pride in the Indians as people."

Curtis, Harold, Upshaw, and Meany rode 20 miles north from the Pine Ridge Reservation to Wounded Knee, leaving Clara and William Myers in camp. Along the way, rattlesnakes slithered through the prairie grass, spooking the horses. Despondent cattle gazed at the riders, their bovine heads swollen from snakebite. Just before Wounded Knee, the crew came to a fast, deep river. They converted the wagon into a boat towed by the swimming horses. Harold rode the lead horse, and, when they started drifting downstream, he slid from the saddle and splashed water in the horse's face to keep him pointed toward shore. "My efforts weren't too successful, nor exactly to the horse's liking."

They arrived at Wounded Knee to discover that a "scalp tipi" had been erected by the Sioux for discussions of the work ahead. Red Hawk was glad to see his friend whom he called "Pazola Washte," or "Pretty Butte." Curtis had promised to give Red Hawk a feast for the 20 Sioux who had ridden with him across the Badlands two years earlier, in exchange for reenacting battle scenes. Instead of 20, he found several hundred Indians waiting for him. Among them were two important

An educated Crow who had returned home to advocate for his people, Alexander B. Upshaw served as Curtis's interpreter and guide during two field seasons with the Plains tribes.

chiefs, Slow Bull and Iron Crow, who pointed out that Curtis had not brought enough beef for everyone. It was a tense situation. Rations promised to the Indians by the government had not arrived, and the Sioux were hungry. Twelve-year-old Harold rode off that night to round up another steer, and the next day Red Hawk and his men staged battle scenes for Curtis's camera.

Many of these men had fought Custer in the Battle of the Little Bighorn, and most were survivors of the 1890 massacre at Wounded Knee. They had been reduced to depending on the government agent for their meager rations and were no longer allowed to wear war clothing or paint. Putting on their regalia for these reenactments must have stirred memories of the real battles they had fought not so very long ago. They sometimes got carried away: "We would be driving our four horse outfit along an old wagon road and far off in the distance we observed a small figure [an Indian scout] on horseback...a band of Indians came sweeping down on us at full gallop with bloodcurdling yells. When they were within shooting distance the big fellows slipped to the side of their horses, firing from the side or from under the horses belly or between his front legs.... They continued galloping in circles around us and of course our team went wild and usually broke their harness. It was mighty realistic even if they were only shooting blanks, and needless to say it was enjoyed by the Sioux more than ourselves."

From Wounded Knee, Curtis, Harold, Upshaw, and Red Hawk rode several hundred miles to the Little Bighorn Battlefield on the Crow Reservation in southeastern Montana, a two-week journey. Curtis wanted to learn about Custer's last stand from the Indian people who had participated on both sides of the battle. He first rode over the battlefield with Red Hawk and other Sioux and Cheyenne warriors who had defeated Custer there, recording their descriptions of troop movements, Sioux strategy, and the final battle.

Then he hired three Crow scouts—Goes Ahead, Hairy Moccasin, and White Man Runs Him—to ride with him over the battlefield and describe what they had seen. Many Crow, traditional enemies of the Sioux, had served as scouts for Custer. These three told Curtis that they had warned Custer of the danger he was in, but that the general had not listened to them and had sent them away just before the massacre.

In a newspaper interview published in the *New York Herald*, Curtis is reported to have said, "Such an investigation as I made can bring the inquirer to only one conclusion—that General Custer unnecessarily sacrificed the lives of his soldiers to further his personal ends. I know

it is unpopular to criticize a military commander.... There is absolutely no question that Custer could have won this fight with little loss of life. When the wise old Indian warriors that were in this fight are asked what they think of Custer's course in the battle, they point to their heads and say, 'He must have been wrong up here.'... They can explain his actions in no other way." The article annoyed many of Curtis's East Coast supporters and enraged Custer's widow, who wrote an angry letter to Gifford Pinchot. Even Edmond Meany chastised Curtis for his lack of tact.

Curtis and the crew stayed on with the Crow, making many photographs and recording information from elders. This was Upshaw's home, and he introduced Curtis to many Crow families and to men who had achieved the status of chief in the days before 1876, when they were still able to do battle with their enemies. Curtis wrote that the Crow men "were the finest specimens of the buffalo hunting Indians and the women were equally noteworthy; ideal mates for powerful, warrior men. Decidedly they were not the clinging vine type. The average woman could fell a horse with a blow of her fist, and while they were noticeably affectionate with husbands and children, taking great pride in dressing and caring for their mates, yet it behooved the husband to avoid arousing their anger."

Curtis made striking portraits of Crow men in their war shirts, and the information Upshaw helped him to record, which appeared in Volume IV, is considered among the best ethnological data of the tribe made at that time. Curtis remained involved with the Crow people and later corresponded at length with Woodrow Wilson's secretary of the interior about how to encourage them to become successful farmers. He believed that this was their only hope of survival.

On the two-week ride back to Pine Ridge, Harold came down with a fever. "I tried not to say anything for I didn't want to bother the Chief, for he had problems enough it seemed to me. Finally I became so woosy I couldn't sit in the saddle and was put to bed. Mother said immediately that I had typhoid; she could tell by the smell. She had nursed the Chief with it some years before.... No doubt it was lucky for me that mother was along, and seemed to know quite a bit about nursing a case of typhoid."

Harold lay unconscious for weeks on a rubber mattress in a tent under cottonwood trees. The doctor on the nearby reservation did not have any special medicine for typhoid. In order to fill his prescriptions, Curtis had to send someone 20 miles to the railroad tracks to flag down an eastbound train, give the prescription to the conductor to fill

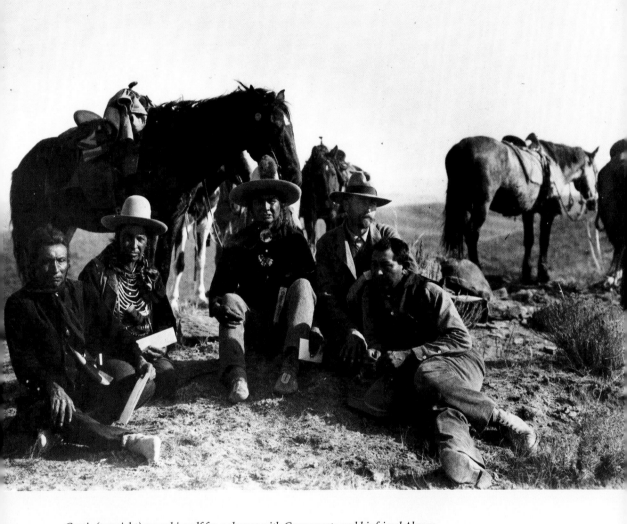

Curtis (top right) poses himself for a change with Crow scouts and his friend Alexander Upshaw (far right). The three men to Curtis's left—Goes Ahead, Hairy Moccasin, and White Man Runs Him—had served as scouts for Custer against their traditional Sioux enemies at the Battle of the Little Bighorn.

in Chicago, and hope that the conductor would bring it back on his next trip west.

Curtis had planned to head north to work with the Sioux in the Dakotas, as well as the Mandan, Arikira, Hidatsa, and Atsina (Gros Ventre) people. "Needless to say plans were changed and all thoughts and efforts were given to the boy's care." Curtis sent the crew ahead without him and stayed with Clara and Harold.

The strains of his son's illness and chronic financial worries took their toll on Curtis. His expenses had reached $4,500 per month, including the publishing costs in Boston, Hodge in Washington, and the field expenses. In addition, the time and costs of developing, printing, and retouching the photographs before publication strained the studio's resources. That year, Adolph Muhr hired a young assistant, Imogene Cunningham, to help him keep up with the work.

Various Seattle businessmen had repeatedly turned down Curtis's requests for loans. He wrote to Meany from the field, "Of late I have had little but swats from my home town and feel in a most disagreeable mood. Most of those who say good things about the work would if I owed them two and a half and could not pay on the dot kick my ass and say 'Get to hell out of this.' Yes, I will try to cheer up a bit but when I think of some of the Seattle bunch I go mad. I am an unknown man trying by sheer bulldog tenacity to carry through a thing so large that no one else cared to tackle it…."

To make matters worse, Curtis received eight long letters from his nephew William Phillips, who was in Boston overseeing the publication of the first two volumes. Phillips apparently had accused Curtis of lacking a well-defined plan, said that he would never succeed, and wrote that Hodge was deliberately slowing down delivery of the manuscripts in order to ruin the project. These letters infuriated Curtis. He wrote to Meany, "If you hear anyone say I am not to succeed tell them they don't know me. I am not going to fail and the sooner the whole 'Damn Family' knows it the better." Stunned to learn that the texts of the first two volumes had not reached the printers, Curtis wrote to Hodge explaining that he must make definite statements to the bank, that "to fail in keeping my promise there will mean failure, and I do not care at this stage of the game to have the croakers say I told you so."

Harold's fever finally broke, and he was able to take a little catfish and prairie chicken soup. When he was strong enough, Curtis and Clara put him in the back of their wagon on his rubber mattress, drove to the railroad tracks, and flagged down a train. The conductor opened up two

seats for the mattress. Clara and Harold rode to Chicago, then boarded a westbound train to Seattle, where Harold's sisters were anxiously waiting. Florence remembered that Harold asked her to make applesauce for his return, which she and Beth were "most happy to do. When he arrived home, he was a wraith of his former self. Even his voice was thin."

The Pine Ridge trip was too much for Clara. She had never liked the Indian work, and her two experiences in camp had been disastrous. She never accompanied her husband into the field again. She stopped cooking and caring for her children and spent most of her time working with charitable organizations and women's business clubs in Seattle. Harold, who had learned to cook from Justo, took care of his sisters, Florence and Beth.

Curtis headed north to the Dakotas to join his crew for a season with the Mandan, Arikira, and many bands of Sioux. Meanwhile, his reputation in the East was growing. In *Wilson's Photographic Magazine*, the critic Sadakichi Hartman wrote, "Although it is difficult to tell the whereabouts of E. S. Curtis at this moment, there is no doubt that he is just now the most talked-of person in photographic circles." Anticipation for the first two volumes was also gathering. Hartman continued, "The red savage Indian is fast changing into a mere ordinary, uninteresting copy of the white race. And although opportunities for similar records may continue to exist for some years to come, there will probably be no other Curtis to do it."

IN OCTOBER 1907 CURTIS AND HIS CREW SETTLED DOWN IN A CABIN ON the Crow Reservation near Pryor, Montana, to write Volumes III and IV. They worked 17-hour days, 7 days a week, turning their notes and recordings into text. "Every thought and every moment had to be given to the work."

A few weeks later, Curtis left the crew in Montana and went to New York to finalize the publication of the first two volumes and to raise funds. The financial panic that had begun the previous spring had escalated; companies were folding, wealthy men were being ruined, depositors were withdrawing their money from the banks, and the city of New York was in danger of having to default on its loans. Curtis wrote to Meany, "Things here in New York are strictly Hell and what the future is to be no one seems to want to guess. The book binding, however, is moving along nicely."

Curtis's son, Harold, almost died of typhoid fever in 1907 at this Montana field camp on the Crow Reservation. In the background stands the photographic tent with adjustable flaps to control lighting and a small, dark triangular tent that Curtis used for developing negatives.

To stop the financial panic, J. Pierpont Morgan ordered members of the New York Stock Exchange not to sell short, warning that they would be dealt with later if they did. He also convinced other wealthy men to join him in providing $100 million dollars in interest-free loans to threatened businesses, so they could meet their obligations and stop the run on the banks and stock exchange. His tactics saved the hemorrhaging economy. In a letter to Morgan about choices of paper for the volumes, dated November 5, Curtis wrote: "I hesitate to trouble you with even the briefest letter in hours like these, when you seem to have the burden of the whole land to carry, and let me say what millions know and would like to clasp your hand and say to you: you have saved the country when no one else could."

Curtis stayed in the East trying to sell subscriptions and seeing the publication through. In mid-December, he went back to Montana to check on the crew's progress. Florence, then eight years old, remembered waiting anxiously, hoping her father would make it home for the holidays. He arrived late on Christmas Eve, to her great joy. He had been home only six weeks of the entire year.

In January Curtis visited all of the banks in Seattle, trying to secure loans. After the run on banks in the East, the bankers in his town were unwilling to risk funds on such an uncertain proposition, and they did not trust the promissory notes made by Curtis's wealthy

friends. He finally returned to Montana without having raised the needed cash.

Volumes III and IV were finished in the early spring. "The work on the Sioux volume has gone like a whirlwind, and consequently happiness reigns among us," Curtis wrote to Hodge. There was further cause for celebration. A letter came from Meany announcing that he had convinced ten friends in Seattle to lend Curtis $20,000 in cash.

Curtis returned to New York in April to present the first two volumes to Morgan and the subscribers. With their expensive handmade papers, rich leather bindings, and hundreds of hand-printed photogravure illustrations, the books were stunning. A *New York Times* journalist wrote that Curtis's portraits were better than oil paintings, with "that illusive quality which can be put into them only by an artist who sees beauty as well as material fact."

Rapturous letters poured in from H. C. Bumpus at the Museum of Natural History in New York, Gifford Pinchot, Charles Lummis, F. W. Putnam of the Peabody Museum at Harvard, and William McGee, former head ethnologist at the Bureau of American Ethnology. Curtis's old friend C. Hart Merriam wrote glowingly: "Every American who sees the work will be proud that so handsome a piece of book-making has been produced in America; and every intelligent man will rejoice that ethnology and history have been enriched by such faithful and artistic records of the aboriginal inhabitants of our country."

Commissioner of Indian Affairs Francis Leupp crowed that the first volume "so far exceeds even my exalted expectations for it that I am constrained to offer you my special congratulations on the successful launching of the project. It has been a leading purpose of my administration to try to make his own contemporaries see the Indian not as he has been pictured in romance or preserved in the mummy-wrappings of archaeology, but as he is, in his life, in his mind, in his spirit, in his artistic ideals and sympathies, and in those traditions which afforded his people their only substitute for literature. And that is what you are doing, far more effectively, for posterity as well."

President Theodore Roosevelt wrote the Foreword to Volume I, praising Curtis as an artist and an observer of Indian life. "He has not only seen their vigorous outward existence, but has caught glimpses, such as few white men ever catch, into that strange spiritual and mental life of theirs; from whose innermost recesses all white men are forever barred."

With two of his beautiful volumes to show and a broadside of

ecstatic letters and reviews, Curtis was able to sell a few more subscriptions, most notably to Andrew Carnegie and Cleveland Dodge. In July, he finally paid Hodge for his editing services.

In August Curtis went to the Southwest to make additional photographs, then traveled north to Montana and the Dakotas to work with tribes there. During this time he kept up a lively correspondence with Edmond Meany, who was writing the history of the Sioux for Volume III. Curtis made some additions of his own to Meany's text about the Battle of the Little Bighorn but reassured his old friend: "Don't have a cold chill when I say I brought in my material…. While giving a great deal of new and interesting information, I have said nothing that can be considered criticism of Custer." The account Curtis published in Volume III does not directly blame Custer, but makes clear that if he had waited for reinforcements as he was advised to do, the outcome would have been very different.

CURTIS WAS STILL BURDENED BY FINANCIAL WORRY. IN SEPTEMBER HE wrote to Frederick Hodge from the field, "Seeing you are inclined to be funny about money matters I shall presume that you do not need any for six months, and as to mortgaging the studio, on your account, have no fear of my doing that, for the simple reason that—like everything else I have or expect to have now bears more mortgages than is comfortable to contemplate. If I had an earthly thing that was not mortgaged I should immediately start out to find some one to loan me a few dollars on it right here in Santa Fe."

By November Curtis was back in New York, anxious to raise funds. Subscriptions were still nearly impossible to sell. Academic institutions were suspicious of the glowing reviews, which made the books sound more commercial than scholarly. Potential supporters were inclined to let Morgan finance the entire project, since he was getting the credit. Acquisitions staff at libraries and museums hoped that Morgan would donate one of his 25 sets to them and were unwilling to commit themselves.

Curtis stayed on in the East through the winter of 1908-1909, presenting shows in New York and Washington, D.C., and struggling to make sales. In the spring, he returned to Seattle for the Yukon Pacific Exposition, where his first five volumes were exhibited to great acclaim.

Relations at home had become increasingly strained. Clara had lost interest in domestic life, and any romantic notions she may have

had about Curtis's fame and fortune had worn thin. Harold was sent to New Haven, Connecticut, to live with the Morris family, whom Curtis had met through the Roosevelts. Harold rarely came home after that. He later explained that there was no home to come back to. Curtis moved his permanent address to the Rainier Club in downtown Seattle. His last child, Katherine, was born in July 1909, while Curtis was in the field. She rarely saw her father when she was growing up.

That summer, Curtis went to Montana to join Upshaw and Myers in the field. Upshaw had been an invaluable helper, responsible for unprecedented access to Crow and other Plains cultures. Earlier that year, Curtis had brought him to Washington, D.C., to visit President Roosevelt in the White House, and he later acknowledged the value of Upshaw's contribution in the preface to Volume VII.

Upshaw was a strong advocate for his people, fighting skillfully against government agents to protect the reservation from encroachment by settlers. His actions stirred admiration among the Crow but not among the local whites. In November 1909, Upshaw was murdered in a brawl just outside the reservation. Curtis was devastated. "It is with the keenest regret that I speak of the loss of one of my field helpers, Mr. Upshaw, an educated Crow Indian. He has been an enthusiastic helper and close companion in my field work for a number of years; yet, as greatly as I feel his loss, to his tribe his death will prove an affliction indeed."

Later that month, Curtis traveled to New York, where he outlined his desperate financial situation to Morgan. Morgan must have been pleased with the first five volumes, because he agreed to advance Curtis an additional $60,000. His approval and the infusion of cash buoyed Curtis's spirits and "encouraged me more than anything else heretofore occurring, and I take up my winter's work with the greatest enthusiasm and determination to make the research and publication deserving of Mr. Morgan's confidence and assistance…."

Curtis and Myers, along with a new stenographer and typist named Edmund August Schwinke and a Japanese cook named Noggie, settled down in a cabin on Puget Sound to write Volumes VI, VII, and VIII. Once again, they kept to a grueling schedule, working 20 hours a day for months. "I was seriously worn out towards the end," Curtis reported, "and the last week of the final reading and correcting of manuscript, I could not leave my bed. The day work was finished on these volumes, we broke our permanent camp, and within a week starting the season in the field."

The Portrait Artist

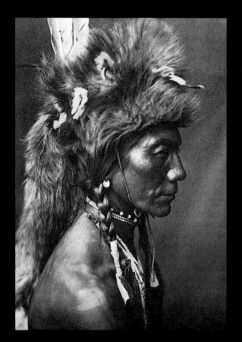

YELLOW KIDNEY—PIEGAN

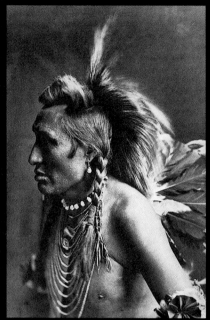

GAMBLER—PIEGAN

QAHATIKA GIRL *(opposite)*

Curtis is best known today for his portraits of famous Native
American chiefs—Geronimo, Joseph, Red Cloud—but his works
of lesser known subjects are also beautifully composed images with
a haunting power previously unknown in photographs of Indian
people. His portrait of the Piegan medicine man Yellow Kidney
(above left) captures both the power and sweetness that the man's
own descendants remembered in him. Curtis must have had an
amazing rapport with these people, since his portraits seem almost
to see into their souls. All three images shown here were probably
taken in his photographic field tent. By adjusting its flaps, he could
control the amount of light that fell on his subjects, allowing him
to sculpt their faces into powerful works of art.

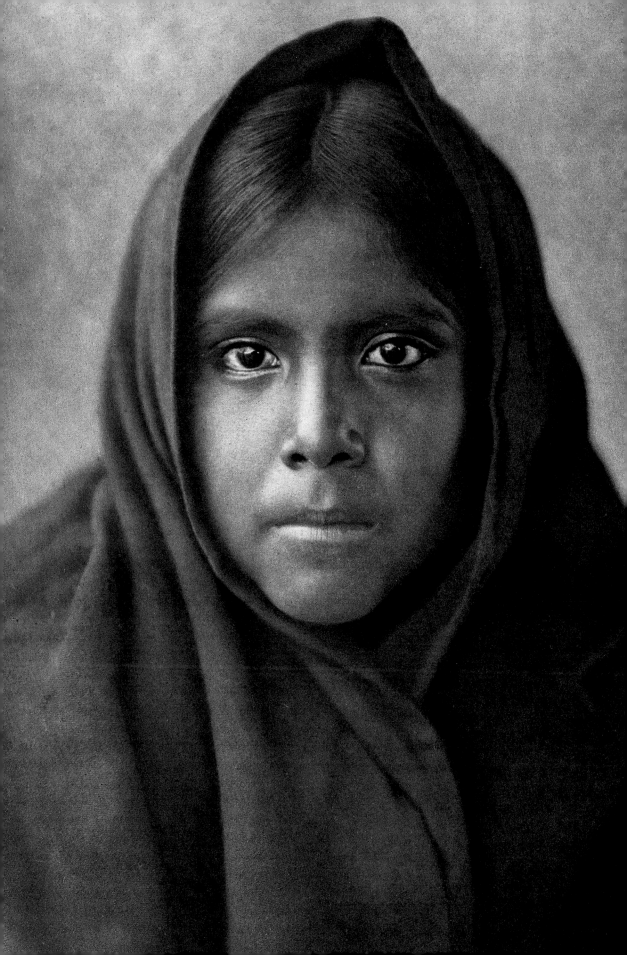

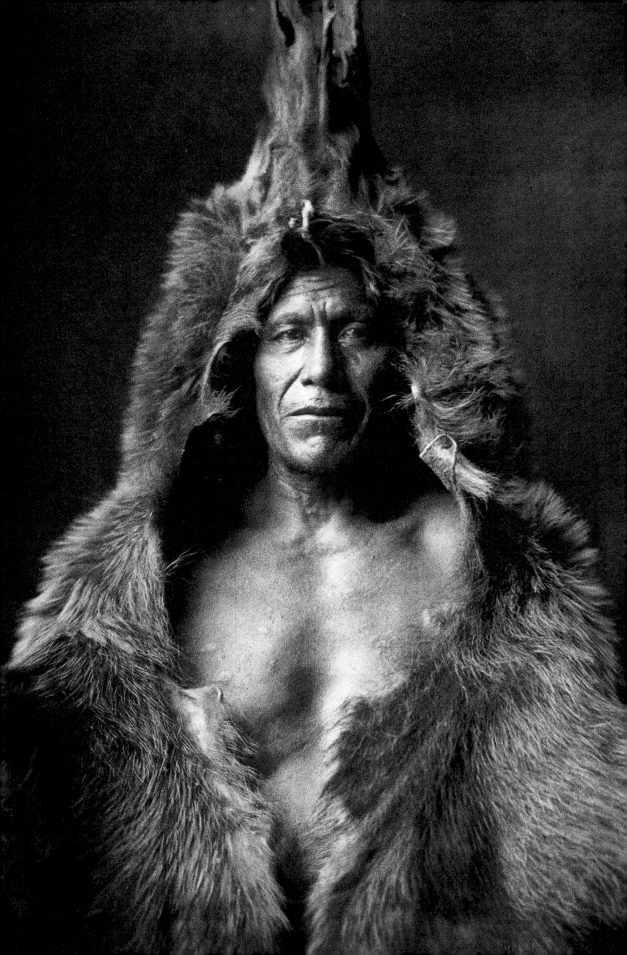

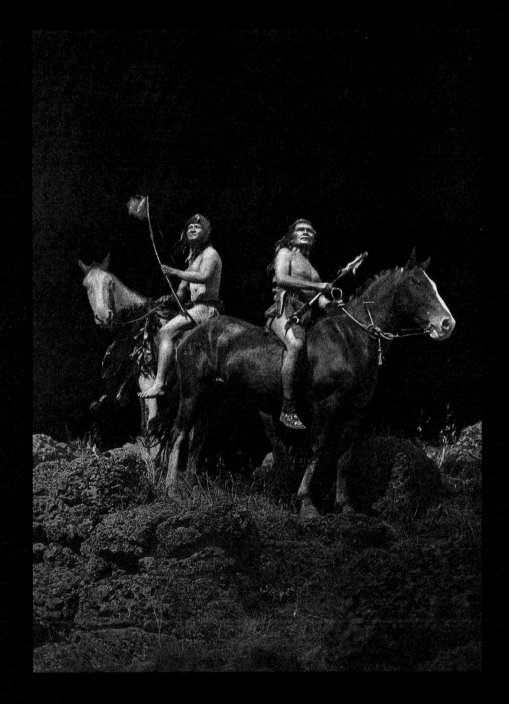

WATCHING FOR THE SIGNAL—NEZ PERCE

BEAR'S BELLY—ARIKARA *(opposite)*

A HOPI MAN

Sikyaletstiwa, the snake chief, adopted Curtis and initiated him into the snake rituals. Curtis often experimented with his photographs, painting over them, hand-tinting them, or drawing on them with chalk, in hopes of selling more images to help pay for his fieldwork.

One of Curtis's most
haunting images, the
portrait of a Hopi
named Warze (right)
from Walpi village
captures the anguish
of a man whose way
of life was under siege.
At the time this pic-
ture was taken, his
children had been sent
away to boarding
school, and his village
was suffering trau-
matic transitions.

THE MEDICINE MAN—SIOUX

A WALPI MAN (opposite)

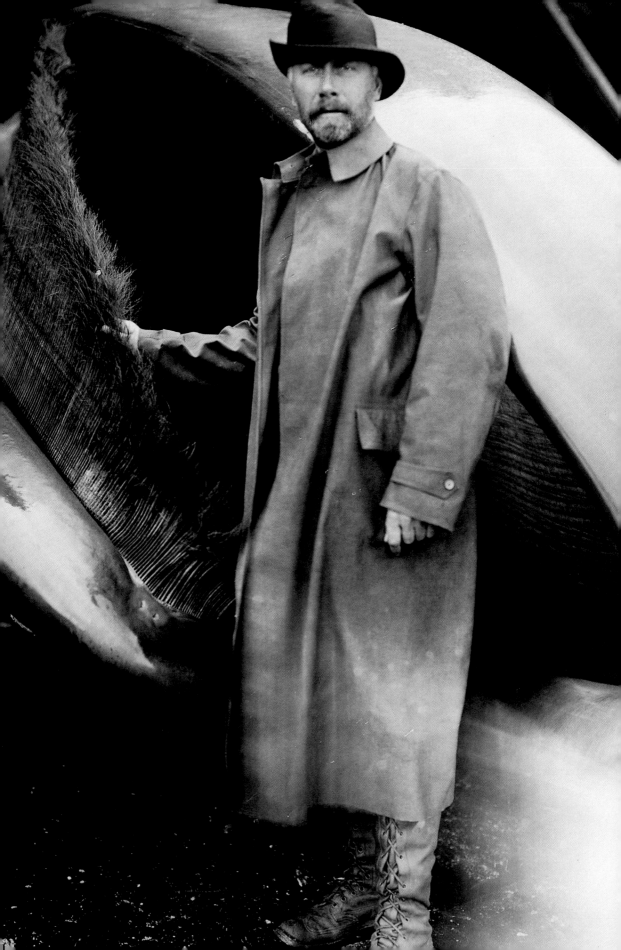

1910 TO 1916

In the Land of the Headhunters

"I have not yet quite brought myself to think the undertaking must be given up, and I will fight on until some anxious creditor asks for a receiver."

—EDWARD CURTIS

IN THE EARLY SPRING OF 1910, CURTIS AND HIS CREW GATHERED ALONG THE UPPER REACHES of the Columbia River in eastern Washington for a new adventure. Traveling by boat, they planned to follow the route of Lewis and Clark from the Cascade Range to the Pacific, visiting various tribes along the way. They built a small, flat-bottom boat and attached a gas engine with barely enough power to hold the course downstream. With Noggie the cook and an old river captain on his last run, they pushed out into the current.

As they floated downriver, they saw many Chinook villages standing empty. The Chinook had been strong and numerous when Lewis and Clark had passed by in 1803, but Curtis found them nearly extinct. "Small pox, measles, and cholera had ravaged them; whiskey too had done its part," he wrote in a later memoir. He had to collect information about the Chinook from their neighbors, the Wisham. Curtis photographed and interviewed elders, while Myers scribbled notes in shorthand and Schwinke operated the Edison recording machine. As they cruised downstream to the next village, Schwinke propped his typewriter on packing crates and typed up the day's notes from Myers's dictation.

At Celilo Falls, the Columbia River tumbles down an 80-foot gorge in its rush out of the Cascades. With great difficulty, Curtis and the crew loaded their boat on a railroad flat-

Curtis poses beside a dead whale during his adventures in the Pacific Northwest.

car and portaged around the falls. Churning rapids surged on for several miles below, swollen with spring runoff. As Curtis gazed at the raging current, locals warned him that he'd never make it in his makeshift tub. Undaunted, he started the engine and headed into the boiling flood with Noggie, Myers, and Schwinke holding on for dear life, and the captain yelling, "Ride 'em high, keep her on the ridges, don't let the whirlpools get us!" They plunged into the breakers, the little boat bucking "like a cayuse in a Pendleton round-up. She stood on her hind legs—she pitched head first into a yawning pit—She shot sidewise with a lurch which almost threw me overboard…. As we sped by, a tree was caught in its swirl, stood half on end and went from sight."

This was too much for Noggie, who wailed and sobbed through the wild ride and immediately quit when they reached shore. The captain went off to visit old friends in Portland and died there. Curtis took over the navigation and cooking, and they continued on down the wide river, stopping to photograph people from many tribes who lived along the banks. When they reached the Pacific, Curtis held an "oyster gorge" with a bushel of oysters for each of the crew. "By the time you have a dozen on the coals, the first one will be ready; swallow it whole with its accompanying liquor. Each time you take one from the fire, replace it with another; now, continue on to repletion…when you can eat no more, curl up in your blankets and sleep."

In June, Curtis bought a 40-foot sailboat called the *Elsie Allen* from a Skokomish fisherman and sailed north with the crew through the Strait of Juan de Fuca and along the eastern shore of Vancouver Island. He was eager to visit the Kwakwala-speaking people, then called Kwakiutl, on the northern tip of the island. Franz Boas's writings about Kwakiutl masks, dances, and ceremonies had captivated Curtis. He was also fascinated by accounts of head-hunting raids that had taken place just a few decades before, and of rituals still held in secret by members of the Hamatsa Society, who were said to eat human flesh.

At Fort Rupert, Curtis and his crew found George Hunt waiting for them. The son of a Scottish trader and a Tlingit woman, Hunt had been Boas's friend and principal informant for two decades. He had been raised among the Kwakiutl, had married into an important Kwakiutl family, spoke Kwakwala fluently, and had taught himself to read and write English. A few years before Curtis arrived, Hunt had been arrested for taking part in an illegal cannibalism ceremony. He successfully defended himself in court by saying he was doing anthropological research and showed his own monograph to prove it.

Hunt would become a crucial contact for Curtis in all of his work on Vancouver Island. With his help, Curtis was able to witness outlawed ceremonies held in secret on remote islands. The array of dancers in vividly carved masks and embroidered, feathered costumes, impersonating Eagle, Wolf, Grizzly Bear, Wasp, Mountain Goat, Thunderbird, and Killer Whale, thrilled Curtis. He described Kwakiutl life as "a veritable pageant…nowhere else in North America have the natives developed so far towards a distinctive drama." He was intrigued by the potlatch ceremony, in which masked dancers reenacted dramatic stories, and vast quantities of valuable goods were given away or destroyed. The British government viewed the potlatch as heathen, wasteful, and an impediment to progress. Curtis came to understand it as the Kwakiutl's highly effective way of distributing wealth as well as keeping track of births,

deaths, loans, and a complicated hierarchical system of social status and wealth. "No individual can starve or be in serious want so long as there is any property in possession of the tribe. The feeling is one of pride rather than greed. A man can never receive as much as he disburses...." By the end of his first season with the Kwakiutl, Curtis felt he had touched only the surface of their rich and complex culture. During the next few years he would return again and again.

THE FIELD SEASON OF 1910 HAD BEEN AN "ACTIVE, AQUATIC YEAR" FOR Curtis, but the hard work had left him exhausted. Back in Seattle, he collapsed in his room at the Rainier Club. For ten days he could not leave his bed. Money worries contributed to his exhaustion. Most of Morgan's additional funds had gone to pay off debts, and the costs of making the copper plates and handmade papers for the volumes had risen at an alarming rate. Curtis went east to raise funds but had little success. "I carried my disheartening effort to secure orders well into the summer; then had to give up all thought of an active field season." One night Curtis walked out onto New York streets in a deep fog of depression. "It was very late and there were few people on the street. Then suddenly there came on the air a whistling such as I had never heard before. It was beautiful, with trills and lovely notes such as I thought only birds could make. I could hardly believe my ears. Around the corner came the musician, a cripple strapped to a skateboard. I was deeply moved. If that man could put his soul in music such as I had just heard, surely there was an answer for me. I would not give up."

To raise money for *The North American Indian,* Curtis created an elaborate entertainment that he called a "picture musicale." He wrote a detailed scenario, edited his hand-colored lantern slides and motion pictures according to his script, and hired Henry F. Gilbert to write a score based on the Indian music the composer had transcribed from wax cylinders for the volumes. Curtis's instructions to Gilbert give a lively sense of the picture musicale: "Quickly following the beginning of the music a sunrise scene will be thrown on the screen (slowly).... Then the Vanishing Race, leaving it on the screen fully half a minute.... Then we start with the South, using an entirely new picture, perhaps of the palms, then the Indians of the Colorado, again those of the southern desert, now the Pueblo life.... The closing scene will be of the Arctic—a sunset over icebergs. In the music we want to carry the mood of the whole, well knit together, yet suggesting the local material...."

The logistics of renting halls and transporting musicians, instruments, and equipment were formidable. Curtis complained that he had passed through 17 kinds of hell in getting the project under way, but by the fall of 1911 he had scheduled performances in cities throughout the Northeast. In September, he sent tickets to Belle Greene at the Morgan Library for a sold-out performance at Carnegie Hall and outlined his schedule: "On Monday I will lecture at Concord, NH, Tuesday at Manchester, Thursday at Northampton, on the tenth at Providence, thirteenth at Springfield, fourteenth at New Haven, and on the fifteenth at New York."

The Carnegie Hall performance was a triumph. While Curtis lectured, Gilbert conducted the orchestra with one hand and signaled the projectionist with the other. Hand-colored slides of Indian people from all over the West glowed from the screen. The audience was transported. Afterward, Curtis wrote to Meany, "I think we can say that my lecture entertainment 'arrived.' The tremendous auditorium was filled to overflowing, a sea of people from the stage to the very sky itself." A reporter from the *New York Evening World* wrote that the audience "found itself lifted out of the prosaic into the wild, romantic life of the redman."

The musicales were not always flawless. One night in Worcester, Massachusetts, the house manager set up the projector at a steep incline so that the slides were out of focus. In the middle of the lecture, a man on stage behind Curtis began to explain that "someone in the orchestra was dead and wanted to go to Boston. This was finally straightened out, and we found it was the father of one of the orchestra men who was dead, and the musician wanted to go to Boston. All this time I was trying to talk to the audience, and it did not tend to help my part of it."

Curtis must have rehearsed a bit more before he took the production to Washington, D.C. The audience at the Belasco Theater included President William Taft, Alexander Graham Bell, the Speaker of the House, the ambassadors from Britain and France, as well as many judges, senators, congressmen, secretaries, commissioners, and other officials. The evening was a great success, "a pictorial and musical gem...full of the mystic spell of romance," according to the *Washington Times.* The *Washington Herald* reported that the performance "unfolded the romance of the Indian in the happy fusion of two mediums which normally are alien to each other [picture and music!], but which, under the...spell of a rare interpretative artist, blended with eloquent effect."

Despite enthusiastic reviews and large audiences, production costs exceeded ticket sales, and by the end of the season Curtis had fallen fur-

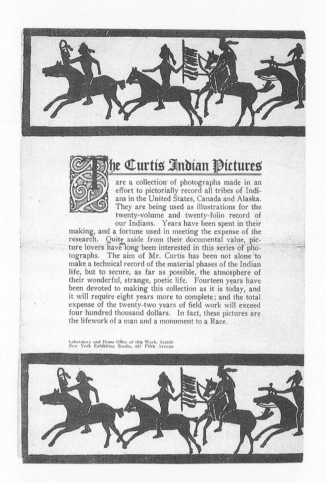

An advertisement for Curtis's Indian pictures looks much like the handbills he later distributed to advertise his Indian Picture Musicale, or picture opera, a huge production that toured up and down the East Coast in 1911. A surviving hand-colored lantern slide (opposite) from the musicale shows a Hopi village.

ther into debt. He decided to create a film production company, confident that motion pictures would be a surefire way to keep *The North American Indian* afloat. Movies were at a peak of popularity in 1911, and films about Indian subjects were especially in demand. In his prospectus for the Continental Film Company, Curtis proposed making a series of pictures covering every aspect of every tribe in the West. He predicted that each full-length picture would earn $100,000 in profits during its first year, with many more dividends to come. In a letter to Dr. Charles D. Walcott, secretary of the Smithsonian, he suggested that the first film should be about the Kwakiutl. "Theirs was a populous region, the people proud, vigorous, crafty, cruel, constantly engaged in warfare, and depending mainly on the sea for food…. Their ceremonial masks are in decoration and variety scarcely surpassed…. Pictures should be made to illustrate the period before the white man came."

It would be another two years before Curtis could begin production on his Kwakiutl film. During the field seasons of 1912 and 1913, he

and William Myers worked with George Hunt and the people at Fort Rupert, Alert Bay, and Kingcome Inlet, taking still photographs and recording information for Volume X of *The North American Indian*. In preparation for filming, he learned as much as he could about Kwakiutl traditions and beliefs. He convinced Hunt to help him become initiated as a Hamatsa, a personification of a powerful supernatural being who becomes enraged during ceremonies and appears to eat human flesh. As a prerequisite for initiation, Curtis had to collect human skulls and mummies. This entailed sailing to a burial island, pulling grave boxes from trees, detaching skulls from skeletons, and bringing them back to the village. Myers was not enthusiastic about this project. He had been through a lot with Curtis but declared, "When it comes to prowling for skulls and mummies, I draw the line."

Curtis eventually collected the bones and claimed to have been initiated as a Hamatsa. "Whether I joined in the eating of the mummy or not I decline to answer…. Mummy eating was by the British Gov-

ernment classified as cannibalism, and if one is convicted of the crime, he is due for a long time behind bars."

CURTIS AND HIS CREW SAILED HOME AT THE END OF THE SEASON, WITH the bones apparently on board. Shortly after his return, a *Seattle Times* reporter interviewing Curtis was surprised to discover a box of skulls and mummified limbs in his studio. Curtis had probably brought them home to make sure they would be available when it came time to shoot the Hamatsa scene in his film. He had no intention of revisiting the Island of the Dead for more skulls and bones.

That same month, he brought his picture musicale home for a sold-out performance at Seattle's Metropolitan Opera House. It must have given him great pleasure to show the breadth of his work to his hometown supporters in such grand style. The following month his mother, Ellen Sheriff Curtis, died at the home of her son Asahel. Eva had moved to Asahel's house and worked for him as a retoucher in the Curtis-Miller Photography Studio. Edward and Asahel probably saw each other at their mother's funeral, but they remained estranged.

Early in 1913, Curtis delivered an annual report to the directors of the North American Indian Corporation. He summarized his arduous work schedule from 1906 to the present and explained the difficulties in making sales, pointing out that early encouragement had been deceptive. "Frankly, being young then, I did not properly discount the enthusiastic commendation and gush; and further, the earlier orders were taken preceding the great financial crash of 1907. The difficulty of making sales since then has been many times harder than before, and it is safe to presume that had the publication matter not been started previous to the changed financial conditions of the country, it would not have been considered a possible publication enterprise." He projected that the fieldwork would take a total of 20 years, with an average cost of $20,000 per year, and that the publication costs would continue to rise.

A month after delivering the annual report, Curtis wrote a desperate letter to Belle Greene, saying that he would be unable to raise funds for the next field season. "I have not yet quite brought myself to think the undertaking must be given up, and I will fight on until some anxious creditor asks for a receiver.... I so deeply appreciate Mr. Morgan's assistance that the desire to succeed for his sake is the uppermost thought of my life, and I assure you I have made about every sac-

Curtis relied on income from subscriptions to support the publishing costs of The North American Indian, *and his subscription forms gave a clear idea of the quality of the volumes. The king of England and business barons Andrew Carnegie and Henry Vanderbilt were among the subscribers. Curtis had hoped to sell 500 sets but did not reach even half his goal.*

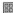

George F. Baker Cyrus H. M^c Cormick Elbert H. Gary
Robert W. de Forest Charles H. Sabin John J. Mitchell
Harry Payne Whitney William Endicott William H. Crocker
agreeing with the statement of

THEODORE ROOSEVELT

that it would be a veritable calamity if a vivid and truthful
record of the life of

THE NORTH AMERICAN INDIAN

were not kept, and that the publication of such a record is not
only a service to our own people but to the world of scholarship
everywhere, extend this invitation to

Mrs Mary K. Rindge

to become associated in the presentation on behalf of the
scholarship of America to fifty of the leading universities,
libraries and scientific institutions of Europe and America of
such a record, the publication of which has been made possible

rifice a human being can for the sake of the work, and the work is worth it." Ten days later, J. Pierpont Morgan suddenly died in Egypt. Curtis wrote a more reassuring letter to Belle Greene and asked her to put in a good word for him with Jack Morgan.

Although Curtis hadn't succeeded in selling enough subscriptions to the volumes, he must have convinced a few investors to back the Continental Film Company. In the late summer of 1912, he and Schwinke sailed to Alert Bay to join Myers and began preproduction for an ambitious film. Curtis's goal was to reconstruct Kwakiutl life for his motion picture camera as it had been before contact, in the same way Boas had done for his photographs and films: framing out or removing signs of modern life, dressing his subjects in precontact costumes, and re-creating traditional ceremonies and customs. Curtis commissioned George Hunt to oversee the carving and painting of masks, totem poles, dugout canoes, and other artifacts, as well as the making of costumes. Scores of villagers set to work building sets for the production. Hunt's wife and other women made capes, aprons, blankets, neck rings, and cedar-bark regalia for the actors to wear.

Curtis's concept for the film was a completely new idea. Boas and other ethnographers, including Curtis, had been making short films documenting specific Indian traditions since the turn of the century. Hollywood was churning out ludicrous Indian stories with non-Indian actors using fake props and costumes. But no one had created a full-length ethnographic motion picture on location with an all-Indian cast from the culture being represented, with the participation of tribal members in the making of sets, props, and costumes, dramatizing their ancestors' way of life.

In November, news from Seattle interrupted preparations for the shoot. Curtis's gifted studio manager, Adolph Muhr, had died. "It came at the end of a day's work at the end of the week.... I returned as quickly as possible, and for the balance of the year I must remain at the studio and get affairs in such shape that I can be comparatively free from the studio burden." Curtis arranged for Ella McBride to run the studio, along with his 17-year-old daughter, Beth, who was already showing her talents as a manager and businesswoman.

In the early spring of 1914, Curtis went to New York to oversee the publication of Volume IX on the Salishan coastal tribes he had visited in 1910. The following month, he met Myers in Phoenix and traveled to the Hopi Reservation for further work there, then headed north to Vancouver Island to begin filming *In the Land of the Head-Hunters.*

Hunt and the Kwakiutl had the sets and costumes ready. They had carved three totem poles and had built an entire village of houses with false fronts, as well as a roofless house with only three walls for interior shots. Hunt had also arranged for six large dugout canoes to be available and for villagers to paddle the canoes and to act in the film. Many of the actors were members of the extended Hunt family.

Curtis arrived with boxes of nose rings and a boatload of wigs from China, to the great amusement of the villagers. Kwakiutl men had worn their hair short for more than a generation, and Curtis wanted them to look the way they had before contact. He paid the men 50 cents each to shave off their mustaches and beards and to clip on the nose rings for their scenes.

Curtis intended to portray traditional Kwakiutl life within the context of an exciting story of love and war designed to hold the interest of a general audience. His screenplay wove dramatic scenes illustrating Kwakiutl culture into a convoluted story rivaling the plot of the most improbable vaudeville play. A handsome young Indian named Motana falls in love with a beautiful girl who comes to him in a dream. As described in a 1915 *Strand* article, "Motana finds the maid of his dreams and marries her, after which there is a tremendous battle, in which many heads are captured. Naida, Motana's bride, is captured by one of the enemy, Yaklus by name, who takes her to his village…. Motana…recaptures his bride and flees with her in his canoe. Yaklus follows hot after them, and is led by Motana into a dangerous gorge, where his canoe is shattered and Yaklus drowned. Thus everything ends happily." According to this article, the story is a minor detail, the real object of the film being "to show the customs, amusements, fights, domestic life, and sports of the North American Indian."

The logistics for the shoot were overwhelmingly difficult. Modern houses in Fort Rupert and Alert Bay made filming where the actors lived impossible. The village set had to be built on Deer Island, with other sets at Blunden Harbor. The locations were accessible only by boat, and there were no harbors deep enough for the *Elsie Allen*, so crew and equipment had to be lightered in every day. Winds, tides, and weather created myriad difficulties. To complicate matters further, the actors had many requirements before they would participate in the film. They would not wear masks or costumes unless they were entitled to them by birth or initiation. Casting had to be done according to each person's social class, and only the most aristocratic could play the main roles. The young actress playing the heroine had to be served separately, in

solemn state. Curtis wrote that at one point, disapproving members of her family kidnapped her from the production. Perhaps this is why three different young women were filmed in the role of the heroine, Naida.

George Hunt's youngest son, Stanley, played Motana. "Our hero, though less difficult to 'manage' than our heroine, was by no means an easy problem," Curtis was quoted as saying in *Strand*. "He had as much 'temperament' as any London or New York matinee idol, and we had all our work cut out to keep him good-tempered and open to reason…. He was under twenty, and as finely formed and as strong as a human being could well be. I am sure he would create a sensation were I to bring him to New York!"

On the set, George Hunt called directions through a megaphone, translating Curtis's instructions, as Curtis or Schwinke cranked the camera. Often the cast would burst out laughing at things Curtis asked them to do. In a spectacular but difficult scene, the actors were paddling three 50-foot canoes toward Curtis as he stood in the water cranking his camera. Masked dancers in full regalia danced on the narrow prows of the canoes. In trying to line up the boats for the shot, Curtis signaled them to paddle to the right. The Indian actors ignored his directions. When Curtis insisted, they changed course and one of the canoes crashed into a rock and capsized. The actors laughed so hard they could not get back into position for some time. Curtis was so frustrated he pulled the film out of his camera and threw it in the water, then remembered that several other scenes were also on the ruined roll.

The Kwakiutl were generally quite happy to participate in the filming. At that time, if they were caught wearing masks or holding ceremonies, the police would arrest them and confiscate all of their costumes and paraphernalia. Curtis was actually paying them to participate in outlawed activities, with the tacit permission of the authorities, and it was a joy to take out the masks again, to hear the beat of the drums, and to impersonate the supernatural beings of their pantheon.

To infuse his film with drama, Curtis took a few liberties. He decided to include a whale hunt, which was not a part of Kwakiutl tradition, although other tribes on Vancouver Island did hunt whales. To film the scene, he brought Stanley Hunt up to the Queen Charlotte Islands, rented a dead whale at a local whaling station, and towed it out to sea for the shoot. In the *Strand* article, Curtis told the story a little differently. "The whale put up a hard fight. Killing a ninety-foot amphibian [sic] and towing him back to shore is no easy morning's diversion, I can assure you."

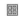

Filming In the Land of the Head-Hunters, *Curtis cranks his 35-mm movie camera, while his interpreter George Hunt stands ready to translate directions into Kwakwala through a megaphone. The set featured totem poles carved especially for the film and had only two walls and no roof, so sunlight could shine in.*

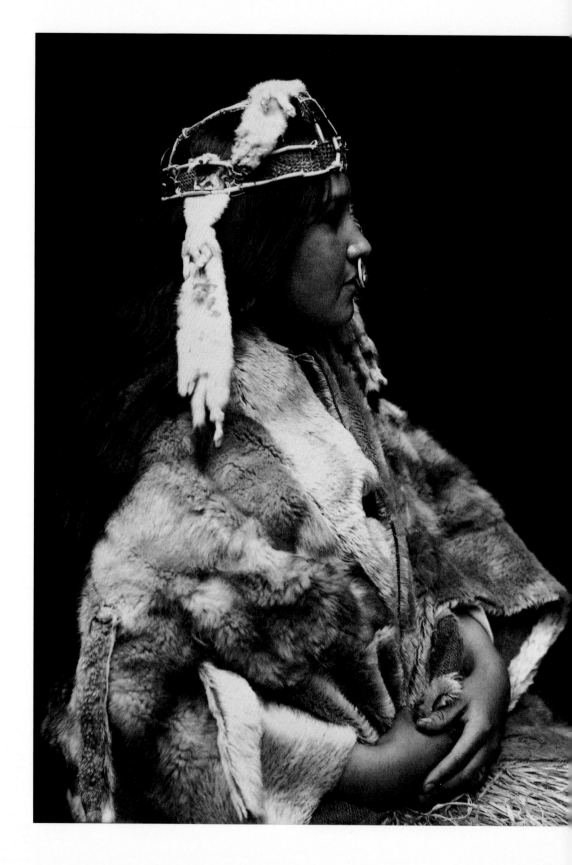

By this time, Curtis had become quite a storyteller, and the line between fact and fiction was beginning to blur. In later memoirs, he wrote that a whale had broken his hip when its tail crashed down on his canoe during the filming. He also wrote that he had nearly been drowned by an octopus that wrapped its tentacles around his leg and held on as the tide rose, until George Hunt was able to stop laughing and rescue him. In his most exciting but clearly apocryphal story of an adventure with the Kwakiutl people, he tells of spending the night with his star, Stanley Hunt, on a small rock island where sea lions rested. According to Curtis, the tide rose higher than the island, and he and Stanley had to lash themselves to the rocks and hold on for dear life in order not to be swept away.

Curtis returned to Seattle in late November with hundreds of vivid scenes captured on 35-mm film: images of cannibal dances and potlatch ceremonies, sea battles, head-hunting raids, chase scenes, vision quests, a kidnapping, a wedding, and many others. He managed to finish editing in December and took the film to New York for its premiere at the Casino Theater.

Critics were ecstatic. In *The Moving Picture World,* Stephen Bush wrote, "This production sets a new mark in artistic handling of films in which educational values mingle with dramatic interest… It ought to be welcomed by the better class of houses that…want to give their patrons a special treat." The poet and critic Vachel Lindsay declared that the film "has brought before my eyes a new vista of camera miracles," and called it a "supreme art achievement." The *Independent* declared: "the masks and costumes of the eagle and the bear…become effective, even awe-inspiring, when seen on giant forms on the prow of a canoe filled with victorious warriors…." According to this reviewer, the moments that brought the most enthusiastic applause were not the dramatic war scenes, but rather "those of waves and clouds at sunset, the herd of sea lions leaping from the rocks, and the fleet of canoes being driven swiftly forward."

A few months after Curtis had finished his production, Robert Flaherty went to Baffin Island to shoot motion picture footage with Eskimo people. In April 1915, Flaherty showed Curtis some of his Eskimo footage, which he later admitted was "too crude to be interesting," and Curtis screened *In the Land of the Head-Hunters* for Flaherty and his wife, Frances. Curtis and the Flahertys lunched together after the screening, and, according to Frances's diary, Curtis gave them the benefit of his own experience in filmmaking. Six years later, Robert Fla-

One of the three Kwakiutl girls who played Naida in In the Land of the Head-Hunters, *Margaret Wilson was, according to Curtis, of such high rank that she could not even eat in the presence of lower-caste Indians; she had to be served apart, in solemn state, with specially prepared food.*

herty filmed *Nanook of the North* with many of the same techniques Curtis had used: He built a half igloo to let in light; he hired actors to make traditional clothing and to re-create precontact life; and he eliminated Scottish woolens and other signs of acculturation. *Nanook of the North* is every bit as staged as *In the Land of the Head-Hunters*. Perhaps the theatricality of Kwakiutl culture gives Curtis's film its slightly bombastic tone, or perhaps Flaherty's choice of filming everyday life rather than imposing a story line makes Nanook feel more real. Whatever the reason, *Nanook of the North* would become a classic, considered by many to be the first ethnographic motion picture, while Curtis's film vanished into obscurity.

IN THE LAND OF THE HEAD-HUNTERS WAS A FINANCIAL DISASTER. World War I had just broken out in Europe. Newsreels on the evils of the Germans held people's interest; Curtis's ethnographic film did not. The $75,000 investment in the project was lost. Curtis filed suit against his distributor, the World Film Company, but no money was ever returned to him or to his investors. He never made another film about Indians, partly because he had no money but also because after 1916, the government refused to allow Indians to participate in motion pictures that depicted the old ways.

Curtis published Volume X on the Kwakiutl in 1915 with the help of additional funds from Jack Morgan. In a cover letter to his subscribers, Curtis wrote, "I feel that this volume is in many respects worthy of special consideration…. No volume of the series has required an equal amount of labor…and in few places have I been so fortunate in securing information needed…. The pageant-like ceremonies of the life, their great canoes and ocean-shore homeland, have afforded rare material for pictures."

Despite the commercial failure of *In the Land of the Head-Hunters,* Curtis planned to continue making motion pictures. He decided to produce one picture a week, culminating in a series of 52 films about the "beauty spots of America." He wrote to Schwinke, telling him to be ready to leave Seattle at a moment's notice and including a long list of equipment to bring to the first location, the Grand Canyon. "I will work with you a few days in starting it and then leave you to finish. You will next join me at Yosemite and there you will have two or three days with me and again it will be up to you to finish the picture…."

Schwinke promptly quit. He wrote to Myers that he had had

enough of motion picture photography to last him three lifetimes. Undeterred, Curtis hired a new assistant and began the series of films at Yosemite, then went to either the Grand Canyon or to Yellowstone. In 1916, these "Curtis Scenics" were distributed to theaters by the Hearst Company on reels that also contained Katzenjammer Kids and Krazy Kat cartoons.

Back in Seattle, Curtis's life was unraveling. On October 16, 1916, Clara filed for divorce. After the failure of *In the Land of the Head-Hunters,* she must have realized that Curtis would never be free from debt. Perhaps she was protecting the studio from ruin; perhaps she wanted to prevent her husband from mortgaging more of their property; or perhaps she wanted to put a legal end to a relationship that had failed years before. The divorce was headline news. The *Seattle Times* announced that "After 24 years of married life…Mrs. Clara J. Curtis, wife of Edward S. Curtis, well known Indian photographer, author and friend of the late J. P. Morgan, filed suit for divorce against her husband Friday in the Superior court."

Florence and Beth were furious at their mother. Although their parents had been separated for years, divorce brought shame to the family. Florence, a freshman at the University of Washington, was not allowed to pledge for a sorority because of the scandalous publicity.

The divorce hearing was postponed many times due to Curtis's constant absences. Finally, in 1919, the case was settled. The court awarded Clara the house and studio and everything in them, including all of Curtis's equipment and his original glass negatives. It was a bitter divorce, with suits and countersuits that continued for years. Before turning the studio over to Clara, Beth and two assistants printed many goldtones for Curtis and copied some of the negatives onto celluloid film. Then, two studio employees took all of the glass negatives across the street to the Cobb Building and smashed them. It is not clear whether Beth or Curtis ordered this heartbreaking attempt to prevent Clara from profiting from the Indian pictures. For her part, Clara burned a trunk full of letters that Curtis had written to her since the beginning of their courtship.

Beth and Curtis moved to Los Angeles and opened a new Curtis Studio. Beth managed the studio and her future husband, Manford Magnuson, made most of the portraits. Curtis dropped from the public eye. He had lost his studio, his home, and negatives from the work of a lifetime. He avoided old friends and disappeared from Los Angeles for long periods of time. For the next few years his movements are largely unknown. ✻

Ceremonial Curtis

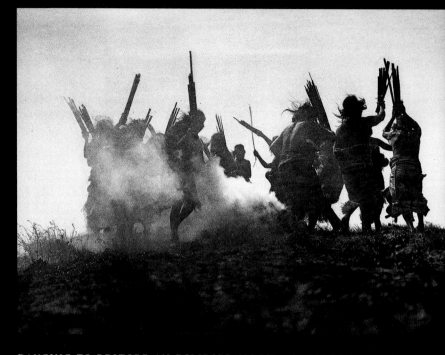

DANCING TO RESTORE AN ECLIPSED MOON—QAGYUHL
FOR STRENGTH AND VISIONS—APSAROKE *(opposite)*

Curtis was deeply affected by the spirituality he found among Indian peoples. "There seems a broadly prevalent idea that the Indian lacked a religion," he wrote. "Rather than being without a religion every act of his life was according to divine prompting." It was a religious gathering—the Sun Dance—that inspired him to begin his life's work in 1900, and he became determined to capture traditional Indian ceremonies. In some cases, he photographed rituals as they were being performed; in others he paid people to enact them. In every case, Indian people drew the line about what he could photograph. In recent years, his photographs have inspired a resurgence of traditional ceremonies and are sometimes the only visual reference available for their revival.

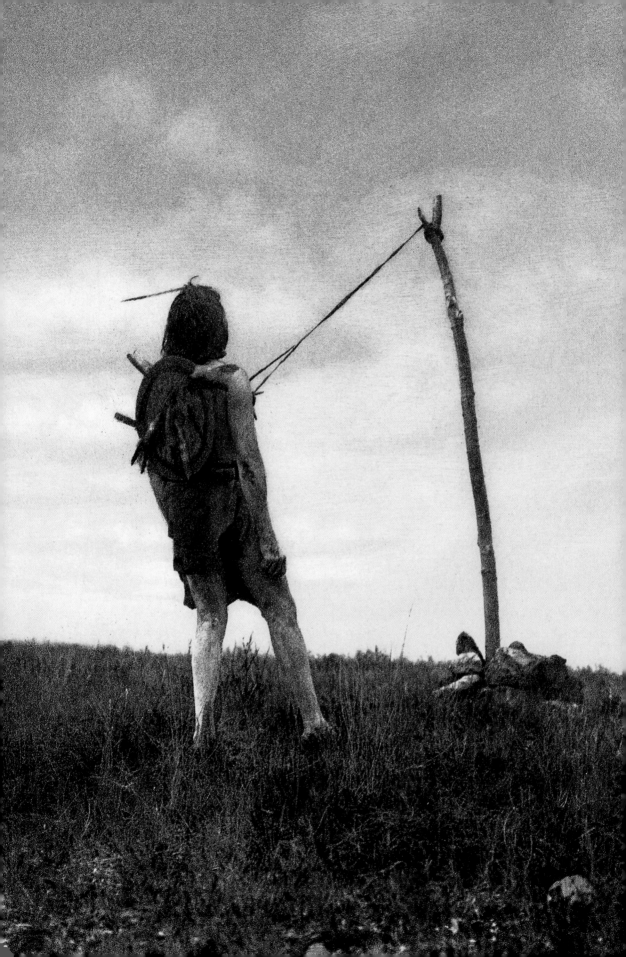

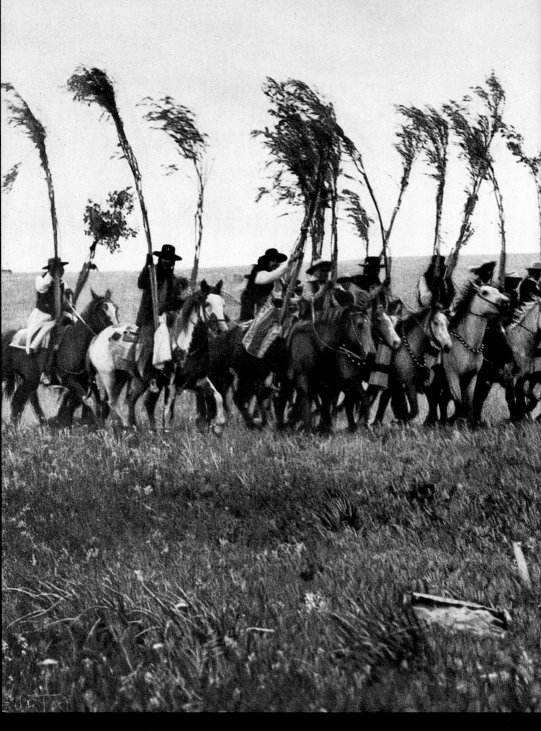

BRINGING THE SWEAT-LODGE WILLOWS—PIEGAN

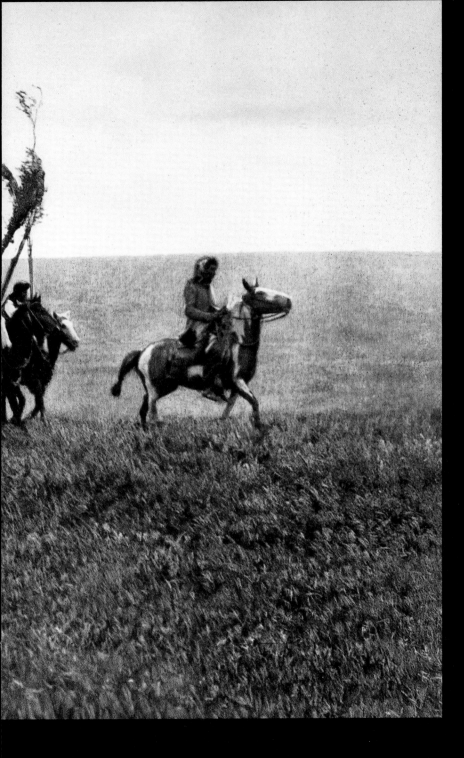

*Members of the
Piegan Brave Dog
Society ride toward
the Sun Dance lodge,
bearing a hundred
willow branches and a
hundred "buffalo
stones" that will be
used to build sweat
lodges for purification
before the dance.*

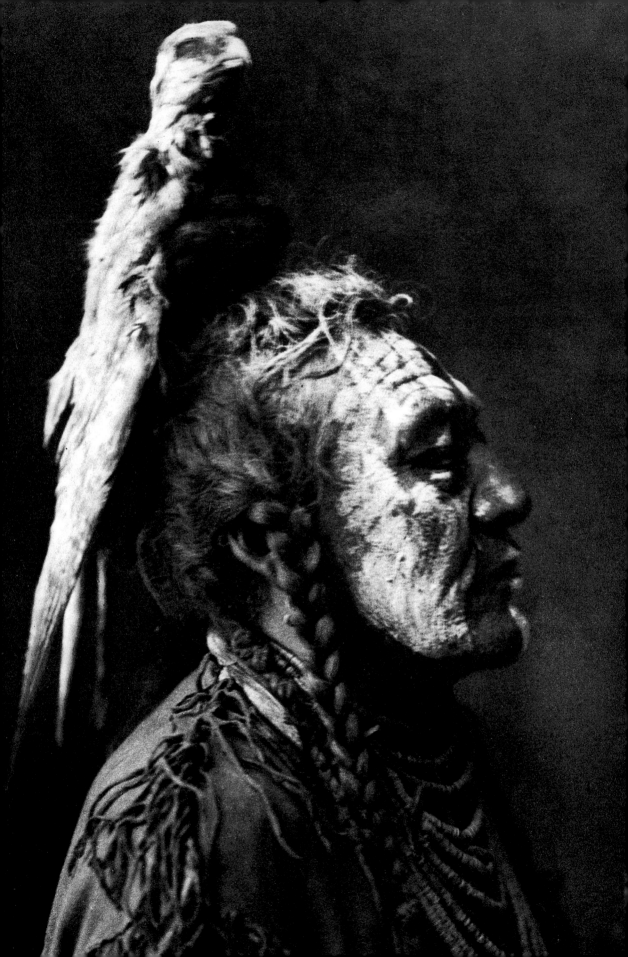

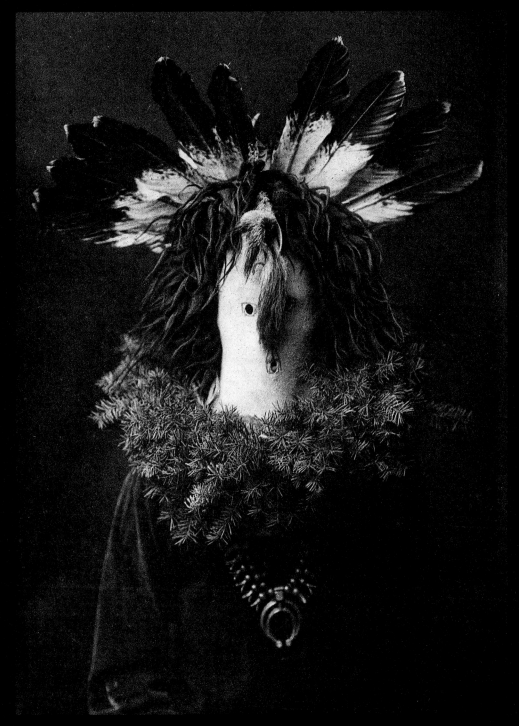

HASCHOGAN—NAVAHO

TWO WHISTLES—APSAROKE *(opposite)*

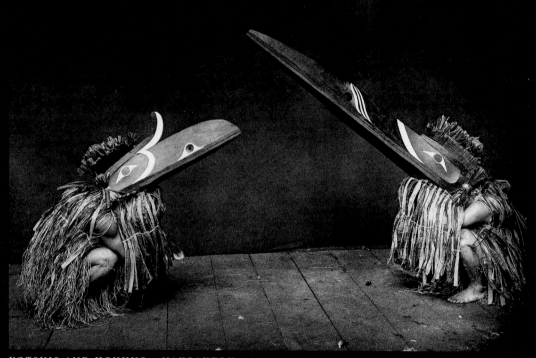

KOTSUIS AND HOHHUQ—NAKOAKTOK

GRIZZLY BEAR DANCER—QAGYUHL *(opposite)*

ATSINA CRAZY DANCE—THE FLIGHT OF THE ARROWS

"For all his brawn and bravery,
he was a gentle, sensitive man and a wonderful companion."

—FLORENCE CURTIS GRAYBILL ON HER FATHER, EDWARD

THE 1920S ROARED THROUGH THE PASTEL STREETS OF LOS ANGELES AND OUT TO THE SANTA Monica Pier, where speakeasy barges floated just offshore. Restaurants shaped like hot dogs, igloos, and tepees lined the boulevards. Thousands of cars competed for road space with trolleys, homemade oil pumps gushed in backyards, and the movie business bloomed in a sunny suburb called Hollywood. Near the Curtis Studio on Rampart Street, elegant New York-style apartment buildings mushroomed along Wilshire Boulevard. Glamorous stars of the silent era moved in, and one block away from the studio, Charlie Chaplin starred in scenes shot in beautiful Westlake Park.

While his daughter Beth ran the photography studio, Curtis set out to find work in the movie business. His first job was as a still photographer for Tarzan movies, taking pictures of the star, Elmo Lincoln, in fake jaguar skins straddling a rocky chasm and blowing fiercely into a wooden flute. Curtis called the movies "a circus kind of business," but it was a living. Fifty years earlier, he had read that same phrase in *Wilson's Photographics,* the book he had used to build his first camera. Wilson had also warned that photography was "unfit for a gentleman to engage in." The warning hadn't stopped Curtis as a boy; and, if the movie business sometimes depressed him, it also amused him, employed him, and gave him a new

Curtis took this cyanotype production still for the then popular Tarzan movies.

set of colleagues and friends. He joined the Screenwriters' Club and became good friends with the cowboy star William S. Hart; the brilliant and innovative director D. W. Griffiths; and Cecil B. DeMille, who hired Curtis as a biblical researcher for his epic film *The Ten Commandments*.

William Myers remained in the field, collecting information on reservations throughout California and the Southwest for *The North American Indian,* often without pay. Frederick Webb Hodge, now the director of the Museum of the American Indian in New York, continued to edit Myers's text, even though he hadn't been paid for years. It is a testament to their belief in the project and to their loyalty to Curtis that they kept working during his absences, depressions, and distractions.

Curtis did join Myers when he could afford the time and travel costs, which Beth usually paid from the studio income. In the summer of 1919, Curtis met Myers on the Hopi Reservation. Six years had passed since his last visit. Baptists, Mormons, and Mennonites had erected churches. The government had built houses below the mesas in an attempt to break up traditional social structures. Photographing ceremonies had been banned, and it was difficult to find people in their traditional dress. Hopi men wore cowboy hats, the women wore calicos, and the children often wore flour sacks with neck and armholes cut in them. Their hair had been cut short at school, and Curtis found it difficult to find girls with hair long enough to put up in the traditional butterfly whorls.

In 1922, during another break in his movie work, Curtis joined Myers in northern California to make photographs for Volumes XIII and XIV. He invited Florence to come along on the trip. "I had the wish for a member of the family.... I asked if her husband could spare her for a couple of months...."

Curtis and Florence crisscrossed the Coastal Ranges in an old Chevrolet coupe stuffed full of camping gear, cameras, and field equipment. They nicknamed their car "Nanny," as "nothing but a goat could get over the mountain trails our work has taken us to.... On one occasion while creeping around a mountain grade the ground gave way and the car started to roll over.... I lacked three feet of being killed to a life-saving oak on the mountainside. I gave the car all the gas I could and shot ahead for energy to reach the tree and stopped. Sitting in the seat I could look down two hundred feet to the first ledge of the gorge."

At night, Curtis cooked salmon over an open fire or cheese omelettes on the Coleman stove. He made applesauce, poached pears in syrup, and even whipped up his specialty, Roquefort dressing. They

Another Curtis production still shows work on Cecil B. DeMille's The Ten Commandments. *Though Curtis's* In the Land of the Head-Hunters *was the first ethnographic film ever made, Hollywood directors initially used his considerable talents only to make production stills.*

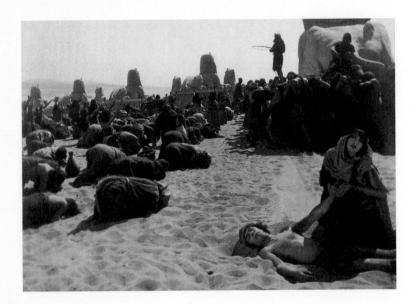

camped "under a canopy of living greenery," filled with "the pungent fragrance of pine and tarweed and the persistent chant of crickets. Dusk with its sleepy call of birds and then the stars of night enfolded us." As a child, Florence had rarely seen her father. She was deeply impressed by his attachment to the land and by his respect for the Indian people he met. "For all his brawn and bravery he was a gentle, sensitive man and a wonderful companion. He had a vast knowledge of and kinship with the outdoor world in which he lived so many months every year. He knew the trees, the animals, the birds and flowers. Camping with him was an unforgettable experience."

They drove hundreds of miles, visiting Hupa, Pomo, Achomovi, Shasta, Yurok, and Karok bands in the mountains and along the California and Oregon coasts. They found many Indians camped by fields, harvesting crops for large landowners. At one of these camps, a dying elderly woman asked Curtis to bring the medicine man to her. Florence was surprised that her father did as the woman asked, rather than calling in a medical doctor. Curtis explained that the woman's faith would help her more than anything else. The shaman arrived, and the next day the woman recovered.

Curtis had seen starving, devastated native peoples on reservations throughout the West, but the condition of the California Indians shocked him. He wrote to Meany: "While practically all Indians suffered seriously at the hands of settlers and government, the Indians of this state suffered beyond comparison. The principle outdoor sport of the settlers during the 50's, and 60's seemingly was the killing of Indians.

There is nothing else in the history of the United States which approaches the inhumane and brutal treatment of the California Tribes...." Gold-hungry immigrants had sabotaged the Treaty of 1851, leaving the Indians homeless. Many northern California Indians had become seasonal migrant workers, following the harvest. Very few of their traditions survived.

Nevertheless, Curtis was amazed by the rich and varied cultures of these people. "In Oregon and California we recorded more root languages than exist on the rest of the globe." He noted that there were more than 350 California Indian languages. At one camp he found six different languages being spoken. "We in several cases collected and recorded the vocabularies from the last living man knowing the words of a root language. To me that is a dramatic statement."

The photographs Curtis made on this trip are very different from his earlier work. Gone are the soft-focus, dreamy pictorialist images of timeless traditional Indian life. Gone are the warriors and the Indian groups vanishing into darkness. The California portraits show a new awareness of the emotions of his subjects. Grief, loss, confusion, and courage leap out from these images directly into the heart of the viewer—perhaps mirroring Curtis's own losses.

Near the end of their journey, Curtis and Florence took a canoe trip down the Klamath River to visit an Indian village. "It was a happy idea for both of us, for a love of boats and fast water seems to be part of the family heritage....When we were in the throes of that white water I looked at Florence, and a wordless exchange of joy was transmitted."

At the end of 1922, Curtis published Volume XII of *The North American Indian*. It had been six years since the last volume had appeared, and several subscribers had written to Jack Morgan asking when they could expect the rest of the books. It is likely that Morgan covered the printing costs of Volume XII and all the remaining volumes.

Curtis dedicated Volume XII entirely to the Hopi. The book and portfolio are full of luminous images—landscapes, architecture, ceremonies, snake priests in full regalia, young girls in butterfly whorls grinding corn or smiling from rooftops, and painterly portraits taken in his photographic tent. It also contains a wealth of information about Hopi songs, legends, ceremonies, beliefs, and language. His many unposed pictures in this volume show the friendliness of Hopis, their welcoming smiles, and their humor.

There was no fanfare when Volume XII came out, no recognition other than the appeasement of subscribers, and no new subscriptions

sold. Short of funds, Curtis offered to sell the negative of *In the Land of the Head-Hunters* to the American Museum of Natural History in New York. Pliny Goddard, curator of ethnology at the museum, showed the footage to Franz Boas, who encouraged him to buy the scenes with the big set pieces—the cannibal ceremony, the animal dancers in their elaborately carved masks, and the huge dugout canoe scenes. Negotiations for the sale would continue for more than a year.

EARLY IN 1923, CECIL B. DEMILLE HIRED CURTIS AS A STILL PHOTOGRApher on *Adam's Rib,* a silent film about a cuckolded wheat farmer. Later that year, DeMille promoted Curtis to second unit cameraman and still photographer on his monumental film, *The Ten Commandments.* As Curtis cranked his camera, scores of actors in Egyptian costumes raced chariots down the sand dunes of Point Sal, north of Santa Barbara, and hundreds of "Israelites" fled from the pharaoh at Seal Beach. The filming was hard work, but Curtis seems to have enjoyed it. "I am now working on the picturization of the Ten Commandments, and aside from breaking the one which mentions the fact that we should keep the Sabbath holy, I am working about eighteen hours a day, both on said Sabbath and on the days between."

With Beth's support, Curtis was able to meet Myers in the Southwest for part of the field season of 1924. Myers had discovered practices in the Rio Grande pueblos that both he and Curtis found objectionable. According to their informants, young girls were being offered to priests for sexual initiation during certain ceremonies. In an essay called "The Indian and His Religious Freedom," Curtis protested that young girls returning home as Christians from the boarding schools were also being forced to participate. "I grant the individual, whether red, white, yellow, or black, the utmost freedom in this respect…. But when a religious order whips, maims, brands, fines, or ostracizes individuals of the community because they do not see fit to follow the religious practices of the order, then it ceases to be religious freedom and can be nothing but religious persecution." Ten years later, this treatise, along with descriptions of rituals in the Pueblo volumes, would come back to haunt him.

That same year, Curtis helped found the Indian Welfare League, an organization of prominent men and women who lobbied for the enfranchisement of American Indians. Their activities were instrumental in the passing of the Indian Citizen Act of 1924, which finally gave Native Americans the right to vote.

"Nanny," the Chevy coupe that carried Florence and Curtis back and forth across northern California in 1922, takes a rest after almost careering over a cliff face—with her two passengers aboard. A tree broke her fall.

At the end of 1923, Curtis published Volumes XIII and XIV on the many tribes of northern California and Oregon, and prepared Volume XV on the southern California tribes for printing. His debts were accumulating, and, after protracted negotiations with Pliny Goddard, he agreed to sell all rights in his Kwakiutl film for $1,500—a paltry sum considering that the initial investment was at least $75,000. Between 1923 and 1928, Curtis also relinquished copyright in all of the photographs and text for *The North American Indian* to the Morgan Company, in exchange for the funds to publish the remaining volumes. In a letter to Edmond Meany, he wrote, "About the only thing my friends can do is to hold a little belief in me. I am working hard and trying to justify such faith as my friends may have. The problems are many, however the real work moves on."

In 1925, Curtis went to New York to oversee the printing of Volume XV, then traveled west by train for a field season in "the wilds of Canada." Myers met Curtis in Alberta, in a "large, heavy-duty automobile equipped with axes, shovels and saws, also a block and tackle to pull the heavily loaded car out of the muskeg swamp." They worked together on the Peigan Reserve in Alberta, just across the border from the site where the Sun Dance had inspired Curtis 25 years earlier. They found the once powerful tribes of the Blackfoot Confederacy weakened by disease and demoralized by government assimilation policies. The photographs Curtis took on this trip are very different from the glorious images

he had made in 1900 and published in Volume VI. Curtis and Myers had more success farther north on the remote Sarsi and Cree Reservations, where they found some remnants of traditional Indian life.

Myers planned to vacation in Europe that winter with his wife. Out of the blue, he received a letter from Curtis asking him to get the Pueblo volumes ready for printing immediately, rather than waiting until all of the fieldwork was complete as they had agreed. Myers had to cancel his trip. He wrote to Hodge that he had not yet told his wife and that even if he promised her a vacation the following winter anywhere she liked, he would be lucky to get off with his life.

Four months later, Myers quit. His letter came "like a bolt of lightening out of a clear blue sky." Myers had been an invaluable assistant for nearly 20 years and had become an excellent ethnographer in his own right. Curtis had counted on him to stay through to the end of the project, which was almost in sight. But Myers had other plans. He explained that an important real estate opportunity had come up and that he must stay in Seattle. In a letter to Hodge, Myers confided that it would be impossible for Curtis to find an experienced person to take over the job unless he were to receive credit as the writer.

When Curtis published Volume XVIII two years later, he praised Myers for his 19 years of work. "His service during that time has been able, faithful, self-sacrificing, often in the face of adverse conditions, hardship, and discouragement. It is with deep regret to both of us that he has found it impracticable to continue the collaboration to the end." Myers confessed to Hodge that reading these words caused him heartache.

At Hodge's suggestion, Curtis hired Stewart Eastwood, a young man just out of college. In the summer of 1926, Curtis and Eastwood traveled to Oklahoma to work with the many Indian groups there. These tribes had been decimated, relocated, intermarried, and assimilated. Very few remembered the old ways, and when they did, it was nearly impossible to tell which tribe's customs they were describing. One elderly interpreter insisted that what Curtis was looking for no longer existed. When Hodge complained that the text from the field contained very little useful information, Curtis replied rather tartly that he could not get what wasn't there.

For his last volume, Curtis decided to sail to the far north, retracing his Alaska journey of 30 years ago and sailing to even more remote islands in the Bering Sea. After his experiences in Alberta and Oklahoma, he was desperate to find native peoples untouched by missionaries and

This 1920s portrait of Curtis was probably taken by his future son-in-law, Manford Magnuson, who worked in the Los Angeles Curtis Studios. The cigarette dangling in his hand was characteristic. Curtis smoked constantly, often with more than one cigarette burning at a time.

government agents. Beth financed the trip and went along for the adventure. On June 2, Curtis, Eastwood, and Beth boarded the steamer *Victoria,* bound for Nome. Beth brought a 16-mm motion picture camera with her and kept a detailed journal. She was thrilled to be part of the expedition. "And it truly seemed as though I was going to the other end of the world as the boat pulled out from the wharf and I was finally on my way for the much longed for trip with Dad." The ship was full of men returning to the goldfields. Beth remarked that, "to belong you must wear nuggets, either in the form of a tie pin, watch fob, ring, or better still, an entire watch chain of nuggets with a real large one in the center hanging down."

The trip north was breathtakingly beautiful. They glided by glistening icebergs drifting in the blue water. Seals gazed lazily at the ship and slid from the ice into the sea. But the crystal mountains soon became the enemy. The ice thickened, surrounding the ship and slowing progress nearly to a standstill. A thick fog descended, chilling the passengers and dampening spirits.

Finally, after days of bumping and grinding blindly through the ice pack, the sky cleared, the ice opened, and the *Victoria* steamed toward Nome. At 11:30 at night, Beth went on deck to photograph the sunset. "The sun was clear gold and there was not the slightest bit of haze so the colors stood out absolutely transparent." At midnight Nome appeared in the fading light. The *Victoria* blasted her sirens, and the passengers cheered.

Nome, with its muddy abandoned streets, broken sidewalks, and empty buildings, was a strange sight to Beth and Curtis. Wire ropes were all that supported their dilapidated hotel. When Curtis had passed through Nome in 1898, the city was throbbing with life, as thousands of people passed through on their way to the goldfields.

The delayed arrival of the *Victoria* was a serious setback to Curtis, as no one wanted to risk chartering a boat to him so late in the season. He finally convinced a fisherman nicknamed "Harry the Fish" to sell them his beloved vessel, the *Jewel Guard,* which Curtis described as "an ideal craft for muskrat hunting in the swamps but certainly never designed for storms in the Arctic Ocean." Harry agreed to sell the boat only if he could buy it back in the unlikely event it survived the summer.

Locals shook their heads as Curtis, Beth, and Eastwood prepared their dubious craft to sail out into the Bering Sea, still known to local fisherman as "the sea that breaks your back." At the last minute, Harry could not bear to part with his ship and joined the expedition as skipper.

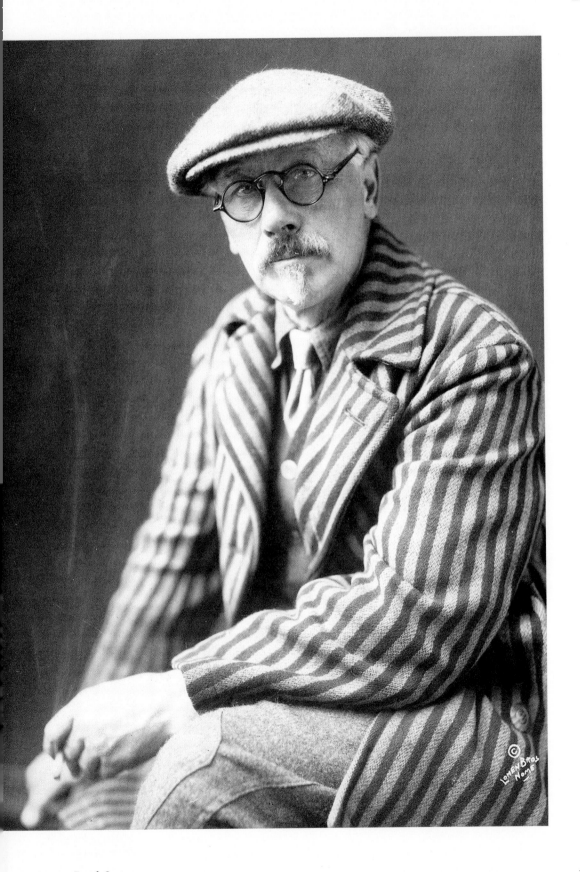

Rough Seas

This heartbreaking 1928 document records Curtis ceding the copyright to his North American Indian *photographs and text to the Morgan Company. At the time, he had completed seventeen of the twenty volumes and desperately needed funds to cover the printing and publication costs of the remaining three.*

Beth wrote, "He is a Swede and hates liquor, tobacco and women. Even so we are courageous and plan to set sail Saturday for St. Michael's, Hoopa Bay and Nunivak Island.... And so it seems that at last I am about to realize a life-long ambition, a trip into Indian country with Dad...."

At midnight on June 28, they set sail for Nunivak Island, three days away by Curtis's calculations. A cold fog enshrouded them, making it impossible to see more than two boat-lengths ahead. The sea became thick with drifting icebergs. From his watch on deck, Curtis wrote in his journal: "Gloomy night, wind howls through rigging and there is the constant sound of grinding, shifting ice.... Not so good a start." Huge waves battered the boat, and the wind spun them around like a top. Even with the engine at full power, they could only make one mile an hour.

That night, they ran aground on a sandbar. The hull split a seam, and the waves crashed so that "it did not seem that anything made of wood could stand such hammering." They were stranded, just two miles from shore. No other boats would pass by so late in the season. Curtis considered making for the beach in the dinghy, but it was not a pleasing prospect. "If we do get to safety ashore and reach a native village it will take at least a month to get word out. The condition of my lame hip is causing me a lot of anxiety as I can only go as far as we can get in the boat. I could not walk a mile if all our lives depended upon it."

Despite their desperate situation, Beth kept up her high spirits. Curtis wrote, "Beth is a brick and if she is worried she is not letting anyone know it." She wrote cheerfully, "We are now high and dry on the sand so we go out and play around making pictures of the boat. An eider duck comes near and we get out the shotgun and drop him." They took turns digging trenches under the boat, and, finally, at high tide on the second day, they sailed free of the sandbar. Curtis exclaimed in his journal, "Oh Boy! What a relief it was to feel her floating free.... All hands are smiling, we are afloat.... We had celebration supper of eiderduck with dumplings, and tapioca pudding with apples. Well, we know what the floor of Bering Sea looks like."

The *Jewel Guard* bucked heavy seas and howling winds for nine more days and finally arrived at Nunivak Island. Eskimos lined up on a high bluff and stared at them in amazement. On shore, they greeted the crew with smiles and gestures and welcoming C'upig words. There was a good deal of confusion until Beth was able to communicate the name of the interpreter they had arranged to meet. The natives raised a flag and indicated that he would come in the morning.

Paul Ivanoff arrived the next day in a kayak with his wife, May, their two young children, Emma and Ralph, and a puppy. Ivanoff, who was part Russian and part Noatak Eskimo, ran a store on the island and managed the reindeer herd for the Lohman Reindeer Company. Curtis and Beth became very fond of the Ivanoffs, a handsome and charming couple who generously shared their hospitality and their knowledge of Eskimo culture. "Paul…is about King of the Island, has the confidence of the natives and can get almost anyone to talk with us."

Curtis was captivated by the islanders. He had found what he was looking for. The people still lived by hunting seals and walrus, fishing, and gathering greens and salmonberries on the tundra. They dressed in sealskin parkas or seal-gut raincoats, lived in traditional houses, and practiced their religious rituals in vivid masks, unhindered by disapproving missionaries. Curtis made some of his most natural and charming pictures on Nunivak. There are group portraits of children in fur parkas, proud parents holding babies or posing with youngsters. There are also pictures of reindeer herds, men carving walrus tusks, fish drying on racks, and above all kayaks—kayaks on racks, hunters in kayaks, even Beth and him in a kayak.

"They are certainly a happy looking lot…," Curtis wrote. "We know now our decision to visit this island regardless of the problems was a wise one. Think of it. At last, and for the first time in all my thirty years work with the natives, I have found a place where no missionary has worked…. They are so happy and contented as they are that it would be a crime to bring upsetting discord to them. Should any misguided missionary start for this island I trust the sea will do its duty."

Ten years later, Christian fundamentalists would arrive on the island, preaching hellfire and damnation and scaring the natives into giving up their masks, which the missionaries ceremonially burned. Curtis was blissfully unaware of the changes to come, although he did run into two men gathering bones for respected East Coast institutions. "Their plunder consists largely of skulls and bones, about a ton of said human bones in sacks. A skull or two as types might be all right but what in hell do they want with tons of the stuff?" He did allow them to load the bones onto his boat, and gave them a ride to the village of Etoline. "They are like a bunch of infants and should be home in the hands of a wet nurse. Why are such inefficient men sent out?… They are working on limited funds and their getting about must depend on charity transportation of school boat, revenue cutter, trader, school teacher, etc. Hoboing in the name of science."

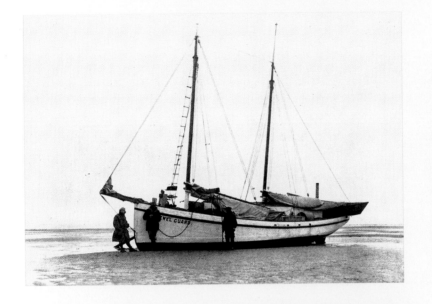

The Jewel Guard, *also known as the "mud hen," ran aground on a sandbar off Nome, Alaska, in the summer of 1927, with Curtis, his daughter Beth, and two others onboard. Eventually, the boat floated free and the party continued on to Nunivak Island.*

Curtis and his crew stayed on Nunivak Island for 16 days, making pictures, recording information, and enjoying the Ivanoffs and the friendly, curious Eskimos. In the evenings, many natives paddled out to the *Jewel Guard* and crowded onto the boat's deck to observe the strange habits of their visitors.

On July 26, Curtis and Beth invited the Ivanoffs on board for a farewell lunch. "Paul has been one of the best helpers I ever had. It was hard to say 'good-bye' to him. In fact, we all left Nunivak and our friends there with a real heart ache. I suspect that much of our liking for the island is our deep regard for Paul and through his help our work on the island has been a great success."

They sailed for Hooper Bay, where Curtis noted 68 white beluga whales drying on racks. He convinced some of the natives to take him along on a whale hunt. They set off in a small gas boat towing kayaks, but after 20 miles engine trouble prevented them from going any farther, and they returned to the village. The *Jewel Guard* sailed on to St. Michaels, where Beth hoped to catch a boat up the Yukon, then across to Fairbanks, and home by way of Seward and the Inside Passage. Curtis wrote, "It gives me a heart ache to think she is so soon to leave us. She has been the sunshine of our troublesome cruise." Heavy storms prevented them from getting to St. Michaels, and instead they sailed for Nome.

Beth flew from Nome to Fairbanks with the bush pilot Joe Crosson, becoming the first woman to make the journey. From there, she boarded a steamer and sailed for home. "Having spent six weeks in a forty foot boat in Alaskan seas.... I had to say good-bye to Dad. I knew

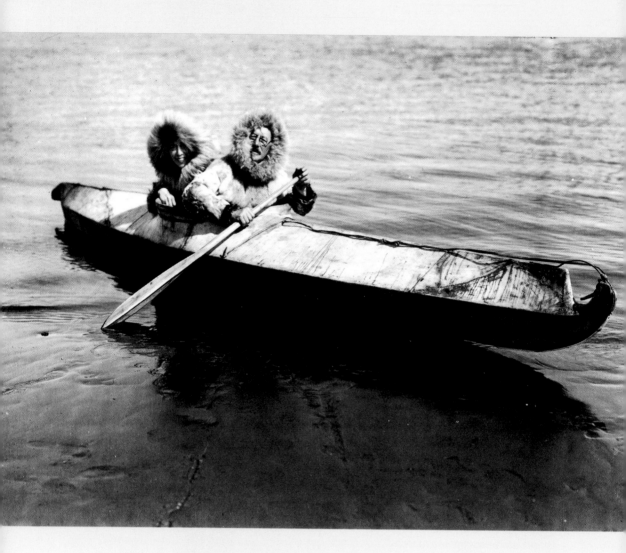

Beth and Curtis kayak in the Arctic waters off Nunivak Island. Beth was thrilled to be traveling with her father, and, despite the many hardships, both father and daughter thoroughly enjoyed their Alaska adventure.

158

EDWARD S. CURTIS

he was leaving for northern waters and greater storms, and I was so fearful that I would never see him again. Yet I did not dare break down for his sake."

Curtis, Eastwood, and Harry the Fish sailed north to King Island, only to find that the inhabitants had all left for Nome to work in canneries. Curtis made haunting pictures of their houses propped on stilts along the steep shore. "We are through at King Island and almost exploding with joy at our success in getting our pictures of the village." He planned to catch up with some of the King Islanders in Nome, for more pictures and information on their lives.

They sailed through the Bering Strait to Little Diomede Island, then into the Arctic Ocean to Kotzebue Sound. Curtis's hip ached badly from the cold and from the strain of loading and outfitting the ship in Nome. In his journal, he wrote that he was able to keep going by sitting down at the wheel when it was not too stormy and by doing all of the cooking from his stool. "I often prepare a meal, serve it, and do up the dishes without getting to my feet....I save myself all I can." They worked at Kotzebue despite interference by "a particularly vicious brand of missionary." On September 9, their work was done, and they sailed again for Nome.

Two days later, gale force winds blasted the *Jewel Guard*. Curtis awoke from a fitful sleep to find a foot of water sloshing around his berth. In the blinding snow and pelting hail, Curtis, Eastwood, and Harry the Fish pumped water from the boat, working to save their lives. "Between keeping the water out of the leaking hull and shoveling snow off the deck we manage to keep busy...the finish of our trip is getting interesting if not a bit sporting." Curtis calculated that they had one chance in a thousand of making it into port.

Finally, on September 20, the *Jewel Guard* sailed into Nome. "When we rounded the Cape and passed out of the squalls we were a happy crowd, nothing said, but likely a good deal of thinking done." Locals gaped as the frostbitten, weary crew disembarked from their blasted vessel. They had been presumed lost in the blizzard, and a wireless had declared them dead. But they had survived against all odds, along with a treasure chest of glass-plate negatives and priceless field notes. Curtis wrote, "Well, the cruise of the Jewel Guard known to our party as the mud hen is over." Harry the Fish happily took back title to his wrecked boat, and Curtis boarded the S. S. *Alameda*, bound for Seattle. ✳

The Curtis Controversy

BEFORE THE WHITE
MAN CAME—PALM
CANYON (*opposite*)

*Left: The same canyon stream,
natural and undammed*

Curtis's stated goal for his Indian work was to capture the beauty
of traditional Native American life. He often framed his images to
block out evidence of modern life and asked his subjects to dress in
traditional clothing. Occasionally, he even manipulated the natural
environment. In his 1905 image "Before the White Man Came—Palm
Canyon," Curtis dammed the stream in order to create reflections in
the picture. The romantic, painterly conventions of the pictorialist
movement suited Curtis's own style and purposes perfectly, though
what he chose to portray and how he achieved those portrayals
continue to evoke controversy.

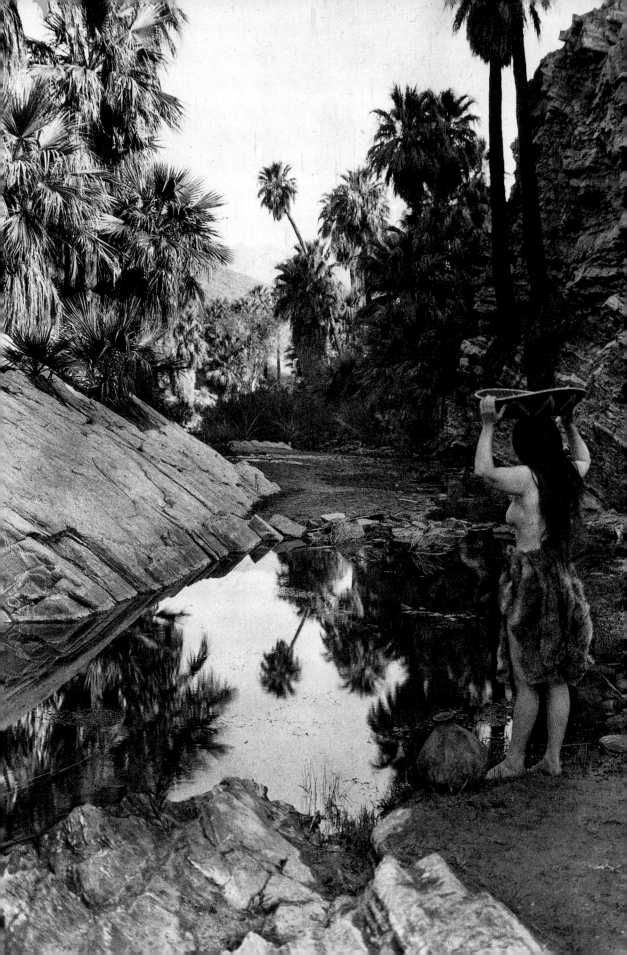

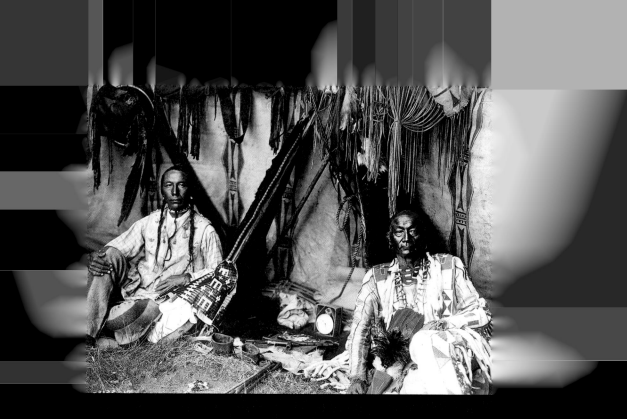

"In a Piegan Lodge" (below) features medicine bundles and other sacred objects. Curtis and Muhr retouched the negative, replacing an alarm clock (above) with a basket.

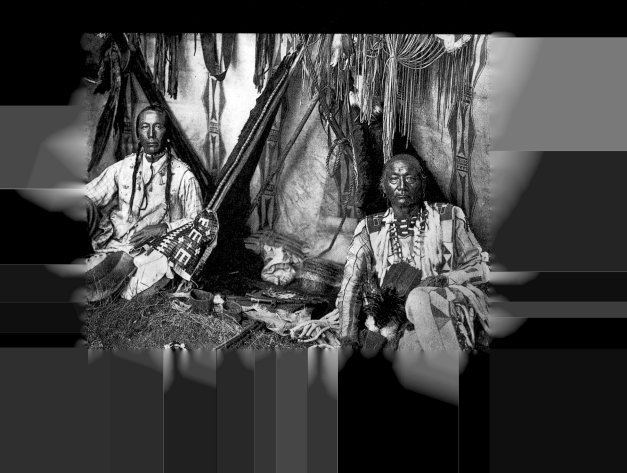

Before taking "A Painted Tipi" (below), Curtis moved his car and asked the Assiniboin to don traditional clothing.

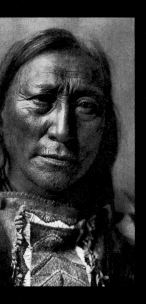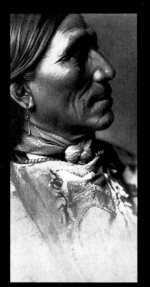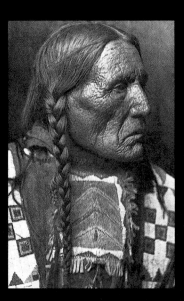

The buckskin shirt worn by these three Plains Indians—all from different tribes—also appears in several other Curtis portraits. Though Plains tribes did wear such shirts, Curtis's use of this particular beaded buckskin in a

The Mandan owner of these sacred turtles was very reluctant to let
Curtis see them, much less photograph them. Curtis persisted, though—
perhaps to an ethically questionable degree—and paid the owner several
hundred dollars to get the picture. When other Mandan unexpectedly
arrived, Curtis put away his gear and pretended to be recording stories.

Opposite: Kwakiutl actors relax in a dugout during the filming of In the Land of the Head-Hunters. They are wearing fake nose rings and traditional cedar-bark costumes made for the production by Tusuquani, George Hunt's wife. Top: The dead whale Curtis towed out to sea for his "whale hunt." Bottom: The film's villain holds human heads, though where he got them remains unknown.

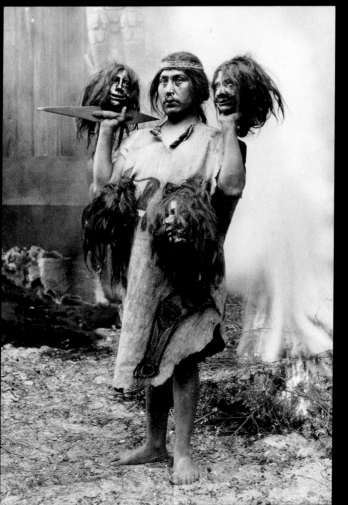

1927 TO 1952

The Lure of Gold

"Once one is bitten by that particular bug, the victim rarely recovers....
There is always that will-o-wisp beckoning."

—EDWARD CURTIS ON GOLD FEVER

AS HIS SHIP STEAMED INTO PUGET SOUND, CURTIS WATCHED HIS PAST SLIDING BY—PORT Orchard, where he had homesteaded as a young man and where he had met a girl named Clara Phillips; the beaches where he had photographed Princess Angeline and Indian fishermen in dugout canoes; downtown Seattle, where he had made a name for himself as a photographer; and Queen Anne Hill, where Clara and his youngest daughter still lived. Above the city, Mount Rainier glowed like a crown.

Curtis had completed 30 years of fieldwork for *The North American Indian*, despite tremendous physical, financial, and emotional obstacles. No one was at the docks to cheer him. He had no plans to see family or friends. He limped down the gangway and headed directly to the train station. What happened there was more devastating than any hardship he had ever faced. "In a fashion as unexpected to him as it was dramatic in its denouement, Edward S. Curtis...made a startling, if humiliating, reappearance in Seattle Sunday morning after an absence of more than 7 years," a reporter wrote in the *Seattle Times*. As he was boarding a train for Los Angeles, policemen blocked his way. "Vehemently protesting, he was taken to the county jail." They locked him up and showed him an affidavit signed by Clara alleging that he owed her $4,500 for seven years of alimony and child support.

Despite poor health and diminished fortunes, Curtis strikes a rakish pose in this later portrait.

Curtis appeared in court a few days later, exhausted, humiliated, and alone. He sat before the judge, a local paper reported, "Garbed in his rough hiking clothing, his nerves upset since his arrest…a shabby, hunched and weary figure—and a stubborn one—and heard himself berated for refusing to provide for a minor child, and in the same breath lauded for carrying on ceaselessly the great work which he regards as a moral obligation, his life hobby, but which in the end will be a financial loss." Curtis said he had never taken a salary during all the time he worked on *The North American Indian,* and that the volumes were being published at a deficit. "'Do I understand,' insisted Judge Ronald, 'that you will receive no money for this work—why are you doing it?' And there Curtis broke down completely—from nerves or hatred or sheer desolation. 'Your honor,'—he gulped, broke—'it was my job. The only thing I could do which was worth doing.… A sort of life's work,' he said, with all his pride and ambition and skill and love wrapped up in it. He was dutybound to finish. Some of the subscribers had paid for the whole series in advance—and he must finish the series."

The judge discovered that Clara and Curtis had been involved in nearly 20 court actions since the divorce. Neither of them could produce the final alimony settlement papers, so the judge dismissed the case. Curtis limped from the courtroom and left Seattle.

Clara sold the studio later that year, and the Curtises' youngest child, 18-year-old Katherine, took a job in a restaurant. Billy, as the family called her, had not seen her father since she was 5 years old. As a child, she had always imagined him striding across Mount Rainier in his Abercrombie and Fitch hiking outfit with his camera over his shoulder. She felt that the mountain belonged to him, and she longed to see him.

When she was 12 years old, Billy had discovered a bundle of letters that Curtis had written to her over the years, hidden in the pocket of a suitcase. Clara had kept letters from her, perhaps fearing that Curtis's charm would win over her last child's heart, as it had the hearts of all the others.

In the fall of 1927, Beth invited Billy to spend Christmas with the family at Florence's home in Medford, Oregon. Florence had two boys: three-year-old Edward Curtis Graybill, nicknamed Ted; and one-year-old Jimmy. Beth and Harold would be there, and their father. Billy had not seen her father in 13 years, and for the last hour of the journey to meet him, she had cried. When Curtis saw her, he, too, broke down in tears. Just two months after his Alaska trip and his arrest in Seattle, Curtis was in poor health, his emotions raw. It was the first time that he had

ever been together with all of his children. He would remain close to them for the rest of his life.

Volume XVIII of *The North American Indian* was published in 1928. The last two volumes were ready for printing the following year, but Hodge misplaced their introductions. Curtis wrote and told him to "just go into a trance and think where you have them stored." In the same letter, he mentioned that the severe pain in his leg made it hard to keep up his courage. A letter from his old friend Edmond Meany arrived "at a moment when I was down in the Deep…. I will confess to you that its reading caused me to break down and cry as a child…. Thank you a thousand times for sending the letter. Your old friend, E. S. Curtis."

The Christmas of 1929 was spent in Oregon with Florence and her family. Billy came down from Seattle, and Beth and her husband may have been there. Florence's sons, now four and six, inspired Curtis to invent delightful stories. In January he sent a nine-page letter to them, written from the point of view of a cat. The letter begins, "Dear Ted and Jimmy, The chief tells me that you want to know how I like snow…" and goes on to describe the cat's journey through deep drifts. "For a kitten in the deep snow it is a long way from the mill to the cabin and it took a lot of jumps and my feet were awful cold."

The mill and cabin were part of a gold-mining operation that Curtis and Harold were working on near Grants Pass, Oregon, not far from Medford. Apparently, the cat had eaten some arsenic in the cabin. "The chief looked at me and said I guess that is about your finish. Then he gave me a lot of milk to drink to see if that would make me feel better…. After a while I felt better…. The chief said you better be careful cat, you only have nine lives and you have now fooled away one of them." Curtis inked the cat's paw, signed the letter with a paw print, and mailed it to his grandsons. Later that year, he began writing a children's book called *Indian Days of the Long Ago,* based on Indian myths that he had collected over the years. The book was published two years later and sold more than a million copies.

In 1930, Curtis published the last two volumes of *The North American Indian.* There was no publicity, no acknowledgment from anyone except Curtis's family and his close associates. He had hoped to be able to sell more subscriptions when the sets were finally complete, but the stock market crash of 1929 had thrown the country into depression, and he found sales impossible.

Thirty years of rough camp life, hard berths in cold boats, thin tents, sleepless nights, tinned food, the constant lifting and hauling of

heavy equipment, and 18-hour days without end had taken their toll. Curtis was exhausted, depressed, and in physical pain. He checked himself into the New Rocky Mountain Hospital, an osteopathic clinic near Denver, Colorado, where he hoped to recover his strength and his spirits. He may have been hospitalized for as much as two years, but it is more likely that he moved to a boardinghouse near the clinic after a few months, remaining under the care of Dr. R. R. Daniels, the well-known osteopath.

Early in 1932, Curtis felt his strength returning. He began writing to Meany, Hodge, and many of his old friends. He also sent a letter to Belle da Costa Greene at the Morgan Library, explaining why he had dropped out of sight. "Following my season in the Arctic collecting final material for volume twenty, I suffered a complete, physical breakdown and for two years was about a 99% loss. Ill health and uncertainty as to how I was to solve the problem of the future brought a period of depression which about crushed me. Lacking the courage to do the obvious thing, I fought up and out of the mire of despondency. I am again in a measure physically fit and have much of my old courage back. During the long months of despondency, I could not write to my friends: no one wants to listen to the wail of lost souls, or to the down and outers. I am again writing and hoping I may do something worth while. Do drop me a line; even a word from my old friends gives added courage." Belle Greene sent the letter to a colleague saying, "He does not ask any favor of me, but I think it wiser not to reply to it." The colleague agreed, and Curtis's letter went unanswered.

During his years in Colorado, Curtis came down with a lifelong case of gold fever. "Once one is bitten by that particular bug, the victim rarely recovers.... There is always that will-o-wisp beckoning." Curtis had completed a correspondence course in metallurgy in 1918, perhaps

inspired by Harold, who had mined for gold in Colorado that year. In 1929, they had worked together at a gold mine in southern Oregon. Three years later, Curtis formed a mining partnership with a Colorado friend named Ted Shell and set out once again for the goldfields.

In 1932 Curtis also designed and patented an ingenious gold recovery device, which he called the Curtis Counter Current Concentrator. He wrote to Shell from the field, "My gold concentrator equipment has proved a complete success in saving fine gold." Once again he worked from dawn to dusk, camping by rivers in the foothills of the Rockies. By December, he had worn himself out. His hip ached, and he had developed chronic intestinal problems. He wrote to Shell that he had "dropped down lower than a snake's belly." He returned to Los Angeles to recover.

In October his former wife, Clara Curtis, drowned while rowing across a slough near her sister's home in Bremerton. After the funeral, Billy packed up her belongings and moved to Los Angeles to be near her father. She later remarked that her mother had had an ego as big as her father's, but that she could never get it back after the divorce.

Curtis's hand-drawn diagram shows his Counter Current Concentrator. Designed and patented in 1932, the invention was used to extract fine gold from abandoned placer mines. Curtis declared it a total success.

IN 1933 CURTIS BECAME EMBROILED IN A CONTROVERSY OVER RELIGIOUS freedom for American Indians. The new Commissioner of Indian Affairs, John Collier, accused him of slandering Pueblo religion in *The North American Indian*. Collier was working hard to inspire respect for Indian religion in the American public and to change oppressive government policies. Ironically, Curtis found himself on the opposite side of this battle. Ten years earlier, he had accused Pueblo priests of religious persecution. In a 1933 letter to Curtis, Secretary of the Interior Harold Ickes demanded a written apology from Curtis for allegations of this kind in Volumes XVI and XVII. "The effort of the Pueblos and of the other Indian tribes to obtain a measure of justice from the American people is perhaps more seriously handicapped by such defamatory statements made against them than by all of the hostile special interests opposed to just treatment of the Indians."

Curtis stood his ground. He wrote Ickes an 11-page letter documenting the testimony of his Pueblo Indian informants concerning the rituals, as well as reports by other ethnographers of the same practices. Ickes and Collier apparently dropped the accusations, but Curtis was badly shaken. To make matters worse, in1935 the Morgan Company liquidated The North American Indian, Inc., and sold 19 remaining sets,

hundreds of prints, and more than 2,000 copper plates for $1,000 to a book dealer in Boston. The copper plates alone had cost more than $100,000 to make. Many glass negatives and hand-colored lantern slides remained at the Morgan Company. Some were broken, others sold for junk; a few remain at the Morgan Library today.

During the 1930s, Curtis had the company and support of all his children. Billy lived nearby; Harold and his wife were living in the posh outpost of Bel Air; and Florence had moved to Glendale with her husband and two young sons. Beth had married her portrait photographer, Manford Magnuson, in 1929, and together they were running three Curtis studios—one in the Wilshire district, one at the Biltmore Hotel, and another at the Huntington Hotel in Pasadena. Curtis sometimes helped out in the Biltmore studio, but whenever he could, he left Los Angeles in search of gold.

In 1936 Cecil B. DeMille hired Curtis to shoot still and motion picture film for *The Plainsman*, starring Gary Cooper and Jean Arthur in a fictionalized story that included Buffalo Bill, Gen. George Armstrong Custer, and the Battle of the Little Bighorn. They shot the film in the Badlands of South Dakota, where Curtis had photographed Red Hawk and his Sioux band reenacting similar battle scenes in 1907. Some of the Indians riding hell-bent for Curtis's camera in *The Plainsman* had worked and feasted with him 30 years earlier—and surrounded his wagons and tormented him with sham attacks.

Curtis returned from South Dakota with some money in his pocket and immediately left Los Angeles to look for gold. He and Harold staked a claim near Colfax, California, in the foothills of the Sierra Nevada. During the next two years, they often drove 450 miles north to extract fine gold from tailing dumps of abandoned placer mines. In 1938 Curtis stayed too late in the season and a blizzard caught him. He was forced to walk 18 miles through knee-deep snow, a grueling hike for a 70-year-old man with a bad leg. But the following year he was back at his claim, searching for the elusive gold. He never struck it rich, but he did find enough of the precious metal to keep the fever alive, and the lure of gold beckoned him for at least three more seasons in the field.

Whenever Curtis came home from what he called his "hobo wandering," he worked for long hours at his desk. He began writing a book about sea otters in the Pacific Northwest and the expeditions that had all but exterminated them. He also began an odd piece about Chinese slavery in Seattle at the turn of the century. His daughters Florence and

A family reunion in Los Angeles, 1944, celebrates a visit from Florence Curtis Graybill (left of Curtis); on his other side stands his youngest daughter, Billy (Katherine), then Harold, and Beth. Curtis was close to all his children and in later years saw them often. Florence and Billy typed his memoirs, Harold was his mining partner, and Beth ran the Los Angeles studios and took care of her father in his last years.

Billy, who typed these manuscripts, finally prevailed upon him to dictate some of his memoirs. In vivid, often poetic detail, he described the dreamy idyll and terrifying denouement of the family's adventures in Canyon de Chelly, his initiation into the Hopi Snake society, his search for skulls that rained down on him like apples on the Kwakiutl Island of the Dead, and the wild ride down the Columbia River in 1910. The memoirs are replete with Curtis's love of adventure and his enduring passion for the Indian work.

During these years, Curtis would sometimes pick Billy up from her job at the Forest Lawn Cemetery and drive her to his home for an evening's work. "It was worth your life to drive with him—he could jump it!" Billy later recalled. Curtis cooked delicious dinners, while his daughter typed from his dictation. She later cherished those times as the greatest part of her life. "I was enchanted, we had the same mind, it tracked. He felt it too, the empathy between us."

In 1946, Curtis moved to a 12-acre ranch near Whittier, California, owned by Beth and her husband. He continued writing and also raised chickens, grew vegetables, and harvested avocados. Florence remembered: "There were snow peas, avocados, berries, and usually he

had a finger in their preparation, for he was an excellent cook, and if you didn't like what he cooked, then there was something wrong with you."

In 1947 he moved to an apartment near Beth at 8550 Burton Way, which he called "the most discouraging place I have ever had to live in." His health was growing worse. He began eating a pound of ground carrots every day to improve his eyesight and claimed to have cured his chronic intestinal problems with a tea made from manzanita shoots. But his aching hip plagued him, his vision was failing, and his arthritic hands made writing difficult. He gave up his hope of returning to his claim in northern California. The Curtis Counter Current Concentrator had grown obsolete with the disappearance of the placer mines, and later that year he sold the machine and all his equipment for ten dollars.

Gold fever still pulsed in his blood, and he began to explore the goldfields in library books. He was so excited by what he found that he decided to write a book on the subject and plastered two walls of his apartment with research notes for a manuscript he called "The Lure of Gold."

In 1948 a librarian named Harriet Leitch discovered a set of *The North American Indian* at Seattle's public library. She tracked down Curtis's address and began a lively correspondence with him that lasted for several years. Curtis was 80 years old, but his mildly flirtatious charm, his revealing answers to her questions about the Indian work, and his running commentary about his present circumstances show not only the pathos of his housebound life, but also his far-ranging imagination and his wry, unquenchable humor. He referred to himself as "Old Man Curtis" and as "Job with his boils" and remarked that he had not written sooner because his pen had "died a sudden death."

In 1949 Curtis became overwhelmed with the task of finishing *The Lure of Gold*. "At times I feel that I have tackled a task that's too BIG for me…. Why anyone of my age should attempt such a task is beyond my understanding." At the end of that year, he wrote a friend, "I have been so busy with "The Lure of Gold" that everything else is neglected. So many subjects have to be covered that I lose track where I'm at…. Please hold the thought that I may maintain my strength to finish the task." A year later, at his doctor's insistence, he gave up writing the manuscript and put it on the shelf. "That was a serious blow and hard to take…. I find that it's not easy to junk a script which one has spent the greater part of two years on."

Undaunted, Curtis began planning a new adventure. His research on gold had filled him with a desire to explore South America. "It devel-

ops that a large Scientific Expedition is planning to explore the Amazon. I am invited to accompany the expedition as a metallurgist." Two months later, the expedition was canceled, and Curtis wrote, "No words can express my disappointment in the collapse of the Panama Expedition. During all my active life I have wanted to see the Amazon and the Andes Mountains."

IN THE SUMMER OF 1951 CURTIS WAS HOUSEBOUND ONCE AGAIN. IN characteristic fashion, he wrote to Leitch of the trials of being an invalid. "It's Hell when you can't go to the market and select what you want. You spoke of berries. California can grow super strawberries. The grocer boy just brought me two boxes…." Ever the optimist, Curtis hoped to move out of Los Angeles within the year to escape the smog, which irritated his eyes.

But it was a move that he never made. On October 19, 1952, Edward Curtis died of a heart attack at the home of his daughter Beth. He was 84 years old. The following day, he was buried at Forest Lawn Cemetery. A short obituary in the *New York Times* mentioned simply that Curtis had been an authority on Indian history and that he had also been known as a photographer.

Edward Curtis had lived a long life full of adventure, sacrifice, brief fame, heartbreak, monumental accomplishments, and an enduring belief in the value of his work. In a fond description of her father, Florence wrote: "He was big, six feet two inches, husky, ruggedly built yet with this he had a soft voice with a pleasing tone to it that inspired confidence…. Like most great men he seemed to have little sense of personal gain. Everything he did was directed toward the main theme of preparing material for the North American Indian and other writings about the tribes. His life was certainly dedicated to an ideal."

A few years earlier, Florence had asked her father to summarize his life's work, and he had dictated these words: "As I look back on those years, my brain is a scrambled jumble of desert sand storms, cyclone wrecked camps, exhaustion in waterless deserts, frozen feet and hands in northern blizzards, wrecked river canoes and ocean-going crafts; on the other hand, hours of utmost peace, comfort, and joy of delightful camps; again, the exultation of accomplishment when some particularly difficult fragment of information was secured. Many of the highlights of those years stand out clearly as though they were the happenings of yesterday." ✖

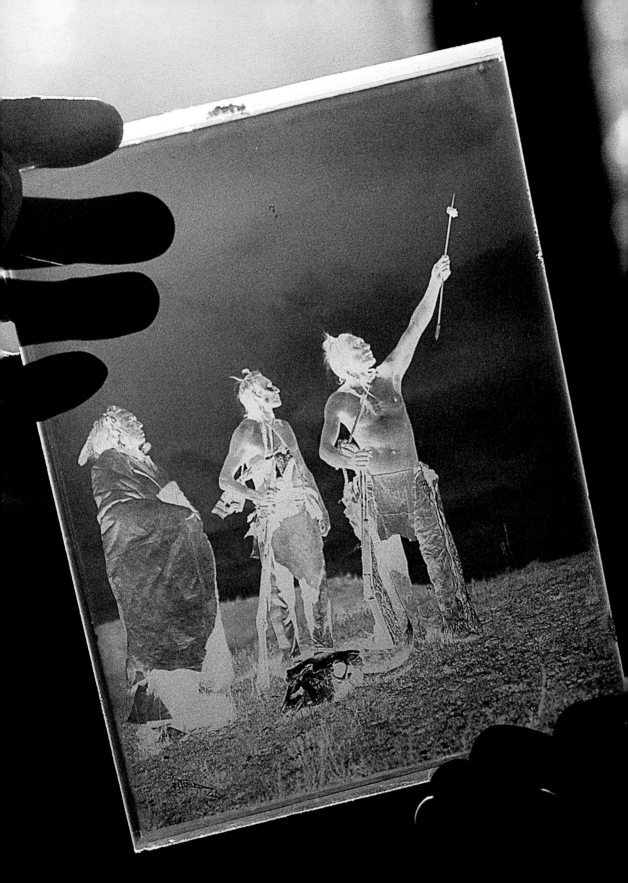

<div style="border: double; text-align: center;">

EPILOGUE

A Legacy Restored

</div>

O N JULY 4, 1998, I FLEW TO CALGARY AND DROVE SOUTH, PAST SPRAWLING SUBDIVI-
sions and out onto the windblown Alberta prairie. I had learned that a Sun Dance was
being held on the Peigan Reserve, and had arranged to meet with two Peigan leaders to discuss
the possibility of filming parts of the ceremony. As the flatlands opened up to the rolling green
foothills of the Rockies, I remembered Curtis's description of the first Sun Dance he had ever
seen, with "the broad, undulating prairie stretching away toward the Little Rockies, miles away
to the west…carpeted with tipis."

My cinematographer and I pulled into the Scarlet and Gold Restaurant in the Old West town
of Fort Macleod, Alberta, just outside the reserve. Allan Pard, a Peigan cattle rancher with a white
cowboy hat and a penetrating gaze, and Jerry Potts, a soft-spoken descendant of the famous Peigan
scout of the same name, were waiting for us. Weatherbeaten, tough, and wary, they listened as I
described my project. Allan asked me hard questions, while Jerry sat back, arms folded, not miss-
ing a beat. Finally, Allan said, "How come people like you come here with such good intentions
but what they make is such shit?"

I had not expected this to be easy. I knew that my request to film their Sun Dance reverber-
ated with a long history of exploitation and betrayal. I also knew that Allan and Jerry were test-
ing me to see if they could trust me. I replied that my track record as a filmmaker spoke for itself,
that I needed their help to portray their traditions accurately, and that the Peigan scenes in the
film would be crucial to show the spiritual power that had moved Curtis so deeply and inspired

Curtis's glass-plate negative of "The Oath—Apsaroke"

him to devote his life to preserving a record of North American Indian life. I explained that I wanted my film to show that Indian people have not vanished, as Curtis feared they would, but are in fact very much alive and are reviving their traditional ways even as they live in the modern world.

In the silence that followed, my stomach clenched and my heart beat fast. This was the first day of production for *Coming to Light,* my documentary film about Edward Curtis, and so much depended on the acceptance and support of these two men. I had learned that in many Indian cultures, the most important information is often communicated in moments of stillness. I lived in what seemed like an endless quiet, not hurrying, waiting for them to decide whether I deserved their trust.

I don't know what it was that changed everything—whether it was my respect for them, or my own silence, or my refusal to be intimidated, or perhaps they just felt sorry for me and decided I was harmless—but there was a sudden shift, an opening. The tension dissolved into amiable conversation. Their questions became friendly and curious.

That afternoon, I filmed Jerry as he carved traditional medicine pipes and talked about Curtis's photographs and the ways they had changed his life. Later, Allan introduced me to members of the Brave Dog Society, the men in charge of policing the Sun Dance encampment. With Allan's endorsement, the Brave Dogs allowed me to film them riding across the prairie with a hundred willow branches held aloft for the Sun Dance sweat lodges. This was the same scene that Curtis had captured a century ago in his stunning image, "Bringing the Sweat-Lodge Willows." The Peigan had given me the opening of my film, and, as had happened with Curtis, they had inspired me with the passion to capture the beautiful in contemporary Indian life.

When Curtis was setting up to shoot this scene, one of the Brave Dogs had galloped straight at him, threatening to trample him and his camera. Curtis reported that Chief White Calf had intervened and saved his life. White Calf must have trusted Curtis and seen the value of his work, but he had also set clear limits as to what Curtis could and could not film. He did not allow him to take pictures inside the Sun Dance lodge or to photograph the most sacred parts of the ceremony. A hundred years later, the Peigan set those same limitations on my own production. I was allowed to film outside the encampment, but I was not allowed to bring the camera anywhere near their sacred, private rituals.

Curtis's life's work, the 20 lavishly printed and bound volumes of The North American Indian, *was finally completed in 1930.*

Several months later, I showed a Navajo medicine man, Avery Denny, Curtis's 1904 footage of the Yeibechei dance, a Navajo healing ceremony in which medicine men impersonate the gods in order to take away a patient's illness. In his interview, Avery pointed out that the Navajo in the film were actually performing the dance backward. He speculated that these men might have decided to show Curtis only part of the ceremony, performing the dance in reverse so that the camera would not capture the real thing. When I asked Avery whether I might film parts of a Yeibechei dance, his response was vehement: "Why would you want to film it? That is like stealing from the holy people, stealing from the gods.... You are taking things that do not belong to you on tape, and what are you going to do with it?"

SINCE THE TIME THE FIRST PHOTOGRAPHERS WENT WEST, THE IDEA OF PHOTO-graphing ceremonies has been extremely controversial. Many Indian people feel that the camera is an invasion of their privacy. Some also believe that photographs negate the effects of their prayers. As Avery Denny says in my film, "The songs and the prayers are supposed to heal, and that sickness and illness is supposed to leave the patient and go on into another time or a dimension. But when you take it and film it or record it or photo it you capture that and the patient will not get healed."

Why, then, did the southern Piegan, the Navajo, and scores of other tribal groups allow Curtis to photograph them and parts of their ceremonies? During months of filming, I came to realize that American Indian people had always set their own limits and that they had participated in the creation of Curtis's images for their own reasons. When the Navajo or the Kwakiutl had donned masks to perform dances for his camera, or when the Sioux and Crow had reenacted battle scenes on horseback, they were doing so to contribute to a photographic record that would be of value to their children and grandchildren.

Most Indian people today refer to their departed family members as relatives, not as ancestors. The spirits of the dead are still with them, and Curtis's photographs are the gifts of the departed relatives to the present generation. His still and motion pictures of the great war canoes have inspired hundreds of young Northwest Coast Indians to don their regalia and paddle from Vancouver Island to Tacoma in what has become an annual summer event. The Makah of Washington State have looked to photographs by Curtis and by his brother

Asahel in orchestrating their recent revival of whale-hunting traditions. On the Suquamish Reservation on Bainbridge Island in Puget Sound, tribal council member Pegi Deam is using a Curtis photograph and an architectural computer program to design a traditional longhouse. At the Little Bighorn College library on the Crow Reservation, a CD-ROM of Curtis's *North American Indian* is a popular resource, and the Crow proudly display the photographs he took of their warrior ancestors.

The images that I exhibited on the Hopi Reservation in 1993 have traveled with Hopi high school students on cultural exchange programs as far away as Moscow, providing visual references as the students talk about their traditions. In the Inuit villages of Alaska, where missionaries long ago burned the traditional sacred icons, local Inuit artists are carving new masks, totems, and walrus tusks—some based on Curtis's images—and they're learning the nearly forgotten songs that he recorded. And at the Peigan Cultural Centre in Alberta, Curtis's Sun Dance pictures glow with the light he captured a hundred years ago, and that captured his own soul in turn.

THE PEIGAN SUN DANCE DIED OUT IN THE 1930S. FOUR DECADES LATER, ALLAN PARD, Jerry Potts, and their friends discovered Curtis's beautiful photographs of the ceremony, and these images inspired them to bring the Sun Dance back home again. They studied the pictures, learned the songs and the dances, and in 1977 they held the first Sun Dance to take place on their reserve in 45 years. Now every July, Sun Dance lodges sprout like mushrooms on reservations all across the Plains, celebrating the life-giving sun and the survival of American Indian people.

During the 1998 Sun Dance, Jerry Potts made an offering for me to hang on the Sun Dance pole. It was a bright green cloth tied to crossed sticks. He explained that when you tie an offering to the pole, you make a vow to sacrifice something and then ask for your heart's desire. The cloths contain sickness, bad thoughts, bad luck, and giving them to the sun releases evil and frees a person for good things to happen in the future.

As the bright pieces of calico fluttered above us like kites, scattering pain to the winds and freeing the spirits of the people inside the lodge, I wondered if Curtis himself had tied an offering to the pole, what he had vowed to sacrifice, and what he might have wished for. ✻

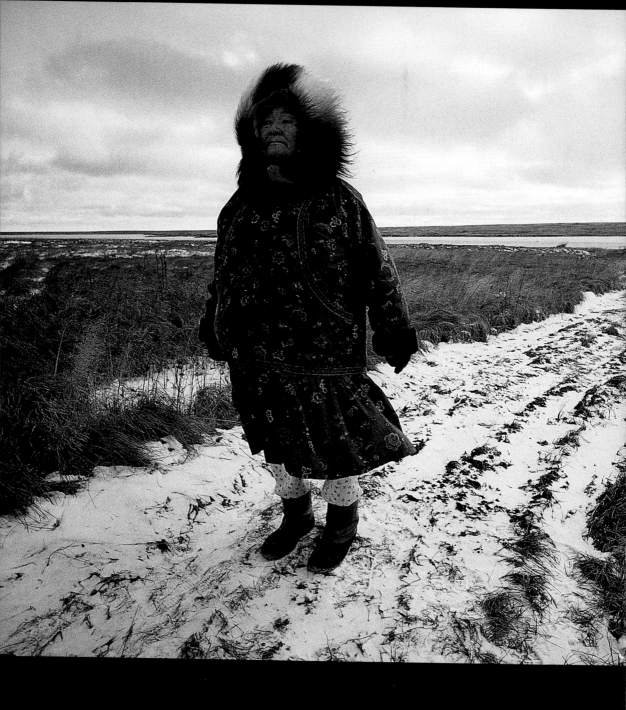

They are so happy and contented as they are that it would be a
crime to bring upsetting discord to them. Should any misguided
missionary start for this island I trust the sea will do its duty.

—EDWARD S. CURTIS ON THE PEOPLE OF NUNIVAK ISLAND

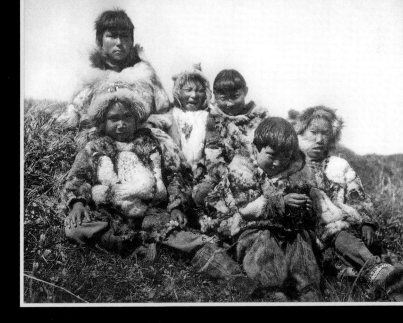

Edward Curtis died a half century ago in relative obscurity, the 20 volumes
of his monumental *North American Indian* as obscure as he. But in the last
30 years Curtis's work has made a remarkable comeback, appreciated both
by the general public and by the members of the Native American tribes he
portrayed. Nan Kiokun (opposite), now a resident of Bethel, Alaska, was
photographed as a child (top, far right) by Curtis in 1927, when he visited
remote Nunivak Island.

The only photograph hanging in our tribal council chambers is of a tribal member taken by E. S. Curtis. Another likeness from the same source adorns a community park. These images are of our people and they are close to us…. Real Indian people are extremely grateful to see what their ancestors looked like or what they did…. We see them at their classic finest.

—GEORGE P. HORSE CAPTURE, FORT BELKNAP INDIAN RESERVATION, 1993

Doug Cranmer (opposite), an internationally respected Kwakiutl carver, crafts a totem pole at his studio in Alert Bay, British Columbia. Doug's great-grandfather was George Hunt, pictured above with his second wife, Tusuquani. The principal informant for anthropologist Franz Boas, Hunt was also Curtis's interpreter in the making of *In the Land of the Head-Hunters;* Tusuquani wove many of the cedar-bark blankets and costumes used in the film.

As we neared this village the natives all climbed a high sand dune and watched us as though they had never seen a boat before. They were certainly a picturesque lot gathered there on the grass grown sand dune.

—EDWARD CURTIS ON ARRIVING AT NUNIVAK ISLAND

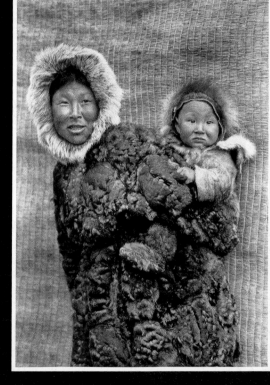

Joe Moses (opposite), now 74, was less than a year old in 1927, when Curtis photographed him on his mother's back (above). Natives of Nunivak Island, both mother and child were clad from head to toe in thick, soft duck-skin parkas. The picture appeared in a portfolio photogravure for Volume XX of *The North American Indian.*

These hardy, sea-going people had developed the ceremonial life until it was a veritable pageant. It is, perhaps, safe to say that nowhere else in North America had the natives developed so far towards a distinctive drama.... Their great canoes and ocean-shore homeland have afforded rare material for pictures.

—EDWARD CURTIS ON THE NORTHWEST COAST PEOPLES

Makah whaler Wilson Parker posed for this Curtis photograph wearing a wig and a bearskin cape over his blue jeans, to invoke traditional Makah life. These contemporary Makah whalers (opposite) are all descendants of Wilson Parker. Whaling actually had become illegal even before Curtis took his photograph, but its recent revival has given the Makah a new sense of cultural pride and a stronger connection to the past.

Sensitive of mind and heart, he recognized the Indians' true qualities.

They, in turn, revealed to him some of their innermost thoughts,

which were usually concealed from the white man.... It is gratifying

to me that Father is finally winning the recognition he himself was

certain would eventually come.

—FLORENCE CURTIS GRAYBILL, 1976, ON HER FATHER, EDWARD

Curtis's grandson, Jim Graybill (opposite and above as a child), remembers his grand-father as a warm and loving man, who wrote him long letters. The one above, posted in 1930 from a gold claim near Grants Pass, Oregon, was written from a cat's point of view and signed with a paw print: "The chief [Curtis] took me over to the mill, then put me down and told me to beat it for home. That time I fooled him. I just sat down in the snow and yowled…," the cat reported.

INDEX

ADDITIONAL READING

Boesen, Victor, and Florence Curtis Graybill. *Edward S. Curtis: Photographer of the North American Indian.* Dodd, Mead, and Co., 1977.

Cardozo, Christopher, ed. *Native Nations: First Americans as Seen by Edward S. Curtis.* Bulfinch Press, 1993.

Cardozo, Christopher, ed. *Sacred Legacy: Edward S. Curtis and the North American Indian.* Simon & Schuster, 2000.

Curtis, Edward Sheriff. *The North American Indian.*
20 volumes

Davis, Barbara. *Edward S. Curtis: The Life and Times of a Shadow Catcher.* Chronicle Books, 1985.

Gidley, Mick. *Edward S. Curtis and the North American Indian Incorporated.* Cambridge University Press, 1998.

Graybill, Florence Curtis, and Victor Boesen. *Edward Sheriff Curtis: Visions of a Vanishing Race.* Thomas Y. Crowell, 1976.

Smithsonian Institution, ed. *Handbook of North American Indians.* 20 volumes. Smithsonian Institution Press.

In addition to the books above, readers may wish to consult the following web sites:
www.curtismuseum.com
www.edwardcurtis.com

ILLUSTRATIONS CREDITS

All images from *The North American Indian* series by Edward S. Curtis, National Geographic Society collection, with the exception of the following:

Burke Museum, University of Washington: 129, 130, 166-167 (all), 187

Christopher Cardozo, Inc.: Cover, 2, 27, 62, 82, 96, 97, 112, 116, 125, 144, 147, 154

Collection of Barbara Davis: 58

Courtesy, private collection: 54

James Graybill: 16, 21, 23, 37, 39, 41, 52, 53, 65, 84, 92, 101, 104, 119, 122, 150, 153, 157, 158, 168, 172, 175, 193 (right)

Lynn Johnson: 11 (right), 178, 184, 186, 188, 190, 192, 193 (left)

Library of Congress: 162 (up)

NGS Image Collection: 32, 35

Archives of the Pierpont Morgan Library, New York: 86, 87, 88, 123, 160

Mark Thiessen, NGS: 181

Washington State Historical Society, Tacoma: 33

ACKNOWLEDGMENTS

I would like to acknowledge the generous and selfless help of the following people without whom my documentary film and this book would not have been possible: Jim and Carol Graybill, Barbara Davis, Mick Gidley, Rod Slemmons, Hartman Lomawaima, Gloria Cranmer Webster, Bill Holm, Paul Raczka, Jerry Potts, Allan Pard, Leigh Kuwanwisiwma, Curtis Hinsley, George Burdeau, and many other individuals. I would also like to thank the MacDowell Colony, where I began writing this book, and the National Endowment for the Humanities for their generous support through all my years of research. I would also like to thank my editor, Karen Kostyal, for keeping me on the right track, and my friends Nora Gallagher and Virginia McCracken for their love and support.

—*Anne Makepeace*

National Geographic Books would also like to thank Christopher Cardozo for his expertise and generosity; Linda Trammell, director of the Christopher Cardozo Gallery; James E. Goodloe; Mark Thiessen; the Pierpont Morgan Library; and consulting editors Martha Crawford Christian and Michele Tussing Callaghan.

Library of Congress Cataloging-in-Publication Data
Makepeace, Anne.
 Edward S. Curtis : coming to light / Anne Makepeace.
 p. cm..
 Includes bibliographical references and index.
 ISBN 0-7922-4161-4 -- ISBN 0-7922-4162-2
 1. Indians of North America—Pictorial works. 2.
Indians of North America—Portraits. 3. Curtis, Edward S., 1868-
1952. 4. Photographers—United States—Biography. 5. Curtis,
Edward, S., 1868-1952. 6. Curtis, Edward S,. 1868-1952. North
American Indian. Selections I. Title

 E77.5 .M34 2001
 973.0497'0022'2—dc21 2001045017

Printed in the U.S.A.

Composition for this book by the National Geographic Book Division.
Printed and bound by R. R. Donnelly & Sons, Willard, Ohio.
Color separations by Quad Graphics, Martinsburg, West Virginia
Dust Jacket printed by the Miken Co., Cheektowaga, New York.

One of the world's largest nonprofit
scientific and educational organizations,
the National Geographic Society was
founded in 1888 "for the increase and
diffusion of geographic knowledge."
Fulfilling this mission, the Society
educates and inspires millions every
day through its magazines, books,
television programs, videos, maps
and atlases, research grants, the
National Geographic Bee, teacher
workshops, and innovative classroom
materials. The Society is supported
through membership dues, charitable
gifts, and income from the sale of
its educational products. This support
is vital to National Geographic's mission
to increase global understanding
and promote conservation of our
planet through exploration, research,
and education.

For more information, please call
1-800-NGS LINE (647-5463)
or write to the following address:

National Geographic Society
1145 17th Street N.W.
Washington, D.C. 20036-4688 U.S.A.

Visit the Society's Web site at
www.nationalgeographic.com.